Praise for *Wonder Beyond Belief*

'In this beautifully written book, Navid Kermani performs something which, if not unprecedented, is still highly unusual, as he considers Christianity from the distance of a different faith. He does not claim any superiority here, quite the opposite. Unencumbered by the need to accept or reject, he explores the Christian faith with an alter interest and consuming curiosity. Through his keen gaze, coupled with a profound knowledge of theology and art history, Kermani captivates readers with the marvels of artworks that they might otherwise never really notice. The Anglophone world needs and deserves this gem of a book.'

Daniel Boyarin, University of California, Berkeley

'In this book Navid Kermani draws on his unique perspectives as a Muslim intellectual to offer thoughtful reflections on the complex divine ideas underlying Christian art and the deep parallels that can be drawn between it and other traditions, including mystical Islam. As an outside observer of Christianity, Kermani reminds us that the great faith traditions have more in common than they have difference and how, at the end of the day, we all pay tribute to the same divine spirit. May more Muslim and Christian thinkers alike be inspired by his deep reflectiveness and willingness to engage across faith traditions.'

Ambassador Akbar Ahmen, Ibn Khaldun Chair of Islamic Studies, American University, Washington, DC

'When I lived in Deir Mar Musa, Paolo Dall'Oglio would sometimes press a "very important" book on me to read. I am sure that *Wonder Beyond Belief* is one of these books. It encourages debate and impresses the reader with the need for communication and respect for other people's beliefs.'

Emma Loosely, University of Exeter

'*Wonder Beyond Belief* taught me more about Christianity and Islam than seems possible in such a deceptively light and breezy read. . . . It is precisely his outsider's perspective, the incredulous awe he feels when contemplating Christianity through the lens of art, that gives Kermani's book the refreshing and stimulating power which leaps off every page.'

Florian Hild, The Hopkins Review

'Kermani holds in fine balance his reverence and irreverence, his sense of the holy, his outrage at the outrageous . . . His very openness means that looking at Christianity and its art through his eyes can be moving, entertaining, illuminating, uncomfortable and very
rewarding.'

Deborah Lewer, Art and Christianity

Wonder Beyond Belief

Navid Kermani

Wonder Beyond Belief

On Christianity

Translated by Tony Crawford

polity

First published in German as *Ungläubiges Staunen: Über das Christentum* © Verlag C. H. Beck ohG, Munich, 2015

English edition © Polity Press, 2018

This paperback edition © Polity Press, 2019

The translation of this work was funded by Geisteswissenschaften International – Translation Funding for Humanities and Social Sciences from Germany, a joint initiative of the Fritz Thyssen Foundation, the German Federal Foreign Office, the collecting society VG WORT and the Börsenverein des Deutschen Buchhandels (German Publishers & Booksellers Association).

Polity Press
65 Bridge Street
Cambridge CB2 1UR, UK

Polity Press
101 Station Landing
Suite 300
Medford, MA 02155, USA

ISBN-13: 978-1-5095-1484-7
ISBN-13: 978-1-5095-3871-3 (pb)

A catalogue record for this book is available from the British Library.

Library of Congress Cataloging-in-Publication Data

Names: Kermani, Navid, 1967– author.
Title: Wonder beyond belief : on Christianity / Navid Kermani.
Description: Malden, MA : Polity, 2017. | Includes bibliographical references and index.
Identifiers: LCCN 2017024087 (print) | LCCN 2017033839 (ebook) | ISBN 9781509514861 (Mobi) | ISBN 9781509514878 (Epub) | ISBN 9781509514847 (hardback)
Subjects: LCSH: Christianity--Miscellanea. | Christian art and symbolism--Miscellanea.
Classification: LCC BR124 (ebook) | LCC BR124 .K47 2017 (print) | DDC 230--dc23
LC record available at https://lccn.loc.gov/2017024087

Typeset in 11 on 14 Janson Text by Servis Filmsetting Limited, Stockport, Cheshire
Printed and bound in Germany by CPI Group

Contents

Contents

I

MOTHER AND SON

Mother

My Catholic friend has written papers, only one of which I have read, about how he came across this picture. He would not exclude the possibility that it was painted by none other than the evangelist Luke. No laboratory analysis of the wood has been performed to date. The nuns are reluctant, he writes, because it's so brittle. But, even so, the art historians have declared the painting definitely ancient, probably first century. Ageless, the Virgin looked upon me, too.

My friend drove me to the convent, located in an ordinary residential street on Monte Mario, across the Tiber near the Hilton, and asked for the key at a little hatch in the side wall while I waited in the car. Before he led me to the chapel, where the nuns had turned the picture around for us, he peed in the bushes beside the iron gate. Ordinarily the Virgin looks into the oratorium of the nuns, who have cloistered themselves away for life, neither receiving visitors nor travelling, nor even leaving the convent to walk to the shops. God suffices.

We saw a few of them through the barred window in which the picture is hung, and we heard all of them praying in the wan light, wimples past their chins, starched white habits, black veils. Five of the thirteen sisters are over eighty. Those sitting in the section of the pew that I could see through the window were no younger. Vast water stains stood out on the bare walls of their baroque church. My friend said the pipes were rotting, the phones didn't work, and repairs were out of

the question until the convent had paid off its debts. The plea for donations is the part of their prayers which has yet to be fulfilled.

After a few minutes the nuns put out the light, after which we could only hear their voices: one verse low, one verse high, a singsong interspersed with pauses, although I couldn't make out a word. My friend's book begins with a quotation from the retired pope: what it says is nothing new but always needs to be said anew. 'Great things do not get boring with repetition. Only petty things call for variety and need to be changed quickly for something else. What is great grows greater still when we repeat it, and we grow richer, and become calm, and free.' In Rome I was already growing envious of Christianity, envious of a pope who said sentences like that, and, if I hadn't thought the idea of God's incarnation in only one person fundamentally wrong and the world of Catholic concepts in particular so pagan, if I hadn't felt such a revulsion against the order that places all people and all human relations in hierarchies and against the demonstration of power in every Catholic church, not to mention the idolization of suffering to the point of bloodlust, I might possibly have gradually adopted its practices, attended the Latin Mass, and joined, with interspersed pauses, in the singsong, although initially more for aesthetic reasons, perhaps, and out of a fascination with the unparalleled continuity of an institution that forms the people of God into a community. It is the only one to have achieved that for so long. Who knows? Maybe the miracle that produced this most sumptuous of all heavenly houses might one day have manifested itself to me too. As it is, while I continue to consider that this possibility is not reality, I acknowledge – and what's more, I feel – that Christianity is a possibility.

As if the darkness were not seclusion enough, invisible hands closed the shutters from inside so that we now saw only the icon, not the room behind it. Nothing is extant but Mary's

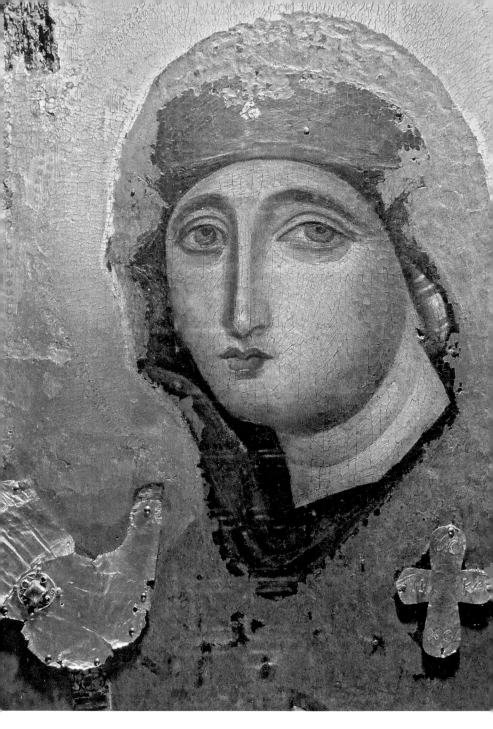

Maria Advocata, late classical, encaustic on wood panel, 42.5 × 71.5 cm.
Santa Maria del Rosario Convent, Rome.

face in the most astounding colours, the edge of her veil, two gilt hands, which could be pointing a way or signalling aversion, and the cross at the position of her heart – nothing else but her silhouette. And of course the gold background! The icon painters call it 'light', my friend whispers, because the gold surrounds the saints like the light of Heaven. There is no side lighting, no imagined light source; instead, the colours themselves are light, and the lightest of them is the gold. As my friend withdrew to say a rosary, I had some time with the Virgin. But why do I call her Virgin if I don't believe in her as the Mother of God? One word: touched. God has touched her. That is both grace and torment; it raises up and strikes down; it is both a caress and the blow of a hammer. All is lost and God suffices.

Her big brown eyes look at you as if her much smaller mouth had cried at first, like the mystic Hallaj, 'Save me, people; save me from God.' And so she did at first; she cried for help when she found out, I'm certain she did. 'Glad tidings!' the kings bellowed, bringing gifts, but I am certain she was anything but glad. She carried it, bore it, as the saints bear it; that's what made her one – not being chosen, but being able to stand it. Having become an enemy of the state overnight, she fled, sleeping in barns, in cellars, and in the wilderness if necessary, which was a real wilderness two thousand years ago, her child always with her, and always her care, which was not increased or diminished by the question whether he was *a* or *the* son of God. Her care was that of every mother. Later she stood by as they struck him in the face, drove him with whips through the spitting mob, saw the thorns piercing deep into his brow, saw him carrying the cross, saw them nail him to it, saw the cross erected and the people jeering, saw her son hanging upon it, bleeding, groaning, thirsting, crying out in pain and despair hour after hour. Perhaps he was not the only one to look towards Heaven and ask why God had

forsaken him. Certainly the son looked down from the height at which the people displayed him towards his mother. Does the painting show her before or after that?

No doubt there is a rule of icon painting that answers my question. My Catholic friend writes, as if it went without saying, that these eyes had seen how the son, her son, was tortured to death an arm's length away from her. Yet the Virgin doesn't look old enough to be mourning a grown-up child. For that matter, with the thin bridge of her nose, as if it was pulled taut, and her big, almost spherical cheeks, she is quite beautiful – not a Roman whore like Caravaggio's or a French countess like Raphael's, but undoubtedly Oriental. No, she is still young, and yet she has already experienced what it means to be touched, struck, by God; at least she believes she has experienced it; she has felt the pain, and she senses – more: she knows – that the pain will grow beyond measure. Only the immeasurable itself is beyond this Virgin's experience. If that were depicted here, this would no longer be an icon. People would run from it in terror. The miracle of the Catholic Church, if it is one, would be that they don't: they do not run away. For reasons I can't understand, they celebrate precisely what is most repulsive – which, I admit, may be what is most true – whether out of sadism, if one were to interpret it maliciously, or out of realism, as we may hope is the case. Yet Mary alone the Catholics keep pure, and I understand that perfectly. They paint madonnas for consolation, because without consolation you can't go on; they paint pictures of an immaculate face. Virgin, to me, means exactly this: pure – and hence, in the language of immanence, purified – of all experience.

Son

The boy is ugly. He is much uglier than he looks in this picture, or in any of the others that I have found on the Internet or taken myself with the good camera I borrowed. Clicking from one photo to the next, I would even go so far as to say that the boy is downright photogenic, when I remember how ugly he really looks. His mouth, for example, that open mouth: his receding lower and protruding upper jaw; and the lips more so: the lower lip short, or, more precisely, not short, but pressed, extruded into two fat bulges, accompanied by an upper lip pulled upwards like a tent on two strings, spreading out sideways to shelter the corners of the mouth. Because each picture captures only one point of view, they give no more than an inkling of how stupid the boy looks with his gaping lips – really stupid, more than just unbecoming: dim-witted, a mean kind of dimwit with something awkward and boorish about him at the same time, something of a spoiled brat thinking only of himself. It is unpleasant, unsavoury no less, to imagine a kiss, no matter how readily and easily we receive kisses from other children – but from him? There are children like that, five-year-olds who still scratch blithely in their unwiped bum crease and hold out their shit to you. This one has only lost some paint, but precisely on the three fingers that he holds up in blessing, and from the tip of his fingernails past the second knuckle. At first glance he seems about to stick his bent, brown fingers down your throat.

And how round he is – not fat in the sense of overweight, but rounded, his nose wider than it is long, his skin rotund like blown-up balloons. His cheeks look all the more spherical because the retracted lower lip lifts up his ball-shaped chin. In all, his face consists of three – no, four – no, five balls, because his double chin and the tip of his nose are also globular, but the spherical shape of his exaggerated bulk is what you can't see if you look at the boy from a single point of view, that is, in only two dimensions. The two breasts are likewise round, like a woman's, I notice looking at photos of the boy, and the fat encircles his upper and lower arms, forming more balls. A cherub, a mother would call him, believing her child the most beautiful on earth even if he is a paragon of hideousness to anyone else, especially an unbeliever or a believer in a different faith like me. My Catholic friend, whom I asked to go by the Bode Museum on his next visit to Berlin because, in the photos I had sent him, the boy's stupidity is only two-dimensional, my friend too conceded on the phone that the last thing he would associate with the boy was beauty, grace, charm.

'Did you see his fingers?'

'I'm standing right in front of him,' my friend whispered.

He had no trouble finding the boy; he just asked the first guard he saw where to find the ugly Christ Child and was shown the way with a grin. All the guards knew it: Fatty is down the corridor to the hall under the smaller cupola, then first door on the left. In the catalogue, meanwhile, there is no illustration of the Christ Child, and even the special catalogue of the sculpture collection contains only a small, almost tiny photo, flatteringly lighted, as if the museum's directors were ashamed of it or did not want to cause any trouble by a kind of blasphemy. Although blasphemy no longer bothers anyone in Berlin, except perhaps some of the Turks. But this boy, and this is the important thing to understand, praises the Father.

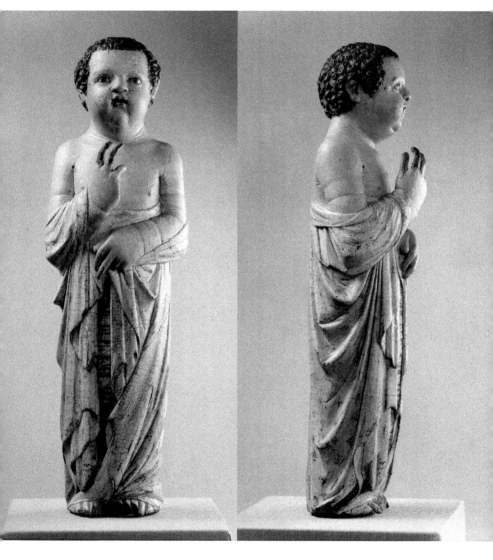

Christus Child, Perugia, *c.* 1320, nutwood, height: 42.2 cm.
Bode Museum, Berlin.

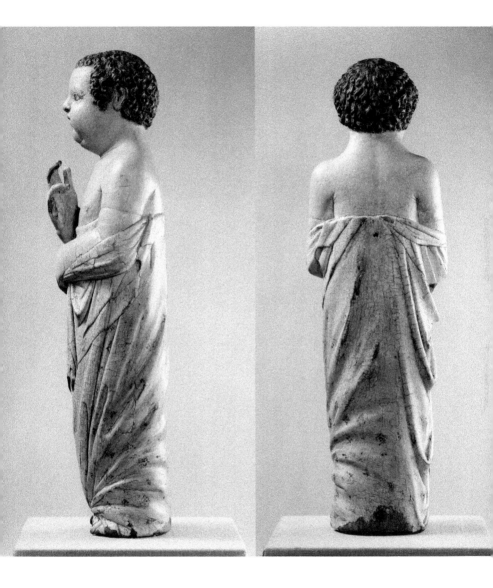

The motif of Jesus as a child did not appear in Catholic art until the thirteenth century, my friend digresses, so the sculpture must be a very early, immature specimen. St Francis in particular loved the Christ Child, he explains, and female mystics cherished Him in contemplation and rocked Him in their arms, feeling themselves one with the Mother of God.

'That snotface?' I ask.

'Well,' my friend whispers. The sculptor of this particular piece, he supposes, which is perhaps less propitious to *unio mystica*, immortalized the features, and probably the dense curls, of his patron, or his patron's child.

'Aha,' I say, just to say something in reply to his explanation, which doesn't entirely satisfy me.

But my friend begs to be excused, he has to hang up, he just wanted to let me know. 'Look it up in Ratzinger,' he follows up in a text message. 'I've read it,' I answer.

I would rather have asked my friend more about St Francis, who didn't mind the Son's ugliness perhaps because he cherished every child, ugly or beautiful, as a child of God. Be that as it may, the retired pope, whom my friend esteems more highly than he does Pope Francis I, has not written a book about Jesus' childhood. The years of Jesus' childhood, when he was no longer an infant and not yet a youth, are omitted from the *Infancy Narratives*. Benedict XVI describes the annunciation of the birth, the birth itself, the visit of the three wise men, and the flight into Egypt – Jesus was still a baby then. Benedict XVI then continues the story only when Jesus is nearing adolescence. And in the meantime? He must know, the retired pope, that there are indications: the Infancy Gospel of Thomas. Although it was not included in the canon, Christians gave it consideration as a testimony for many centuries.

Without entering into the philological controversy, I always found the Infancy Gospel to be a very realistic text. Precisely because it is disturbing, because it deviates very

unfavourably from the notion we form, believing or unbelieving, of the adult Jesus, its conservation and propagation among Christianity would be plausible only by means of a particularly strong chain of transmission. For I never found the Infancy Gospel to be logically consistent, of a piece, with the beloved infant and the so fiercely loving later man. Playing on the bank of a stream, for example – and this is the bang that opens the book – the five-year-old diverts its rushing waters into little puddles by the sheer power of his will. A neighbour boy takes a willow switch and sweeps the water back into the stream. The two quarrel, and up to here it reads like a normal story: a scene between two boys that could happen in any kindergarten. But then Jesus cries out that the neighbour boy should wither up like a dead tree, never to bear leaves or roots or fruit again. And immediately the neighbour boy withers up completely, which can only mean he dies, he dies a wretched death, plunging his parents into sorrow, as the Infancy Gospel explicitly says. Jesus, unmoved, goes home.

And the account continues, in exactly that style, with those character traits: in the village, a boy running accidentally bumps Jesus' shoulder. What does Jesus do? Kills the boy with a single word. And when the parents of this and the other boy, and more and more people, complain to Joseph – what does Jesus do? Strikes them all blind. And when his knowledge exceeds that of his teacher Zachaeus, he makes a laughing stock of the old man in front of everyone; Zachaeus despairs and wants to die on account of this child, who must be a paragon of hideousness.

Perhaps Benedict XVI, and my Catholic friend along with him, are too spellbound by the beauty they seem to find so important in Christianity, and hence in Jesus Christ, to see the ugliness as well. I understand their persistence; in a city like Berlin I need only attend a simple Sunday service to concur with them that beauty is sorely lacking in Christianity

today. Poverty alone can't make a God great. But beauty can only be realized together with its opposite. Jesus himself said, or is said to have said, in a saying transmitted by the Church Father Hippolytus, 'He who seeks me will find me in children from seven years old.' That would seem to mean that the Saviour is not to be found in the five-year-old that the Infancy Gospel describes. It means that even the Son must first become that which, in the canonical tradition, he is from the beginning. Jesus may have been a snotface, a monster of a child, one who possessed miraculous powers yet used them with malice. I am afraid some will think I am now blaspheming against Jesus himself. But it is no blasphemy, and malice is an attribute that is ascribed to God too.

Clicking from one picture to the next, I wonder whether it was not by remembering with shame the loveless child he had been that Jesus became filled with love, ultimately an ecstatic, enthusiastic, understanding man who emphasized the good even in a felon, who praised beauty even in what is ugly. This anecdote is a favourite of the Sufis, and also the one I love best: Jesus and his disciples come across a dead, half-decayed dog, lying with its mouth open. 'How horribly it stinks,' say the disciples, turning aside in disgust. But Jesus says, 'See how splendidly its teeth shine!' Jesus might have been speaking not only of the dog but also of the child he used to be.

But the mother – you couldn't wish it on any mother to have such a son: announced by angels, exalted by kings, and then he turns out to be a spoiled brat brimming with supernatural power. The Infancy Gospel mentions Mary only at the very end, when Jesus is more than seven years old. She must have agonized over him, felt ashamed of his misdeeds, and yet stood by him, loving her cherub unconditionally. That is his mother, the epitome of the mother: no matter how the child is. That is her son, every son, who has to learn love from his mother. I wouldn't want to cradle this boy in my arms.

Mission

As a youth I often dreamt that Jesus appeared today, here in Cologne, at the train station or at H&M, and in every dream I saw a freak, probably homeless, or a hippie holdover with long, unkempt hair, his shirt and trousers of motley rags, and on his bare feet, even in winter, the sandals that are often referred to by his name. A misfit, a nutcase, he stood in a pedestrian zone warning that the end of the world was near, or else he was a political rabble-rouser, a fanatic in his contemporaries' eyes, although peaceful and therefore harmless, more ridiculous than dangerous. I assume such dreams, as miniatures or caricatures of the uniform non-conformity of my political socialization in West Germany, reveal more about my time than about Jesus. The Jesus I dreamt about could just as easily have been mistaken for a tramp as for a founding member of the Green Party.

Later I realized that Jesus was not particularly obtrusive in his outward appearance. John the Baptist was conspicuous, as were later the early Christian hermits. Jesus himself was so fond of eating and drinking that his feasts were held against him. Without supporting their accusations, we must take seriously what his adversaries said: after all, they could as easily have decried him as a liar or a thief, but instead they

Overleaf: Veronese (Paolo Caliari, 1528–1588), *The Wedding Feast at Cana*, 1562/3, oil on canvas, 677 × 994 cm. Musée du Louvre, Paris.

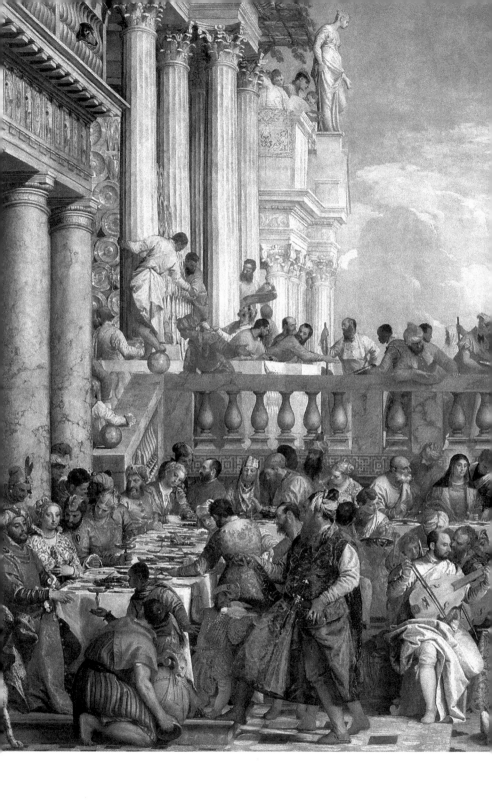

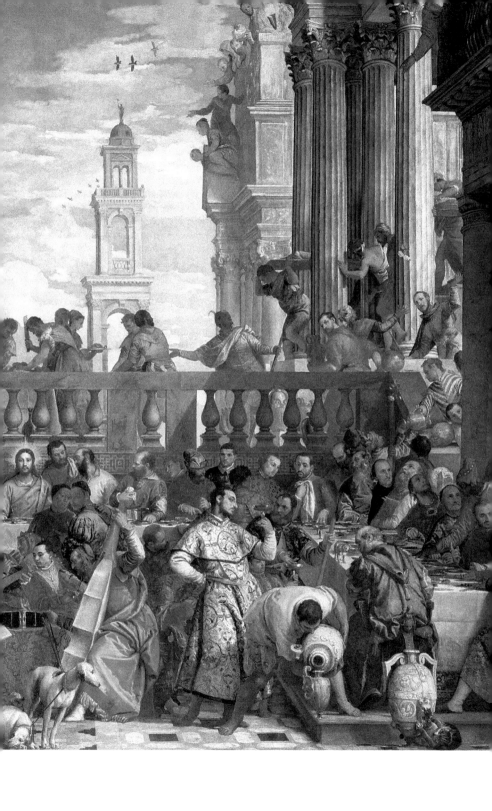

cried, 'Behold a man gluttonous, and a winebibber, a friend of publicans and sinners' (Matthew 11: 19). In other words, they accused Jesus of holding banquets for the godless and the collaborators with the Roman occupation. I don't think he sympathized with them. More probably, he wanted to demonstrate community with all members of his people – not just the dignitaries and the orthodoxy, not just the outcasts and the disadvantaged, no: all of them, even the narrow-minded and the lawbreakers, those of little imagination or character – with us. Seen in that way, Jesus was the very opposite of a misfit; he was gregarious in the extreme.

In Veronese's painting, Jesus is feasting among all the people, his mother beside him, the Apostles Peter, Andrew, Philip and, with the knife in his hand, Bartholomew of Cana, who will later be flayed alive, as well as cooks, waiters, butlers, musicians, the *maître de table* with his oriental turban and, evidently very genteel in his gold brocade gown, the wine steward. All the garments, for that matter: not historical, but contemporary with the painter, from the sixteenth century, for which reason it was long a popular pastime to try to identify all kinds of contemporaries with the various wedding guests, from Veronese himself, and a few of his fellow artists, to church officials, to heads of state such as Queen Mary of England and Suleiman the Magnificent. Perhaps, art historians answer sympathetically, but perhaps not.

The individuals are not what counts. What counts are the numbers: Veronese has positioned a hundred and thirty people in *The Wedding Feast at Cana* and given them a hundred and thirty different faces, gestures and expressions, so that the viewer's gaze gets delightfully lost in the details and constellations, in the architecture and the countless props on this stage of humanity. As I stand before this huge picture, almost 70 square metres in area, the same thing happens that would most likely happen if Jesus were to appear today: I pay

him no more mind than anyone else. He sits in the centre, true, and is illuminated by a little halo, like his mother, but what is that halo against the dazzling splendour and abundance all around? Apart from the disciples, the other guests pay him no mind at all; they sit still, talk, cook, serve, play music as if there was nothing out of the ordinary. That is all the more painful since they, or at least some of them – the wine steward, the butler, the black boy at the left, the first guests at either end of the table, even one of the dogs – have already noticed the miracle. But no one looks at Jesus, who turns water into wine. And accordingly no one suspects whose flesh they will eat. It is lamb, as we can see from the platter being carried into the scene by two servants at the upper right. And it is being cut into plate-sized portions directly above Jesus' head.

Maybe my dreams had it right, except that they connected Jesus' differentness and strangeness to superficialities, his clothes, his hair. In the Gospels too he belongs to a different present, a second here and now so to speak: he is on earth, he is feasting with everyone, he is not outwardly conspicuous – and yet he is touched so deep inside, penetrated by God, that he glows, even if only the disciples, artists and children from seven years old on can see it. What distinguishes him is so subtle that not even Mary Magdalene recognized the resurrected Jesus at first sight, not even the disciples who ate with him at Emmaus. It is not his eyes, not his voice, and it cannot be his words if he so often says nothing. Perhaps it is nothing more than a look – all the other 129 wedding guests are looking at one thing or another; not all of them are absorbed in conversation, many are still, more than at any ordinary wedding; many are thinking, as if they had noticed the light after all, or at least been disturbed by something. But Jesus is looking at nothing, and thus at everything. The difference is more distinct if you compare his gaze with that of his mother,

who also looks absent. Only her gaze, which is also slightly lowered, is directed inward, where she is grieving, because with the first miracle she foresees the martyrdom that awaits her son. Jesus on the other hand is looking outward, out of his present place and time. He is looking at none other than you.

And anyway, who takes their mother to a wedding? A young, well-built man like Jesus goes with a girl, or, if he hasn't got a girl, he goes to meet one. Just looking at his mother's appearance, you can see she's a wet blanket: never budging from her son's side, wearing the traditional mourning colours black, blue and grey, where others only wanted to enjoy the feast. In my time, that would have been the odd thing, the absolutely strange and segregating thing: that he always had his mother along – and she's even called *sponsa Christi*, the bride of Christ – his mother! That's probably why we in West Germany were at such pains to portray him as having a relationship with Mary Magdalene: to make his non-conformity conform just a little bit – although the Gospels contain nothing to suggest any erotic connection. At most, one might hear Mary Magdalene's complaint as implying she is in love with the young man. For his part, however, Jesus never says a word to the woman that indicates love for her. Jesus was solitary. For all his gregariousness, amid 129 wedding guests, Jesus was solitary. At most, he was with his mother. And, what is more, he demanded solitude of each individual in his community. 'If any man come to me, and hate not his father, and mother, and wife, and children, and brethren, and sisters, yea, and his own life also, he cannot be my disciple' (Luke 14: 26). There is no character trait that permeates all four Gospels as distinctly as his insistence on being free of all relationships, free not only of relations, friendships and loves but also of all things, including houses and lands, as he explicitly adds in Matthew 19: 29.

It drove me mad that no one recognized him, that I could not persuade anyone of his presence, did not even try to

persuade them since it seemed hopeless and I might have been taken for a madman myself, for one of the nutcases in the pedestrian area warning of the end of the world or chaining themselves to the doors of H&M in protest against starvation wages.

Love I

There's no knowing whether Jesus' eyes and mouth are opened wide in dismay or in suspense, whether his hand is upraised in defence or in command. There's no knowing whether Mary's amazement is ecstatic or in panic, whether her hand is reaching towards the open tomb or repulsing her brother. There's no knowing whether Martha is really recoiling, silhouetted as she is in the lower left corner. There's no knowing what is going through the minds of the three men, at the back perhaps the Apostle Peter, as they stare at the reawakened Lazarus. There's no knowing whether Lazarus is laughing, however tiredly, or whether he is shouting, 'No! I don't want to.' Rembrandt left that open; he did not interpret, much less evaluate. But he made the exertion visible, the spiritual and likewise the physical strain on Jesus, who does not merely speak an easy word, as the other painters have it, but rather calls into the tomb 'with a loud voice', which in the English of the King James Version means he screams or shouts; he 'groaned in the spirit' and was weeping a moment ago, and he foresees that the high priests will fear him now if they haven't yet and will condemn him to death when they recognize his power. Rembrandt does not make the two sisters raise their hands to Heaven in devout gratitude; he has given Mary an expression of stunned amazement and Martha the hint of a cringe – no one here is happy, not even the three men, not even Peter. But most of all, Rembrandt breaks

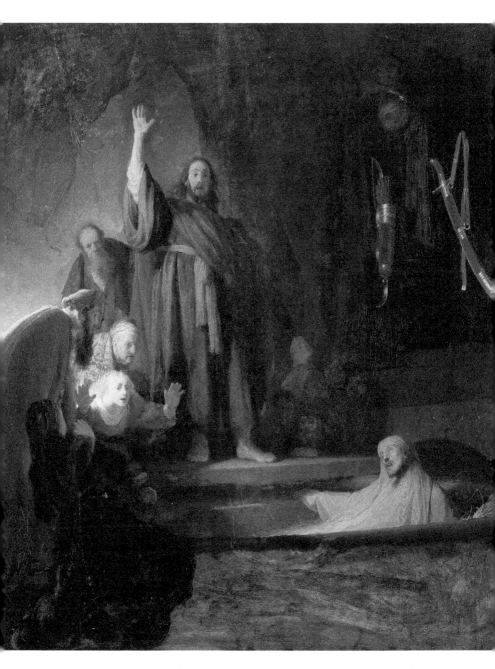

Rembrandt (1606–1669), *The Raising of Lazarus*, *c.* 1630, oil on wood,
96.4 × 81.3 cm. Los Angeles County Museum of Art.

radically with his predecessors who painted Lazarus with a sound body. His Lazarus bears distinct traces of decay and a cadaverous green phosphorescence.

We have to realize that no one who believes in the resurrection of the dead would want to be reborn in this world. Jesus himself, who 'loves' Lazarus more than other people, is aware that he is not doing his deceased friend a favour by bringing him back to life. Jesus does it for his disciples – 'to the intent ye may believe' – and for the bystanders – 'that they may believe'. From the very beginning, in fact, the moment the news arrives that Lazarus is sick, Jesus makes it clear that, at bottom, he must act for his own sake: 'that the Son of God might be glorified'. For he correctly anticipates that Lazarus will die and his reawakening will be the provocation to crucify Jesus himself – after all, Jesus' own resurrection is what is meant by 'glorification'. This is consistent with Jesus' view in which his trip to Bethany is a return to Jerusalem – 'Let us go into Judaea again' – which he associates with the course of time – 'Are there not twelve hours in the day?' – and Thomas urges the other disciples, 'Let us also go, that we may die with him.' It is still more consistent with the weeping, Jesus' quite remarkable, apparently passionate weeping in Bethany, which is often read as mourning for Lazarus – but why should Jesus mourn the death of the man he is about to reawaken? Thus Hippolytus and other Church Fathers interpret Jesus' tears not as grief over the death of his friend but, on the contrary, as sorrow over his return to life. In other words, 'Jesus wept' because he had to oblige his friend, Lazarus whom he loved, to return to the misery of this world in order that Jesus himself could be killed and so be resurrected. And in fact, though it has received scant attention, there is a crucial pause during the raising of Lazarus as the tombstone is removed: 'Father, I thank thee that thou hast heard me,' says Jesus on seeing the body. Only then does he call – or, rather, he screams

and shouts Lazarus – 'because of the people which stand by I said it, that they may believe that thou hast sent me' – out of the tomb. That means his thanks for having been heard precede the physical resurrection; they are temporally and linguistically separate acts. So Jesus' thanks seem to refer to something else. But to what?

I go back to the beginning of the story in John 11: 'Our friend Lazarus sleepeth,' Jesus says when he hears that Lazarus is sick in Bethany. 'Lord, if he sleep, he shall do well,' the disciples reply, thinking Jesus is talking about restful sleep. But Jesus explains to them that Lazarus has died: 'I go, that I may awake him.' Because we already know how the story ends, we assume that Jesus is announcing here that he will bring Lazarus back to earthly life. But the awakening could just as well refer to the resurrection. Jesus himself says to Martha, the sister of Lazarus, who has been dead and buried for four days, when she comes to meet him outside Bethany, 'Thy brother shall rise again.' That doesn't surprise Martha: 'I know that he shall rise again in the resurrection at the last day.' And Jesus confirms Martha's words: 'I am the resurrection, and the life: he that believeth in me, though he were dead, yet shall he live: and whosoever liveth and believeth in me shall never die.' Here he is clearly talking about eternal life – 'though he were dead' – not about continuing or resuming our temporally limited earthly existence. 'Believest thou this?' And in answer, the simple woman Martha, and not one of Jesus' male disciples, speaks the new community's confession: 'Yea, Lord: I believe that thou art the Christ, the Son of God, which should come into the world.' Jesus' thanks for having been heard must refer to the ultimate, and ultimately eternal, resurrection. The subsequent physical reanimation of Lazarus is only the illustration that, through Jesus, the dead are resurrected; it is an outward sign for the unbelievers and the unsure, not for poor Lazarus by any means.

Or does Jesus weep because, when he arrives in Bethany, it has not yet occurred to him to bring Lazarus back to life, and therefore he actually misses his friend and does not expect to have him back so soon? 'Behold how he loved him!' say the Jews, sympathizing with Jesus in spite of their mistrust. But when a few of them provoke Jesus by reproaching him for not having prevented his friend's death, he goes to the tomb and orders the stone removed. 'Lord, by this time he stinketh,' says Martha to deter him, 'for he hath been dead four days.' But Jesus admonishes Martha to have faith – in him, who is the resurrection and the life – and has the tomb opened. After Jesus has raised his eyes to Heaven and thanked God, he continues for the people's sake, so that they will recognize that he is sent by God, and wakes the dead man. Lazarus rises from the tomb, his arms and legs bound in a shroud, his face bound with a napkin, no doubt for good reason. By omitting the napkin, Rembrandt supplies an explanation for Jesus' odd reaction: instead of embracing or even greeting the friend he had mourned, Jesus only says, 'Loose him, and let him go.' – Go where?

Naturally we wonder, or maybe only I wonder, what kind of life it could be that Lazarus has just regained, with his skin already mouldering, his flesh shrunken or already maggoty, smelling of carrion and horrifying to everyone, not to mention the spiritual degradation, the shock of resting in the peace of the just, God's peace, which is supposed to be eternal, and then suddenly being relegated back into the body, which by now is not just infirm, but rotten. And Jesus already knows that he will be killed, very soon and in the most ruthless way; he knows that Lazarus will then mourn him in turn; he will have Lazarus with him at the anointing that marks the beginning of the Passion – how can a friend subject a friend to that? Or does he subject him to it *because* Lazarus is his friend, just as a man might want to scream and shout the wife he

mourns back to life, or a woman her husband, or parents their children – whether they believe in the resurrection or not? I too wish, and sometimes speak the admittedly egoistic wish, that I may die, God willing, before my wife and especially before our children, and not have to weep at their graves. But Jesus' love surpasses human measure. How he loved Lazarus! There's no knowing whether his friend is laughing, however tiredly, or whether he is shouting, 'No! I don't want to.'

Love II

Supposing you were unaware of the painting's title, and you did not recognize the two figures, and so you took the halo for the rays of the hidden sun, suggesting the shape of a cross as they frame Christ's head; supposing you saw just a man and a woman, both very young, the woman somewhat younger, but the man too no older than his early or at most his mid-twenties, their brows unfurrowed, their cheeks rosy, their lips velvety like those of children and at the same time sensuously full; no aging apparent except in the slight suggestion of concavity below their eyes – what, then, would you think you were looking at? Although I was at an exhibition of El Greco, who had painted Jesus and Mary so often, and I had already read that this painting shows Christ taking leave of his mother, I thought I was looking at two lovers, or, to be more exact, at two people who love each other, and definitely not as mother and son. Their age is of course one factor in creating that impression: just past the threshold of adulthood, where painting, classical literature, and music too rightly situate great loves, for when we are younger we are too ignorant of what we are experiencing, and when we are older we are too quick to relativize it. But it is more than just their age: after all, the Mater Dolorosa is often portrayed as young, and sometimes younger than Christ. But, in El Greco's painting, her motherhood is absent altogether; her gaze is directed not in sorrow or care at her son but, with an expression of serenity, into the

distance, or at nothing. It is the look, so lost to herself, of one who feels safe with her beloved. And indeed he is looking at her with both desire and devotion. He is less a redeemer than a man who has found his redemption in love; his gaze is both ardent and adoring; it shows an almost comical languishing such as you would imagine in a Romeo or an Abelard, although you need only recall your own great love at that age.

The picture's refutation of its own title could hardly be more blatant: the title refers to more than a mere leave-taking; it cites a high point of the Passion of Christ. According to the Bible, Jesus addresses Mary for the last time seconds before his death, calling down to her from the cross, 'Woman, behold thy son!' But the farewell to Mary in Bethany is one of the subjects from Jesus' life that painters do not take from biblical sources. The representation is based on the medieval *Meditations on the Life of Christ* by the Pseudo-Bonaventure, who set the leave-taking earlier, between the raising of Lazarus and Jesus' entry into Jerusalem. To me as an outsider, that seems somewhat strange, since paintings by the same artists portray Mary in Jerusalem, and even on Golgotha, from the beginning to the end of the Way of the Cross. She is present when Jesus begins his doleful Way; she offers him her veil to cover his nakedness; she stands, supported by the other women, lamenting at the foot of the cross. But even in those paintings that set Christ's leave-taking from his mother in Bethany, the home of Lazarus, and thus amid circumstances less dramatic than a crucifixion, the scene is still painful in the extreme – the last words between a mother and her son who is going to his certain death – especially as the popularization of the motif is connected with the emerging Marian mysticism, in which the Mother of God's pain begins with the

Overleaf: El Greco (1541–1614), *Christ Taking Leave of His Mother,* *c.* 1578–1580, oil on canvas, 64 × 93 cm. Private collection.

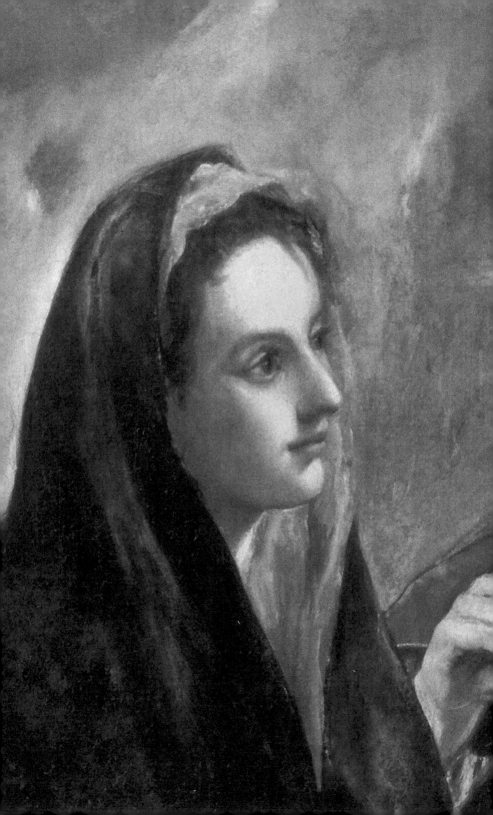

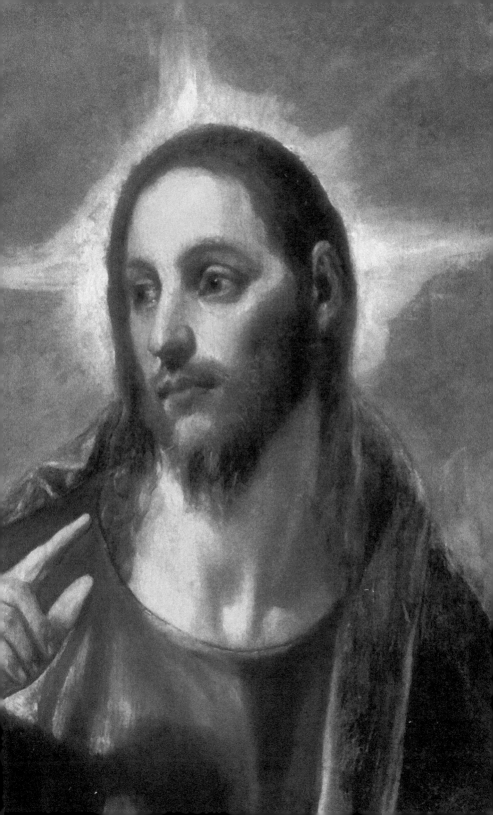

birth of her son, as in St Bridget of Sweden's account: 'When she wrapped him in swaddling clothes, her heart considered how his body was going to be wounded all over with sharp scourges, making it appear like that of a leper. When she bound her little Son's hands and feet with swaddling bands, she called to mind how cruelly they would be pierced by iron nails on the cross.' Accordingly, Mary is portrayed at her leave-taking in a bowed posture, often kneeling or, as Dürer depicts her, collapsed in grief, while Jesus tries in vain to console her, embracing her shoulder or holding her hands, speaking words of comfort. Indeed how could a son facing such an ordeal console his mother? In some pictures Jesus and Mary embrace; in others he kneels before her as she blesses him, or she holds him fast to stop him leaving. Almost all such pictures also show Lazarus' sisters Mary and Martha, and many disciples, all of them weeping, lamenting, despairing. In El Greco, nothing of the kind – or, rather, the exact opposite.

The colours themselves are bright and warm; the luminous blue of the sky, the halo that could also be sunlight around Jesus' head; likewise around Mary an opalescent nimbus that looks more like a friendly cloud; also the red and moss-green of their garments, the bright veil, the healthy glow of their foreheads, their cheeks, their lips. Moreover, the painting avoids all clues that might indicate a certain place, a certain station of the cross; El Greco only makes it plain that the two say their goodbyes outdoors, under a clear sky, although the scene could also be set in Heaven. But it is the eyes most of all that make me think of anything but the Passion, especially the woman's eyes, in which there is more than just love: there is the bliss of its fulfilment. The man on the other hand – and this is the only touch of terror in the picture – seems to have a presentiment of the transience of all things, and especially of happiness – a certain what-if that overcomes a lover: if anything were to happen to her; if she were no longer there; if

I ever had to live without her. Avicenna teaches, I once read, that melancholia has to do with two functions of the brain, cognition and imagination – that it is produced by simultaneously understanding what is present and imagining what is absent. Melancholic people enjoy summer even as, and in fact because, they think of winter; they see a thing and its transience simultaneously.

The man in the picture is not necessarily melancholic; a moment later he might look happy again. But in his eyes, it seems to me, the artist has captured the essence of melancholia. If it lasted longer than a moment, very much longer, if it were to remain fixed on his face, melancholia would destroy the very thing it fears for. Melancholia is not compatible with love because it inevitably evokes a feeling that one is not living but observing one's own life, which is why Avicenna, and medieval medicine in general, treated it as an illness. As a moment, however, as that touch of terror, melancholia heightens your feeling just when you felt it was the highest possible. You step outside the present and are in it at the same time. What the man was about to say, I imagine, when he raised his index finger is the suggestion to look at things for a moment from outside – but, thinking better of it, he says nothing, lest she also perceive the transience of things.

And yet El Greco called the painting 'Christ Taking Leave of His Mother', and not something like 'Romantic Idyll'; the light around Jesus' head suggests a cross; the nimbus around Mary is certainly not a cloud. Is it not astonishing that there is no tradition concerning either of these two people, who loved as no one else, that tells of the love between a man and a woman? El Greco was astonished, it seems to me, when he painted their lips so sensuously that they seem likely to meet at any moment in a kiss. He added two pairs of eyes which are absent from the Gospels, but which everyone who remembers a great love must know.

Humiliation

Nothing demeaned Jesus more than the indifference of the soldiers whom Pilate had charged with the crucifixion. Why the people, why the high priests and elders in particular were not content to see Jesus die but wanted him publicly tortured is explained in the Gospels by a number of reasons, of which the most important and the most banal is the one Pilate himself acknowledges: envy – although envy is perhaps too general, and today, in these years, it would be more exact to call it resentment, that aversion that is founded on envy but not only on envy: for, because it also rests on prejudice and malevolence, fear and feelings of inferiority, it necessarily extends into the unconscious, so that the people, so that the high priests and elders, could not answer Pilate's question what evil Jesus had done but could only scream the louder: 'Crucify him!'

Without wanting to justify their accusations, I can empathize with the reason why the extreme humility and the extreme presumption that were united in Jesus infuriated the people, and still more the high priests and elders, especially if I take into account the apocryphal Infancy Gospel of Thomas: Jesus as a repulsive little monster who bullies the grown-ups and invokes his transcendent authority in every little argument. But the modesty, the submission, the unshakable endurance that the Gospels attribute to the adult Jesus also encompasses a haughtiness, intentional or not, because

his ostentatious selflessness declares as negligible and ridiculous what ordinary humans find indispensable: their own welfare. The sentence in Mark 10: 45 which says he 'came not to be ministered unto, but to minister, and to give his life a ransom for many' contains a tremendous presumption in the eyes of those many: why should they need someone to ransom their lives? The furious rejection of the people, among them the high priests and elders, reveals their consternation, how 'offended' they are, as the Gospels say remarkably often, and their 'astonishment' could only confirm Jesus as their opposite, as the chosen one. 'And blessed is he, whosoever shall not be offended in me' (Matthew 11: 6) – a tiny minority, for whom Jesus goes on to prophesy, 'And ye shall be hated of all men for my name's sake' (Mark 13: 13). Jesus never felt a moment's doubt, in spite of being subjected to a mockery of a trial. He did nothing to mollify his accusers or even to explain himself; he answered not a word of their denouncements, so that Pilate was quite amazed.

There is little for me to say about Pilate. The Gospels present a plausible description of him as a pragmatic governor who decides, not between right and wrong, but by utilitarian considerations. By meting out weathervane justice, Pilate merely fulfils what has been ordained for Jesus. Up to that point, up to his judgement, everything goes according to a higher necessity, one which at the same time exalts the condemned man. But then Jesus is handed over to anonymous soldiers, simple henchmen who are not of his people, who know of him only what they have heard tell, and have no resentment, or any feelings at all for that matter, towards him. They take him with them into the hall, out of the view of sympathizers, and call their comrades, the whole squad, and make

Overleaf: Caravaggio (1573–1610), *The Crowning with Thorns*, 1602/3, oil on canvas, 127 × 166.5 cm. Kunsthistorisches Museum, Vienna.

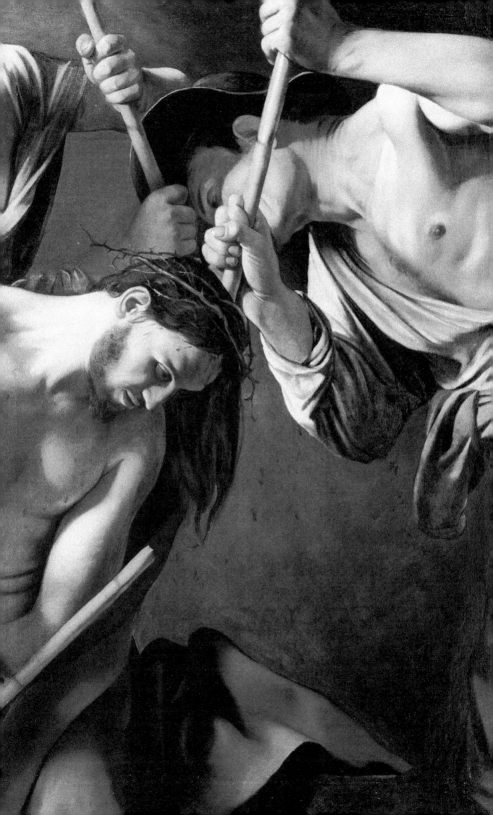

such sport of him as was perhaps not even called for in God's doom. The crown of thorns they put on his head, for example, was commanded neither by his accusers nor by Pilate but is their own idea, like the reed they place in Jesus' right hand and the purple in which they clothe him – a mere amusement; they bow their knee before him as if in a farce, taunt him and address him as a king. And it goes on! It goes on and on ... The time it takes even just to braid thorny switches into a crown and use sticks to twist it so firmly onto his head that the blood spurts onto his cheeks and his back and the crown sticks fast no matter how vigorously he shakes his head – it takes more than a few minutes to do that; it is a drawn-out spectacle, and one of high craftsmanship by the way, attended by the gang of soldiers bawling, cheering and goading; it takes an hour perhaps, or longer. And Jesus has nothing to do with them: that is the worst part of it; he is so foreign to them, as indifferent as an object they have picked up in the street, a plaything that chance has put in their path, or, rather, thrown into their hands.

Earlier at the governor's palace, and afterwards on the way to Golgotha through the seething mob, and finally looking down from the cross, he looks his accusers in the eye. But in the hall, in the keeping of the soldiers who have no connection whatsoever with him yet are not, like Pilate, simply doing their jobs but rather enjoying a foolish joke, thought up by no one, or only by the evillest Providence – whom could he then look at, who could return his gaze, if only with wrath, contempt, hatred, and in doing so accord him some importance as a fellow man? 'Father, forgive them,' Jesus murmurs with bowed head, but he does not mean all of humanity, the entire people, to say nothing of the high priests and the elders. Only the soldiers know not what they do, and they strip him of the consolation of being chosen of God by degrading his Passion to a mere amusement. And crucifixion was already the most

disgraceful, the most shameful of deaths. The people rail on him, 'Save thyself,' and the high priests gripe, 'Let Christ the King of Israel descend now from the cross, that we may see and believe,' and even the common criminals who were crucified with him 'reviled him'. Nine hours Jesus contained himself before, in the darkness, he called out to God, Whose silence likewise mocked him.

Then one man, one of the soldiers, Luke emphasizes, goes and fetches a dripping sponge, which he puts on the point of a lance to stuff it in the thirsty man's mouth. Today this is understood as an act of pity, since vinegar – a few drops of vinegar in water, to be exact – quenches thirst and so prolongs life, but, if it is pity, why do the soldiers taunt him at the same time as they give him the vinegar, 'If thou be the king of the Jews, save thyself' (Luke 23: 37)? If it is supposed to be water with vinegar, why doesn't the Gospel say so, instead of explicitly mentioning vinegar, whose nauseating taste we immediately imagine on our tongue? And what would be merciful in the first place about prolonging Jesus' life, which would only mean drawing out his harrowing death? And if the sponge would prolong Jesus' life – why is Jesus dead a moment later? No, that is not the refreshment he begged for, hoped for, when from high on the cross he saw the sponge. The soldiers are fulfilling what is written in Psalms 69: 21: 'In my thirst they gave me vinegar to drink.' Jesus realizes that it is a joke; it's only a joke, one that the soldiers would laugh at who today are crucifying troublemakers in Syria and Iraq. 'Reproach hath broken my heart; and I am full of heaviness: and I looked for some to take pity, but there was none; and for comforters, but I found none.' The sponge apparently still in his mouth, Jesus cried out with a loud voice and died.

Beauty

The farther away you get, the more feminine Jesus becomes. I was alone in the underground room – forty, fifty minutes alone on an August afternoon, when the queues in front of the better-known museums coil like liquorice whips. There must be an explanation why, although the Pinacothèque possesses some of the most important paintings in European art history, the travel guides consider it so minor that it gets by with just one cashier, who also checks coats and then hurries over to the exhibition entrance to tear the tickets. But why no one kept watch, so that, in the middle of Paris, beneath one of the busiest squares in the city, I was able to spend forty, fifty minutes alone with Botticelli, Rembrandt, Picasso, Modigliani – I don't want that explained, no more than I would want an explanation from a most beautiful woman for the unexpected gift of an evening. And then it was as dark as a moonlit night, the walls painted black and the only light that of the spots aimed at the paintings. Jesus' robe looked almost indecent in such a glowing red, as if it were illuminated from inside.

No print can reproduce that red, I assume; in any case the postcard I bought at the exit from the cashier who also ran the cloakroom, tore the tickets and probably kept watch at video screens shows only a matt reflection of that red. Maybe not even the original has that glow – maybe it's only an effect produced by the spotlight against the otherwise black wall. But then, the woman who gave me the evening – would I still

find her most beautiful in the light of day? Would I want to find out?

I can see that the comparison that I have resorted to for the second time now is an unsuitable, indeed an improper one: here the Passion of Christ, there a pleasure, perhaps the greatest of earthly pleasures. Botticelli himself, however, has peppered his *Christ Carrying the Cross* with erotic signals. Not only Jesus' robe – which is pleasing not only for its colour but also for its silky texture and its neat collar – but his body too is so delicate: the graceful wrist, the velvety skin, the fingers marked by no drudgery, the elongated calves and thighs discernible under the fabric. Botticelli even suggests just enough of Jesus' bottom to draw attention to its curve. And that is to say nothing of his face: the high cheekbones; the thin, evidently plucked eyebrows; the hair not just long, but styled; the crown of thorns looking at first glance like a multistranded circlet. Most attractive of all, though, is the movement that Botticelli captures: while Jesus' legs, with long, springing steps, lead the way towards the background of the picture, the torso turns almost ninety degrees towards the viewer, and the neck further still, so that his gaze is out of the picture to the left.

'*Jhule lāl*,' the Sufis I saw and heard in Pakistan call to their saint Shahbaz Qalandar: 'Red dancer'. And the drummers respond alternately, '*Shah jamāl*' – 'King of beauty'. I could not help thinking of that evening in the cemetery of the thirteenth-century shrine in Lahore, incessantly reminded of that *Jhule lāl* that the frenzied men whirling in place cried out, they too long-haired, in glowing robes, beads round their necks, rings in their ears, bands on their brows, as I stood before the young, red-robed Jesus, he too painted as the King of Beauty, who appeared to me so delicate, so lissom, that I instinctively took him for a dancer, just such a red dancer, whirling in place. The Sufis' torsos were turned sideways like

his, and their necks still further. Only they weren't carrying crosses; they looked weightless, as if they were floating. But Jesus' cross doesn't look heavy either: with no trace of exertion in his face, he is not so much carrying it as balancing it on his shoulder, as if it were his dancing partner. His face could be expressing just as much longing as forlornness, but hardly the physical pain associated with the Passion. And his fuzz!

I have read that the Florentine Renaissance painters drew upon Oriental art just as Dante and Boccaccio did upon Oriental literature. They were more concerned, however, with perspective, symbolism and composition. Nowhere have I found an indication that Botticelli copied the fuzz from the faces of the handsome youths in Persian miniatures. Be that as it may, the cross-bearing Jesus has just that very first down that was considered a badge of beauty in Persia. His youth is still further underscored by the fact that the mourning woman, with her veil, her posture and the slight hump of her back, looks older than Mary is usually painted.

The poems and verse epics that the miniatures illustrate often leave unclear whether the love they recount is for a man or a woman. Persian grammar has no gender, and the poets, most of all the mystic poets whose longing is for God, are all too content to avoid resolving the ambiguity. Unlike the painters: in presenting a picture, they cannot leave the decision up to the viewer's imagination. Yet it is interesting that in both arts, in poetry as in painting, the beauty of the beloved was seen in femininity, whether it was the beauty of a male or a female beloved, so that the men, or youths to be precise – for even when the lover is old, the beloved is always young – so that the youths in the miniatures were always given androgynous features.

Botticelli too, whose mind was Neoplatonic, very consciously painted the human body – generally the female body, and here the body of Jesus Christ – as a manifestation of God,

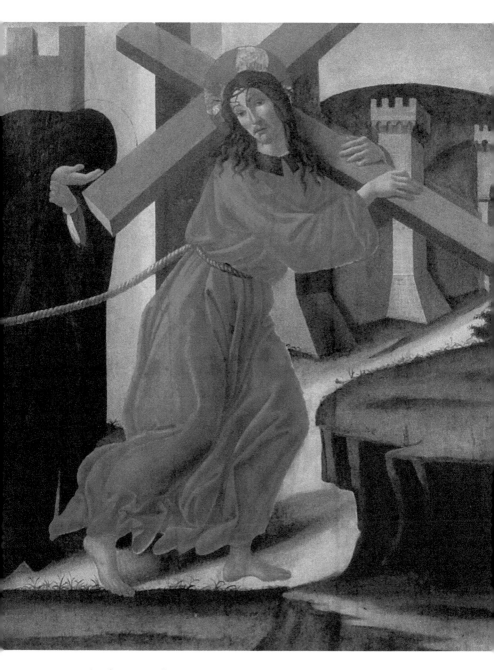

Sandro Botticelli (1445–1510), *Christ Carrying the Cross*, undated, tempera on canvas, 131.5 × 106.7 cm. Private collection.

and thus stylized. Someone once wrote that his female figures were more beautiful than reality would allow, and, indeed, the elongated legs, necks and facial contours did not look 'natural' to his contemporaries; nor are they so today when they reappear, stripped of their deeper religious meaning, in magazines and on catwalks. The work of art was not meant merely to give pleasure or erotic stimulation; it was meant to permit an experience of the beauty of God.

I was alone in the underground space, alone for forty, fifty minutes before Botticelli's glowing red picture, hanging in the first alcove beside the narrow staircase. Once, I turned away to move on to Rembrandt, Picasso and Modigliani, but in stepping away I turned back in surprise towards the cross-bearing Jesus, for suddenly he seemed to have the features of a woman. I stepped back in front of the picture again, and Jesus was indisputably a maturing man: the down on his lip of course; the crown of thorns that, on a closer look, was impossible to mistake for jewellery; masculine too his slightly protruding chin. I stepped away again, backwards this time, my eyes glued to *Christ Carrying the Cross*, and again Jesus was feminized, the more clearly the further away I got, until I stood fifteen, twenty yards back, and finally saw, indisputably, a glowing, red-robed woman, whirling in place, floating. No longer discernible from so far away was the longing or the forlornness of her, his, face.

Jesus is the lover – not only in Christianity but, still more distinctly, more shiningly, in Sufism, which declares Jesus, of all the prophets, to be the incarnation of mystic-erotic love. There is some justification – including the epithet *al-Masīh*, Christ, attributed to him in the Quran and even in colloquial usage – for the idea of a specifically Islamic Christianity, one which is, in any event, no more arbitrary in its interpretation of the Gospels than some Christian theologies. It is possible to be a Muslim and yet view Jesus as one's prophet – not just

one of many prophets in the history of revelation, which reached its completion only in Muhammad – in the history of the prophets, to be more exact, for God continues to reveal Himself anew every moment in His creation. In the depths of mystical experience, and of the mystical interpretation of experience, Islam even approaches the Trinity, although only in one direction: that of man's deification, not God's incarnation, although the Quran too calls Jesus, and only Jesus, the 'Word of God'. The mystics assimilated Christology as a paradigm for the apotheosis of man, which is manifested and personified in Jesus, but not limited to Jesus. Titus Burckhardt, the grand-nephew of the famous art historian and an outstanding scholar in his own right, went so far as to see in Sufism 'the traits of a Christianity freed of its exclusive and consecrated connection to Christ'. That, according to the Sufis themselves, is why Jesus, only Jesus, was able to raise the dead: because through his unparalleled love he was like a creator – that is, the most similar to God of all human beings. As a result, Jesus became the epitome and model of lovers in literature – which in the Orient was not merely secular, even where it was concerned with the most earthly of pleasures – and at the same time Jesus was revered as a master of the mystic path.

But God, to Whom Jesus is the most similar of all humans, is not only loving. To the Sufis, who peppered their texts with erotic signals, God is also the Beloved. Nowhere in Islam is Jesus the Beloved; he cannot be, for the deification of man is never more than hinted at. The Christian mystics, on the other hand, who, whether men or women, aspired to unite with the incarnation of God, found it almost natural to want to experience Jesus as Beloved. Like the miniature painters, faced with the necessity of choosing, Botticelli too interprets beauty in either sex as equally feminine.

By going forward and back again and again, I became certain that the effect Botticelli produced, which no spotlight

could explain, was absolutely intentional: the further away you get, the more feminine Jesus becomes. I was so excited by my discovery, I wanted so urgently to share it, that I looked around me in the darkness for other visitors, but there was no one, as I said, for forty, fifty minutes on an August afternoon beneath one of the busiest squares in Paris. For a moment I thought about calling the cashier, who also kept the cloakroom and tore the tickets, and might well have been the museum guide too, and I actually began searching the walls for a video camera to wave at her from one of her monitors. But in the darkness where I stood, illuminated by no spotlight, she wouldn't have seen me anyway.

Cross

After my Quran meditation at the Church Conference, I will bring my Catholic friend back to my office with me to plead for the cross by Karl Schlamminger of Munich, which stands on my desk, twenty inches tall. In general, my attitude towards crosses is negative; I said so to Karl when I asked him to send me his model before the Church Conference. Not that I respect people who pray to the cross less than other praying people. It is not a reproach: it is a rejection. It is because I take what it represents seriously that I reject the cross outright. Incidentally, I find the hypostasis of pain barbaric, somatophobic, ungrateful towards the Creation in which we rejoice, which we should enjoy, recognizing in it the Creator, as my grandfather preached when he looked down from the terrace of his country estate at the splendid Zayanderud, the 'Life-giving River'. In my heart I can understand why Judaism and Islam reject the crucifixion. They do so politely, much too politely I sometimes think when I hear Christians explain the Trinity and the doctrine that Man needs redemption because he is born in sin. The Quran says another man was crucified; Jesus escaped. Speaking for myself, I phrase my rejection of the theology of the cross more drastically: it is blasphemy and idolatry. Earlier, knowing that my daughter was in church, where she occasionally read the intercession because, for a primary-school pupil, she was such a good reader and also vain enough to want to stand on any stage, even if it meant

having to get up an hour earlier – knowing she was standing under the cross was discomforting. Of course I said nothing; after all, one is liberal-minded. I intervened only when the children were allowed, regardless of their religion, to eat the Host. At that point I wished the Church were less liberal.

If I thought such doings were simply childish, my daughter could have crossed herself too. But the cross is a symbol that, theologically, I cannot accept – accept for myself, I mean, and for my children's education. Other people can believe whatever they want; their ideas are as good as mine. But I, when I pray in a church, which I do, am careful never to pray towards the altar because behind the altar there is always a cross. And now there is also, for days now there has also been a cross on my desk, to the left of the computer screen, diagonally above the prayer rug, and it is so enrapturing, so full of blessedness, that I would prefer to purchase it myself and keep it forever, at any price. For the first time, I think: I – not just someone – I could believe in a cross. It stands not for the Incarnation in one man; it stands for Incarnation as a principle.

Ordinarily, sculptors break something off, I assume, making chips or splinters. Or they add something on, such as clay, to create a shape. A cross, specifically, usually requires two timbers, one upright, one transverse, and for that reason it became a symbol to the Islamic mystics, not of something divine, but of the world: the four arms reminded them that the world is composed of the four elements and thus, according to the ancient teaching, is transitory – for nothing that is composite, only what is elementary, could be permanent. But in this cross, and all of Karl's recent sculptures, nothing has been added or taken away. Nor is it composed of two timbers or blocks. The material has been set in motion, and from that motion the

Karl Schlamminger (b. 1935), Cross, sculpture (steel model). Collection of the artist.

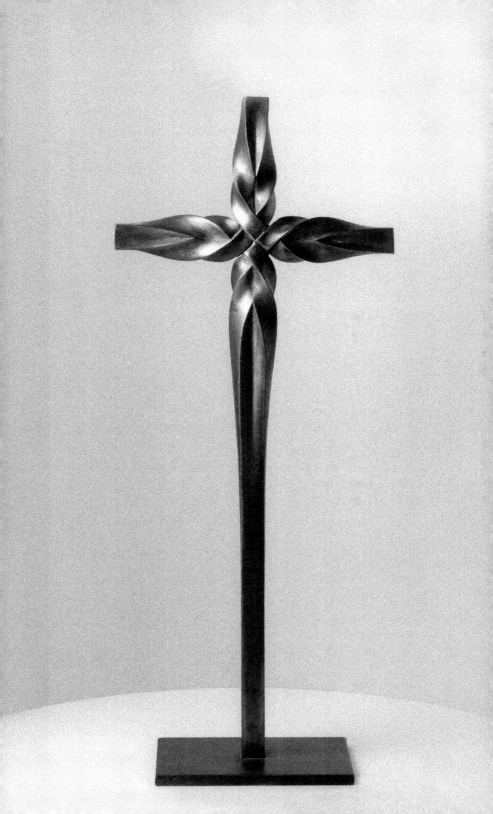

entire form arises. First Karl cuts the block of steel into count-less razor-thin slices, through which he draws an excentric longitudinal axis. Then he twists the slices, not uniformly, but in the shape of a double helix, one slice to the left, one slice to the right, one left, one right, and so on. After the principle of the Oriental *muqarnas* shape, on which the construction of Islamic vaults is based, the square gradually mutates by open-ing from inside into a curve. While Byzantine and Roman cupolas – or the domes made nowadays by modern techniques for mosques all over the world – rest more or less elegantly on the spandrels of the load-bearing walls, the *muqarnas* allows the rectangle itself to curve with perfect regularity. Nothing is added, nothing is taken away. There is no scrap.

The idea is not only an Oriental one but also Far Eastern: Karl's Japanese teacher Toshihiko Izutsu taught him how an object can multiply simply by using, or releasing, its own energy. That sounds more esoteric than Karl's steel cross looks. I never would have associated the word energy with it. But for days now I have felt how it has transformed first the desk, then the room. By forming itself – twisting itself – out of the staggered layering of square slices, it has exactly the same volume at each point along its axis, in spite of the bulges. A block that soars into curves, into circles, to make the four arms into that which is divine: into one. Finally I understand a cross, I comprehend it, I hold it with my hands and feel how the square becomes round under my fingers. The *muqarnas* cross, which is no longer an image but an idea, like the first quite primitive crucifixes and the Greek tau (T), visualizes the monotheism in the Trinity. In this it is decidedly Christian and at the same time more than just Christian: in its aesthet-ics it is early Christian, hence Oriental, and at the same time contemporary.

I have to put on my long trousers, get on my bicycle. In just over half an hour my Quran meditation begins at the Church

Conference. God willing, I will persuade the Catholic Church to erect this cross. It should, it must, soar fifty, sixty feet high into the sky, in a prominent place, where it will shine on the people, regardless of their belief.

I only wonder what my neighbours across the street think, having grown accustomed to my sequence of bowing, kneeling, prostration with forehead to the floor, and standing upright again, now that they see the cross on my desk.

Lamentation

This son has become so light, wasted away literally to skin and bones, his legs thin as sticks, so light that his mother can hold up his torso effortlessly on the flat of her hand. Her fingers unnaturally long, she could embrace his hips with her two hands. But is she his mother? If my eyes do not deceive me, the Catholics almost always imagine Mary younger than a woman could be whose son died at the age of thirty-four or thirty-eight, a mature man, allowing for the life expectancy of the time, but the Mary in St Kunibert looks even younger than usual, almost like a girl, not only because of her red cheeks; her unblemished skin is light, almost white, rarely touched by the sun, inexperienced, so to speak; in her eyes is not just grief but complete helplessness, which has something childlike about it, the helplessness of one who has no one left on earth; this impression reinforced by the other hand, the raised hand, which looks so pitiful because all the rest of the body, the facial expression too, is as if paralysed; there is a plainness in her face, something so absolutely anti-intellectual, something so immediately receptive, not filtering the pain, not understanding the world, that it seems absurd to think she could take comfort in a God in Heaven. Faith may be a consolation to adults, even to mothers who have practised piety long enough, but how could one explain God to a child, a girl, holding her slain father in her arms?

What am I saying, where are my thoughts taking me?

This is Mary; she is the mother and the slain man is her son, although he looks like – no, not her father, but like a very much older brother or an uncle, or – perhaps her father after all, allowing for the marrying age of the time? The proportions are thoroughly confusing: if I imagine the two bodies standing up side by side, they would seem to be the same height; but the way the corpse is lying on her lap, its feet suspended in the air, so that it almost forms the arms of a cross, it looks shrivelled, tiny, and it has something senile about it. All the odder, since Jesus' torso and his legs are not in the right – or, rather, not in realistic – proportion to each other – the torso too big, the legs too short.

There is nothing in the art travel guide about this pietà, placed like a surplus ornament upon the altar of the south middle pier, and even in the thirty-page brochure that is offered for sale on the stand beside the entrance, between postcards and the parish newsletter, there is no more to be learned about it for the price of three euros except that the sculpture dates from the early fifteenth century, not even what kind of wood it is carved from, although every portrait of every past canon of St Kunibert merits a full description. And in fact it was not for the pietà that I cycled the few hundred yards from my office to St Kunibert, but because I wanted to look at a crucifix that is related to, and possibly made in the same studio as, a crucifix which had gripped and shocked me when I saw it in an exhibition because it shows the physical torment of the Redeemer with absolutely unsettling force, his mouth wide open in agony, his brow contorted with pain. Only the crucifix I found in St Kunibert had been whitewashed in the eighteenth century, and even before that it had not been extraordinarily forceful, Jesus' face serene as if he were dreaming sweet dreams.

But the Jesus lying unnoticed across Mary's lap is no more than a skeleton, the skin stretched over it so tightly that the

spaces between the ribs become deep furrows, his lips still pressed together as in the convulsions of death, the wound in his chest open a finger's breadth, the brown blood mixed with dirt spattered over his whole body, his forehead in death still furrowed with the extreme pain, the folds so long in the already elongated face that a scream seems to be forming. Only the closed eyes appear soothed; as if released, the eyelids rest on one another. Yes, released, I can't help thinking when I look at him, released; this Jesus is no Saviour but looks saved himself from torture, from scorn, from the betrayal of his fellows, which raises the question in my mind whether he wanted to be resurrected at all; whether, if he had to decide, he wouldn't prefer nothingness to life, to a life which will in future be eternally blessed, but which holds such torment first. It is not only *his* torment, or, rather, his torment is only the extreme of the torments of all people, whether sons or fathers, whether mothers or daughters – and sometimes not just the extreme.

On the telephone, my Catholic friend, to whom I mailed a flash photo, downplays my discovery. While my pietà, standing unnoticed by art history a few hundred yards from my office, certainly seems to be valuable, it is not extraordinary. No, not even the proportions, my friend replies to my next question, pointing to the Marian mysticism of the late Middle Ages, whose central experience is empathy more with the Mother of God than with her Son; at funerals, my friend adds, we sympathize more with the bereaved than with the deceased, whose situation is beyond our imagining. Because a pietà has the purpose of evoking or renewing the believers' pity, Mary grew steadily larger in the pietàs of the fourteenth and fifteenth centuries while Jesus diminished. I'm not sure I find that convincing, I mutter, pointing to the fact that, when you really look, Jesus is not particularly small, only terribly thin, like an emaciated old man. My friend says he can't

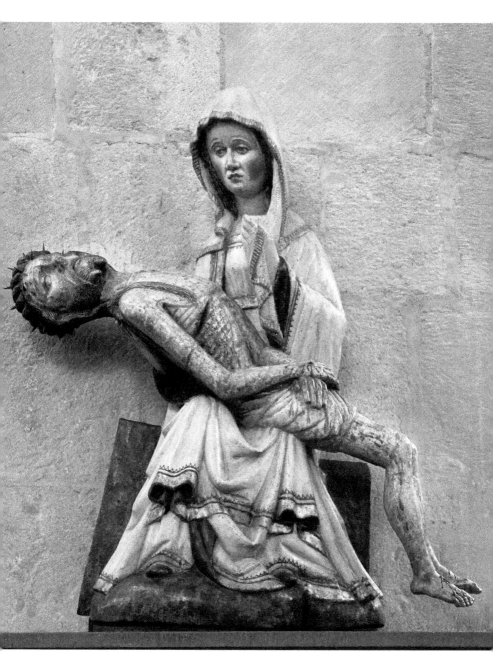

Pietà, wood sculpture, *c.* 1420. St Kunibert, Cologne,
altar at the south middle pier.

judge of that; the proportions are not clearly discernible in the photo. I spare myself the question why the Mary of my pietà is so young, the Jesus so old, to preserve my amazement. Before ringing off, my Catholic friend says he'll be happy to look at it the next time he's in Cologne. I don't know whether I should take him along to my pietà. Perhaps he won't have the same experience I did, but, during the hour I sat more or less alone in St Kunibert on the pew diagonally in front of the south middle pier, the idea gradually came to me that piety, which is the literal sense of *pietà*, ought rather to shake our confidence in God than to strengthen it. Jesus crucified raises questions enough but doesn't invite us to identify with him, not in the sense that we would imagine dying on the cross ourselves. Of course we pity him. But do we suffer, does even a faithful Christian actually suffer with him? Is that exactly what the viewer feels, or is it not rather horror at what many are doing to one? And are not we, whether faithful or not, to be counted rather among the many? Even a mother weeping for her son, as chilling as the very thought must be to anyone watching their own children growing up, even the bereaved mother does not correspond to regular human experience; for most, fortunately, it is the ultimate nightmare. On the other hand, most of us, whether believing or not, have by now held, or will one day hold, their dead father, their dead mother in their arms. If anything is a rule of human experience, then this: that the parents go away and we are left behind on earth; they diminish, we grow larger.

Resurrection

Most artists imagined the life that is supposed to await us after death like – I won't say a rebirth, otherwise there would be babies rising from the tombs, but like a faith healing. There are long, detailed discussions about what body a righteous soul goes to Heaven in, and because it seemed so absurd to imagine a lot of living corpses, or even just old and decrepit people, wounded and blood-covered people, lounging under the trees of Paradise, the scholars, who after all have to present some idea, and with them the painters, who can't help presenting some idea, came to the conclusion that the resurrection of the body was a kind of fountain of youth. What varied was the average age in the next life. Which was the greater promise: youth, but with discernment, or maturity, but with flourishing vigour? Certainly death should leave no trace of the torments and burdens, of the despair that specially afflicts the just, of the doubts they surely suffered. The painters, here following the scholars with surprising piety, portrayed the resurrected Jesus most peacefully of all as one who, completely transported from the turmoil of life – whisked away from the Passion too – has effortlessly conquered death.

I wonder whether that ever was a realistic prospect. No one knows what awaits us after our last breath; even Jesus, to whom God had spoken – if he was not divine himself – even Jesus is known to have died disconsolate. Yet as uncertain, as undecidable as everything about the next world is, nonetheless

I can only accept the belief that appears plausible, persuasive and at all events more reasonable than the assumption of all-embracing randomness. And the prospect of a death that rejuvenates the body, that turns back time, death as a soft reset, so to speak: such a prospect is comprehensible only metaphorically – but then it becomes a mere thought construct, as my Catholic friend aptly points out, in the sense of 'Jesus lives'; or else I must reject the resurrection of the body as preposterous if it literally means, and must mean, the renewal of a human being's earthly form; after all, I believe in God's omnipotence, not in magic. I do realize that, for a Christian theology that does not conform gratuitously to what happens to pass for common sense, the body is necessarily awakened along with the soul; I know too the passages in the Gospel that indicate it. Only, to me, the idea of redemption loses its substance if it wipes the terror from our human faces.

In 1465, Giovanni Bellini gave the abbey of Santo Stefano in his home town of Venice a resurrected Jesus that is painted more realistically than any other I have seen. To begin with, his *Christ Giving His Blessing* is not particularly handsome – his nose too long, the bridge of it straight as a stick. A disproportion in his mouth as well: its width merely makes his upper lip look thin, while his lower lip bulges unattractively outwards. His eyes are almost colourless and slightly bulging, as the arched eyelids indicate; his hair so thin that his skin gleams through his beard and eyebrows; the back of his hand a crooked square, and certainly not because of ineptitude on the part of the painter – the many veins in it are extremely vividly drawn. Yet the resurrected Christ is not especially ugly either – who can look in the mirror, after all, without finding blemishes? – but ordinary, rather, we might say average, a young man like those we walk right past every day. By painting the resurrected Christ as Everyman, Bellini promises that every man can be resurrected.

Giovanni Bellini (*c.* 1430–1516), *Christ Giving His Blessing*, *c.* 1465, oil on wood, 58 × 46 cm. Musée du Louvre, Paris.

That alone may be unusual only for Bellini himself, who painted Jesus in all his other pictures as a remarkably beautiful man. Other painters too, in order to emphasize the human, outwardly unimposing aspect of Jesus, purposely chose models who were not the most handsome or athletic. But there is something more in the picture, something that gives me more hope than the rebirth that the scholars and the other painters promise: 'All my changes were there,' as a line of a Neil Young song says.

It's in his robe, too. I always thought, and saw in all the pictures, that Jesus was naked except for a loincloth when the soldiers nailed him to the cross. But, in Bellini, he is wearing a robe that has a hole in it right over the wound in his breast. That would imply that the spear that pierced Jesus' breast had torn through the cloth. Could that be? Hardly: the wound is horizontal, yet the tear in the cloth runs lengthwise. Besides, there is no blood on the robe anywhere. It was torn open not by the soldier's spear but by two hands, apparently, Jesus' own hands no doubt, to show his wound, which is not scarred, and perhaps never will scar. After his resurrection he bears the marks of all he experienced, all he suffered.

His cheeks, completely sunken, are still marked by his privations, his skin is terribly pale, under his eyes not just rings, but dark, unsightly bags, as if from exhaustion, his hair dishevelled, the blood dried, not removed by a washing of his corpse. His mouth is slightly opened, as if he were still gasping for breath: he is a man who has returned from death's door. He is happy, yes, but as exhausted as someone taking his first step outside after a long, apparently hopeless illness, or raising his hand in a brief gesture of triumph after winning a struggle with his last ounce of strength – are his two upstretched fingers not about to separate into a V for *vici*? It is over, he seems to be thinking, I have borne it. The book with the sealed lock that he is pressing to his body as if he would

never yield it up contains testimony. The resurrected man forgets nothing of life; he softens nothing of death. His feeling of redemption at conquering death is all the deeper. Our hope is all the greater: death can be conquered.

Transformation

For a few seconds I enjoy the delusion that the old gentleman has switched on the three-foot-high electric candles for me, so that I can see better. Then I notice the three worshippers gathered for Mass in the pews across the central aisle. Judging by the number of missals the young priest lays out, many more churchgoers are expected. With a rolled-up poster he pretends to hit the old gentleman, whose suit is too big and collar too wide, over the head. They look at me – of course: I've taken a laptop out of my rucksack.

The church I wanted to go to was Sant' Agostino, to see the *Madonna of the Pilgrims*, which has long since become my favourite painting in Rome, but then, although the day was off to a lucky start when the first bus let me board instead of snapping its doors shut in front of my nose, I got off by mistake in front of San Lorenzo in Lucina. Once I had found where I was on the map, my art travel guide recommended having a look at the *Crucifixion* by Guido Reni, calling it one of his masterpieces. I couldn't remember any other masterpiece of Reni's; all I could associate with the name was adoration, amen, antipode of Caravaggio, but I have rarely been more grateful to the guide. In the photo, the painting is reminiscent of the holy cards that the gypsies sell for fifty cents in front of the churches, but as a huge canvas upon the

high altar of the baroque church, where black and gold columns, a red theatre curtain, chubby angels, a bunch of plastic flowers and the three-foot-high electric candles reinforce the kitsch to the point that its truth content is intoxicatingly stark, and the adulation becomes apparent – upon the high altar of San Lorenzo in Lucina, Reni's *Crucifixion* is an insurrection, a rebellion against the insipid glorification of pain.

One reason why the zest that Catholic art has for Jesus' suffering leaves such a bad taste in my mouth is no doubt because I am familiar with it, and unfamiliar with it, from Shia. I am familiar with it because the celebration of martyrdom in Shia is just as excessive, bordering on the pornographic, and I am unfamiliar with it because, in my grandfather's faith, which was more influential than any other point of reference in my own religious upbringing, precisely this aspect of Shia played no part, indeed was rejected as folk belief and superstition, a dissuasion from making the world a better place instead of just lamenting its condition. Reni does not glorify pain; he doesn't show it at all. He accomplishes what other crucifixion scenes only suggest: he transposes suffering from the physical to the metaphysical. His Jesus has no welts or bruises, no marks of the lashes and blows; he is slim but not haggard. Even where his hands and feet are nailed to the cross, he sheds almost no blood. But for the nails, it would look as if he were spreading his hands wide in demonstration. He is looking up to Heaven, the irises almost vanished in the white of his eyeballs: 'Look,' he seems to be calling. Not just 'Look at me,' but 'Look at the Earth; look at us.' Jesus is not suffering so that God, as the Christian doctrine of redemption suggests, suffers vicariously with humanity, becoming a victim Himself – Jesus' indictment is not 'Why hast thou forsaken me,' but 'Why hast thou forsaken us?'

> But dreadful is't how hither, thither,
> Endlessly, God scattereth what lives.

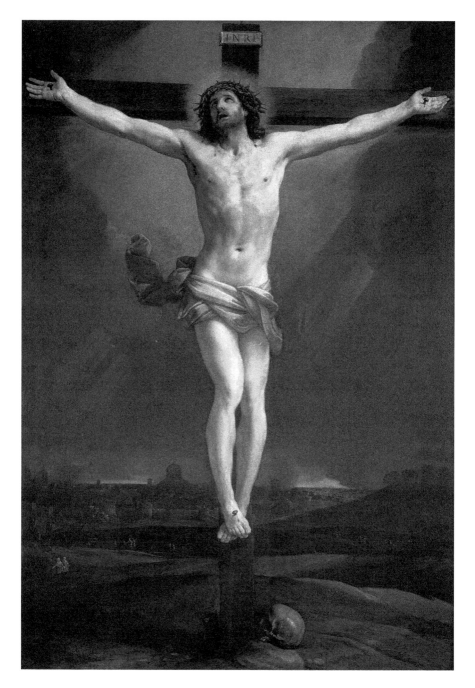

Guido Reni (1575–1642), *Crucifixion*, c. 1635–1638, oil on canvas,
340 × 220 cm. San Lorenzo in Lucina, Rome.

The landscape is Christianized; the division is not the biblical one between the people, the faithful and the unbelievers, but between Heaven and Earth, God and mankind. The skull at the foot of the cross indicates that others have died here before; the people in contemporary clothes walking out on dark roads give us to understand that the dying still goes on; the houses in the background and the cupola, which could be the Temple but also, more probably, the newly built basilica of St Peter in the New Jerusalem, indicate a city that already honours the crucified Jesus. This Jesus is no longer the Son of God, nor is he a demigod, as Hölderlin saw him. Because his pain is not physical, not the consequence of the worst imaginable – extraordinary, inhuman – tortures, this Jesus dies vicariously for the people, for all people; he is every dead person, everywhere, in all times. He looks his last until the resurrection, of which he seems to have no hope.

> But if he then die,
> To whom the greatest
> Beauty clung,

Hölderlin writes, whose poems I also pull out of my rucksack, because I know by heart no more than the two famous lines about dreadful God,

> that on his figure
> A wonder hung and the celestial host pointed
> At him, and if, forever an enigma to each other,
> They cannot grasp
> Each other who lived together
> In memory, and it take away the sand not only
> Or the pastures, and on the temples
> Seize, if the honour
> Of the demigod and his people

Be blown away and the Highest himself
Turn his face
For that never an
Immortal more is seen in Heaven or
On the green Earth, what is this?

This is a speech, addressed to the dead Christ up on the cross, arguing that there is no God, and hence the motif which briefly joins the antipodes: Reni and Caravaggio, who seek the human in God, and Hölderlin and Jean Paul, who see humanity forsaken by God. Hölderlin, however, groans in the next verse an affirmative, just as Jean Paul too promptly excuses the vision of an empty Heaven as a nightmare and trivializes it into a 'flower piece'; only, the strange thing is, that the declining Hölderlin's theodicy is believable –

And not an evil is't if part
Be lost and of the speech
The living sound abate

– while Jean Paul's indictment, in his best years, betrays his idylls. I must leave off, the priest is ready, the Mass is about to begin, so I pack my laptop, along with the art travel guide and Hölderlin's poems, in my rucksack. The three worshippers across the central aisle already think I'm crazy enough, or they think I'm an especially diligent seminary student hard at work on his entry-level qualification.

FOR CHRIST YET LIVES

The clouds are still caught on the tips of the trees, preventing me from looking up to Heaven like the nearly irisless Christ. In Matthew 26, Christ invites his disciples to eat the bread,

for it is his body, and to drink the wine, for it is the blood of the covenant 'which is shed for many for the remission of sins'. Christ's death absolves a world on which lies the wrath of God. Hölderlin too mentions that wrath in his account of the Last Supper, but in his version it is the world itself that rages, and Christ does not redeem but 'cheers' the world, placates it and makes it cheerful:

> For all is well. Thereupon he died. Much might be
> Said of it. And as he gazed, triumphant, on
> The Most Joyous, his friends saw him to the last.

The Sufis would not settle for Christ as the Man of Sorrows any more than Hölderlin did. To them, the Quran's teaching that another man was crucified is an expression of Jesus' exaltation, for he became *rūhullāh*, the 'spirit of God', while Muhammad remained *rasūlullāh*, Messenger of God, and thus distinct from God. If I wanted to set Jesus in Rome in relation to Hölderlin, who grouped the Messiah with the sons of Greek gods Hercules and Dionysus, I could not have bent Reni's crucifixion, which in any case is no revelation, to the purpose. Nor would it avail me to consider Caravaggio's *Flagellation* or *Entombment*, although they are still moving at a second look: even in Christ's path to Heaven, Caravaggio focuses on mortals' earthly acts towards one another. God, as perpetrator or as victim, is out of the picture for him, unless, as for the mystics, He is in everything. To find the demigod Hölderlin could have meant in Rome, I would have had to sit down with my laptop in front of Michelangelo's statue in Santa Maria sopra Minerva, which is so bold that subsequent generations covered the Redeemer's manhood with a golden clout: Jesus muscle-bound as an ancient hero, a pole in his hands whose cross-bar is too short to die upon with outstretched arms, but long and strong enough to smash walls

and gates; Jesus as the victor over death, and the cross as his lance:

> For when higher the heavenly triumph
> Goeth, shall be named, like the eye of day,
> By the strong the Highest's rejoicing son,
> Token and watchword, and here is the staff
> Of song, beckoning downwards,
> For nought is common. He awakeneth
> The dead who are not yet the rude one's
> Prisoners. But many are
> The fearful eyes that wait
> To look upon the Light.

Unfortunately, I had already met Michelangelo's *Christ the Redeemer with the Cross* much earlier in the year, before I had begun studying Hölderlin's hymns to Christ, when I was in a completely different mood, with Jean Paul and always with my family or guests along, since the art travel guide had given stars to Santa Maria sopra Minerva, and with its practical location right near the Pantheon I fit it into every sightseeing tour with visitors, especially since the obelisk atop Bernini's elephant pleases adults and children alike. Hence Hölderlin declared to me at an unfitting moment, 'For Christ yet lives.' Certainly nothing would have prevented me from retroactively creating the impression of necessity by relocating my reading of 'Patmos' to Santa Maria sopra Minerva, but because of the stars, the obelisk atop Bernini's elephant and the proximity to the Pantheon, that church is always so full of tourists that the paragraph would not have worked for different reasons. It never works and cannot work when we are not content to experience the truth but want to put it in words: could any place be a fitting one to hear, to see or to read that Christ yet lives?

For *one* thing I know,
That namely the will
Of the eternal Father
Is bent towards you. Silent is
His sign in the thundering sky. And *one* stands under it
His whole life long. For Christ yet lives.

Down to the grammar, these pieces of sentences in 'Patmos' are – and how much more so in the second, third, fourth versions, in which the language 'works' less and less – so intertwined, rhythmically too so irregular, so throbbing and breathing and rushing and halting, that you would have to pick out each individual piece with tweezers and still wouldn't get the feeling you were on the trail of their true secret. In the verse quoted at the beginning, for example – 'But if he then die' – the sentence is not even syntactically resolved by the end of the verse: the triple conditional phrases, each starting with 'if', are not brought to their conclusion by the question what this is, only further heightened in their urgency. What Adorno calls parataxis, the images placed one after another and not interconnected in any synthesis, which were conditioned by 'an entrenched habit of his mind', is attributed by Bertaux too to Hölderlin's study of a Semitic language such as Hebrew, although he does not pursue the idea further. And indeed, in the Semitic grammars, parts of sentences are not necessarily joined together by a verb; in certain cases the auxiliaries can be omitted; the same principle of unconnected images, and in this case, more specifically, of repeated variations of a question and of the repeatedly delayed answer, achieving their effect through an air of mystery, is also one of the most powerful stylistic principles of the Quran. At the beginning of Surah 101, for example, the lexically ambiguous word *qāri'a* stands all by itself, with no syntactic references, a word whose meaning is enigmatic and has been for fourteen

hundred years, and whose acoustic form, with its deep, guttural *qāf* and the voiced fricative *ʿayn* pressed from the pharynx, causes uneasiness:

> The clatterer [*al-qāriʿa*]!
> What is the clatterer?
> And what shall teach thee what is the clatterer?
> The day that men shall be like scattered moths,
> And the mountains shall be like plucked wool-tufts.

In Hölderlin the answer is both consolation and destruction, in an image as concrete and eerie as that of Surah 101:

> It is the sower's throw, when he taketh
> The wheat upon his shovel,
> And throws it, towards the clear, swinging across the
> threshing floor.

We are the wheat.

> And not an evil is't if part
> Be lost and of the speech
> The living sound abate.

AS IF THEY MET EVERY DAY

In San Lorenzo in Lucina, after stowing laptop, art guide and Hölderlin in my rucksack, I remained seated, silently, expectantly, along with the three worshippers across the central aisle. Nothing happened, and the altar painting no longer interested me. In the course of the next half hour, five more churchgoers sat down in the pews, where the old gentleman and the young priest also took their seats. From time to time

the two of them stood up, disappeared into the sacristy, and returned, without giving any sign what they had attended to. I saw only that the young priest, still whispering, joked with the old gentleman, who did not laugh but seemed content to let him go on. After all, the other churchgoers were chatting too as if they met here every day.

I went outside to find out what time the Mass was to begin. Not until 7:00 p.m., I read on a sign. I understand the dilemma and am happy to help by my attendance: there is such an incredible number of churches in Rome, each a character in itself – the queen, the diva, the pussycat, the coquette, the eyeful; the ethereal, the consumptive, the elegant and the baroque beauty – that the faithful must divide up on weekdays to make sure all of them get their due. The national churches have an easier time of it because they are also community centres of the Germans, French, Americans, Koreans or Ethiopians in Rome, and an international trip for visitors, who find themselves, in the middle of the city's ancient centre, plunged into a foreign language, among foreign people. There are more than enough other churches for the Romans. When Rome had just a tenth of its present population, but as many churches as it has now, every row must have been full of worshippers, standing, not sitting; at every corner of the city centre there were almost a thousand people who remembered their God not just on Sundays. In the early twenty-first century there still seem to be two or three gathered together, although with some effort, in His name. Even strolling schoolchildren help out, chattering girls and boys marching into a church with headphones on; here someone who looks like a lover of Latin and there a Latin lover; businessmen between two meetings and beggars following after to take up their posts at the exit when the Mass is ended. I have always felt comfortable in churches, even with my laptop: the looks cast my way were never disapproving,

although I did not cross myself, did not genuflect, did not step before the priest to take communion; the Church's mission, too, which rubs me up the wrong way outside a church, seems in church not to be aimed at me. In mosques, members of different faiths are at best left alone; in synagogues, they are unquestioningly assumed to be of good will. I have no idea why it is that even Germans look on strangers in friendship once they see them sitting in Mass. Grandfather must have felt that too, otherwise he wouldn't have spread his prayer rug in churches when travelling in Europe in 1963. Forty-five years ago, worship services were probably still held every morning and evening in every church in all French, Swiss and German cities, attended by at least two or three Christians, as if their distribution was organized by an invisible management. Grandfather cannot have perceived Europe as godless; in Isfahan, on the other hand, he was ridiculed in 1963 for going to the mosque every day.

BUT GOD SENT HIS PEACE

Because the pressure in my bladder would not allow me to sit still until the end of the Mass, I bought a holy card for fifty cents – or, to be precise, I bought two holy cards, one of which remained jammed in the vending machine, which cost the gypsy at the door the coin I didn't toss in her coffee cup – and outside I looked around for a bar so as not to have to pee near the wall of the church (never *on* a church wall, as my Catholic friend had laughed when he felt the call of nature during our visit to the *Advocata*). Relieved at last, I did not return to San Lorenzo, where in the meantime more than enough believers were gathered in Christ's name, but hopped up the Spanish Steps to the Santissima Trinità dei Monti, where the evening Mass begins an hour earlier and

lasts an hour longer. Following the Shiite tradition that every believer may choose the scriptural scholar whose reading of the sources he or she follows, in Rome I have chosen to follow at least the rites, if not their interpretation, of the Santissima Trinità dei Monti.

The French brothers and sisters may, as my friend criticized, be innovators in kneeling on the floor, meditating long, singing longer than is usual in the Church, and in prayer, like Muslims, alternately prostrating themselves in humility, standing up resolutely, looking up to Heaven in search of sanctuary and stretching out their arms in confidence; but nowhere else in Rome – more: in no other worship service I ever attended – have I felt as strongly the spirit ascribed to early Christianity as a movement of egalitarian, God-fearing outcasts, a despised minority. I felt it – as real as the air that settled on me, on all the eight persons who were gathered together behind the brothers and sisters – but nothing more: no enlightenment, no conversion, not even purification; only peace, which persisted a while yet after the two hours.

> Then the unbelievers set
> in their hearts defiant pride,
> the defiant pride of ignorance;
> but God sent down His peace
> upon His Messenger and the believers,
> and made them hold fast to the word of the fear of God.
> (Quran 48: 26)

What is translated here as peace is in Arabic the word *sakīna*, and the Arabic name that Grandfather caused to be written, against Grandmother's will, on my mother's birth certificate. In Christianity he is there in the midst of them that are gathered together in his name; in Islam the *sakīna* comes down whenever the Quran is recited, and the angels gather there.

Everything we do physically or outwardly with respect to the Infinite, everything that is not *thinking* – that is, all praying *out loud*, kneeling, folding hands – is ceremony, not virtue (although it is an expression of virtue), and it could just as well be replaced by its opposite: it would be just as pious if I were to *stand up* to pray as it is when I *bow down*; just as pious to cover my head (as the Romans do) as to *bare* it.

Jean Paul wrote these remarks in a letter to a Jewish friend dated 23 April 1795, and concluded: 'The objections against all kinds of ceremony that follow from this observation are – none whatsoever.'

Among the brothers and sisters of the Monastic Fraternities of Jerusalem, as they call themselves, hierarchy, which bothers me more than almost anything else about Catholicism, is reduced to the pragmatic minimum. The priest steps behind the altar only for the liturgy of the Eucharist; afterwards, he bows to his brothers and sisters, who divide all other tasks among themselves, designating according to each person's abilities who sings the leading parts, who reads from the scriptures, who delivers the sermon, who lights the candles, who distributes the bread and wine, the body and blood of Christ. The principle in Shiite mosques of providing a depression in the floor for the prayer leader, often merely symbolic but sometimes so deep that the poor man must climb down a little ladder into it as if he were getting into his own grave, would require no explanation to the brothers and sisters. No man over us, only God. In traditional Shiite mosques, men and women also sit in separate areas, but beside one another in the same room. In the Trinità dei Monti, moreover, the faithful are involved in the service, all eight of us who were in attendance, although I am not one of the faithful. While the priest put on the violet stola, a sister hurried to the pews to ask two of us to carry the bread and wine to the front. My prayer

was heard that she might not ask me. Impenitently receiving Holy Communion is like perjury; 'instead of enjoying heaven', doing so is 'swallowing hell', Jean Paul warns, and holds 'glowingly before our souls the peculiar conditions of this religious act'. For the moment I was willing to believe that 'the power of his presence to bless would be changed to poison.'

The Latin Mass my Catholic friend took me to impressed me as a semiotic event of extreme complexity but was in the end still a programme; after an interruption of more than forty years it had not yet become habitual again, perhaps not even to the priests: a young theologian whispers to them, like a stage manager, which gesture, which steps and which words come next, when they are to sit, when they must stand, when they must bow towards the altar and to each other. It's supposed to be that way: the Latin liturgy provides for the office of ceremoniarius, my friend explained; on certain occasions the ceremoniarius even wields a gold index finger to direct the celebrant. But of course the ceremoniarius also helps to mask any confusion on the part of the celebrant in regard to the complicated sequence of gestures, movements and words. The success of the service does not depend on whether all the priests really know all the procedures by heart; what matters is service to God, not human empathy; the act, not the psychology. That is why the celebrant does not put on the ceremonial vestments himself but is enrobed by the ceremoniarius in front of the altar, in public; and why the people and even the priests can talk among themselves during Mass, or surreptitiously yawn or shamelessly take photographs; that is why there is no more need for the stage manager to disguise his directions than in epic theatre. What must not happen is a wrong gesture, a wrong movement, a wrong word. Accordingly, while the hierarchy is strictly limited to functions and attenuated by kind looks, it is observed down to such fine nuances that it sometimes seems comical,

as when the second and third priests' ranks are distinguishable by their facial expressions in carrying the celebrant's stole: slight reluctance; great self-importance. Yet the final embrace is a sign, a very beautiful one to be sure, very noble, and segregated by lay and clerical spheres: instead of artlessly shaking hands, as is done in the mosque or in any other church in Rome since the Second Vatican Council, the clergy indicate an embrace by putting their heads side by side; the faithful imitate them. As much as it moved me to embrace, carefully, like an actor in a walk-on part, the friend on my right and the stranger on my left, my eyes must have nonetheless shone differently when the brothers and sisters swarmed out into the nave of Santissima Trinità dei Monti, approached the pews, firmly pressed the hands of the seven faithful and mine, gave every one of us a loving smile and looked long into our eyes. Everyone in the church had seen that I did not go to the altar, because I would have received *only* bread and wine.

At the end of the day, which had been a lucky one from the start, I reread a fitting passage of Hölderlin, while a brother and a sister cleared the altar and covered it with three white linen cloths – no, I was a guest and might stay seated as long as I wanted. 'The fruit of earth', the poet calls the bread the others ate,

> yet it is blessed by the Light,
> And from the thundering God cometh the joy of wine.

The celestial choir has left the two gifts 'as a token' since the gods have gone far away, and live only 'up over our heads in another world' while mankind spreads its hands in vain, like Christ in San Lorenzo in Lucina.

> There they labour endlessly and seem little to regard
> Whether we live.

The brothers and sisters, nonetheless, do not omit a single genuflexion.

Death

I knew the date, although it was in the future. It was the eighth of December, a Sunday, I realize as, lying awake, I remember that I have bought tickets to a football match, forgetting that I had been invited to give a reading the same day. I was on the train while the match was in progress back in Cologne; not the train to Nuremberg, however, where in fact I will read next Sunday, but to Vienna, although Vienna is too far from Cologne to go by train, and I always fly when I go to Vienna. The match, which would have to have been unusually long, nine or ten hours, estimating by the length of the train journey and the transfer in Vienna – the match was still going on as I sat alone on the stage, a theatre stage. The stalls were so dark that I could barely discern the outlines of the listeners in the first few rows. I know which book I was reading from, but I don't remember which passage, nor do I know what the score was when I realized that my mother would be dying in Cologne, not right away, not at this precise hour, but so soon that I wouldn't get back to Cologne in time. There were no flights so late in the evening.

If it hadn't been a dream, I would have been able to break off the reading, make the excuse that I was suddenly unwell, and ring Cologne – but, in the event, I read on as if nailed to the chair, before me a great darkness filled with almost invisible people, saying things I can't remember between the passages I read, or perhaps I wasn't even conscious then of

what I was saying, unable to think of anything else but my mother. I don't know – or, rather, I didn't know in my dream – what was wrong with her, whether she had had an accident or come down with an illness; all I knew was that she would die – no, she was already dying, in a room that was neither hers nor a hospital room, some strange room in a strange house, surrounded nonetheless by all our relatives, including her sisters from Iran and the United States, but not my father. Where was my father, whom no one seemed to miss, whom no one called for? Was my father already long dead himself?

My mother, who said nothing, saw herself that she was dying, and it was clear to her, and to her sisters, that she would not see her son again, for which he had her understanding and sympathy – after all, he had a reading and she was just having a death. At four, still lying awake, I console myself at first that my mother, or at least my father – but where was my father? – wouldn't show any misplaced consideration when it came to the ultimate concerns, would have notified me, no matter what, at least left a message on my voicemail. But then the same idea turns to calamity, because I realize that my mother, or at least my father – but where was my father? – must have tried to reach me. I immediately reach next to the mattress for my mobile phone, which is in silent mode, to make sure no one has called.

She must have lain in bed a long time, very long; she had become a different woman, only her eyes the same, still shining green and blue, but her body perfectly emaciated, her skin full of wrinkles, furrows in fact, even on her wrists; a centenarian she looked to me, a hundred years old at least, although she is only eighty, the cheekbones visible in her face, which is actually round, her face so narrow now, her hair a light grey, not white oddly, gathered together at the back, her hair, although she never did that, no longer waving, longer too apparently, probably because it hasn't been cut

in a long time, how long now? What I found beautiful – I can't say pleasing, but, in view of her sadness and my fright, I would like to express it so fastidiously: what I appreciated – or, rather, what I really found beautiful was that she did not have to struggle, that she lay there peacefully, her torso half upright on a big cushion, unless it was a hospital bed with an adjustable head end.

I don't know how long it took – only minutes or, like the football match, nine hours – before I finally realized that I was not nailed to the chair at all, and obviously could interrupt the reading on any pretext at all to ring Cologne. I awoke with the thought that, no matter what I did, I wouldn't reach her bedside in time, not before the next morning even on the night train. Everyone was standing round her bed, including her sisters, everyone but her husband – where was my father? – whom no one missed, though, because he must have been long dead by then, and her son, for whom she longed burningly, uncontrollably, although she was only having a death and he had an important reading. Maybe that is precisely what distinguishes mothers: that they are always willing to sympathize with their children, and especially with an only son, explain their actions, make their excuses to others, forgive them and gloss over them, if only he will stay. His mother, every mother, accomplished in childbed what even Jesus had to learn: love in the superlative. It is hard to understand that God loves us. But that our mother loves us: on that we all rely. We might think of her, or of our father for that matter – but where was my father? – to express the magnitude of Jesus' sacrifice. We might ask ourselves for whom every one of us, without hesitation, without believing in God or any earthly mission, solely for the sake of a single human

Caravaggio (1573–1610), *Death of the Virgin*, 1605/6, oil on canvas, 369 × 245 cm. Musée du Louvre, Paris.

being – for whom we would be willing to die if another's life depended on it: only for our child, ultimately.

When Jesus' mother died, they were all there once again, the twelve Apostles riding in on clouds, as the tradition has it, and Mary Magdalene, as all the artists imagined, and in the third hour of the night Jesus came with the celestial host of the angels and the patriarchs, the martyrs and confessors, and the virgins. In Caravaggio alone, no one comes at the third hour, no angels and patriarchs, no martyrs and confessors and, more importantly, not her son. In Giotto and most of the others, Jesus at least appears in the background or in Heaven, carrying his mother's soul in his hands in the form of a doll-sized Mary. In Caravaggio, the background is much too dark, and where Heaven should be there hangs a red cloth like a theatre curtain. Nothing about the picture is consoling; there is not a trace of promise, just a bare room, the simplest furnishings, a brass bowl, no doubt for washing the corpse, everyone barefoot, a common death, pitiful not least because of its squalor. Where any village priest would be promising beatitude, the Apostles can't bring themselves to say a soothing word.

It is not discernible whether at least the Apostles accompanied the mother as she was dying, as the tradition holds, or whether their clouds carried them too slowly. Evidently her death was accidental, or at least unexpected, otherwise she would not be wearing the simple everyday dress, which is red like the curtain, and wouldn't have been laid out on a table, a kitchen table to judge by the chair on which Mary Magdalene sits hunched over so that we imagine all the more despair in her face. The mother's legs hang in the air almost up to her knees. She couldn't have lain down to die: to die you lie down on a bed, or in a meadow, or on the floor if you must, but not on a kitchen table that's too short for you; she must have collapsed in the kitchen, or been carried into the kitchen from

outdoors, her hair dishevelled, a pillow hastily laid under her head. Not even the clouds can fly as fast as the mother died. I can't be sure of that, of course; God is powerful over everything; but it's the idea I get, as every picture gives me ideas, and before me the painters too got ideas from study-ing the traditions, and Caravaggio got the boldest ones. How easily he could have made the death of Mary into something devotional: wouldn't have had to light the background, open the curtain; wouldn't have needed the angels – only the son would have had to appear, if only doll-sized, and death would have been declared, yea, proclaimed the dawn of a better life. Instead, his mother will miss him for eternity.

I half reassure myself with the thought that my mother couldn't possibly age so many years by the eighth of December, since she rang me up yesterday sounding hale and looks much younger than eighty, feels younger in any case, and she would have to be, God forbid, struck by lightning or suffer something outrageous, something absolutely inadmis-sible, something no one could ever be forgiven, to advance a whole generation in four days. Hardly anything worse could befall a mother than the death of her only son, worse still his violent death, his public and so unjust martyrdom going on and on for days. But dying has made Mary younger, instead of making her look a hundred years old at one blow like my mother. According to the tradition, which Caravaggio cer-tainly took into account, she was fifteen when she gave birth to her son and survived him by twenty-four years, which means she died at the age of seventy-two. Elsewhere we read that she survived her son only by twelve years and died at the age of sixty. The mother as Caravaggio painted her is no longer young but certainly younger than sixty. She is pretty, although no longer in her prime; not stout, although somewhat full around the abdomen, which is why some have whispered that Caravaggio painted her after a pregnant

woman, or even a drowned woman – in any case a harlot, to make the scandal worse. Be that as it may, the Discalced Carmelites who had commissioned the painting removed it from their chapel within a few days of hanging it. Never mind what people say, I would like to have told the Discalced Carmelites; I can explain the fact that she became young and not old like my dying mother, although she had suffered the outrageous, the absolutely inadmissible, what no one could be forgiven, only if I remember her son's Ascension, which she saw with her own eyes.

Yesterday she said she missed me, and if I understand that so well, it is not because I miss her in exactly the same way, with exactly the same trembling in my breast – children probably don't have that any more in adulthood – but simply because I can imagine that she feels for me exactly the way I feel for my children, although my children will not feel that way for me later, not with the same trembling – 'Wait until you have children yourself,' my parents always used to say when I made light of their worries – or only then with the same trembling, a really physically tangible sensation in the heart, when my children realize that I am going to die.

I had better wait a while yet before I ring up; if I ring them at five in the morning, my parents will ask me why I'm waking them up, whereupon I will either have to lie or trouble them with my dream. Besides, I checked my calendar and found that the football match is on the seventh of December, a Saturday, as usual.

God I

The principle that God has never taken on form, and therefore Man cannot see the Divine, is an incontrovertible one in Islam. 'The eyes attain Him not', the Quran says explicitly in Surah 6, verse 103. And when Moses asks God in 7: 139 to show Himself to him, God answers:

> Thou shalt not see Me;
> but behold the mountain – if it stays fast in its place,
> then thou shalt see Me.
> And when the Lord revealed Him to the mountain
> He made it crumble to dust; and Moses fell down swooning.

But there is a hadith – a saying of the Prophet – that seems to contain, in its purest form, the anthropomorphism that Islam strictly rejects. It is Muhammad's description of a dream vision: 'I saw my Lord in the most beautiful form, as a beardless youth with full, curly hair on the throne of mercy, his feet in the green, with golden sandals.' The legal scholars never could make anything of this hadith and so dismissed it as inauthentic or simply ignored it.

It seemed stranger still to the rationalist schools of theology, scholasticism and philosophy. But even the famous

Overleaf: The Good Shepherd, mosaic, first half of the fifth century.
Mausoleum of Galla Placidia, Ravenna.

al-Ghazali, who reconciled mysticism with the orthodoxy (and at the same time disarmed its dogma), saw no other choice but to reinterpret the Prophet's vision as an allegory. The heterodox Sufis were all the more steadfast in their belief that God not only is beautiful, as another equally famous hadith says, but also can be experienced as beautiful, and indeed can take on a physical form.

The beardless youth tending sheep in the Mausoleum of Galla Placidia at Ravenna is seated not on a throne but on a gilded rock, and he has full, curly hair; he is wearing sandals, although not golden ones, but his feet are in the green. It is a different Jesus from the one we are used to seeing. In the late classical aesthetics of the early Christian period, he surely did have 'the most beautiful form'. In another mosaic, in the nearby Basilica San Vitale, Jesus sits, equally young, beardless and winsome, upon the celestial sphere amid the angels. In Ravenna's Archiepiscopal Chapel, he stands with his legs apart, in tunic and knee-length fustanella, like an ambitious esquire, and treads upon the serpent and the lion. In the Basilica of Sant'Apollinare Nuovo, Jesus appears in the mosaics on the north wall, which depict his miracles and parables, again beardless, with soft, androgynous features, his hair full and curly. On the south wall, meanwhile, sits a Jesus on a real throne who strikes us as more familiar, a mature, bearded, strong and resolute man, identified by his dignified appearance as Christ in Majesty. This is probably the only place of its kind in the world: in Ravenna, a single rotation of the body suffices to follow the transition from the comely youth Jesus was in many early Christian representations to the Almighty.

When Sant'Apollinare Nuovo was built in the early sixth century, there was a curious balance in Ravenna between Orthodox and Arian Christians, although elsewhere they fought each other mercilessly. While the Orthodox – or, more precisely, those who would later become the Catholic

orthodoxy – insisted on Christ's divinity, the Arians, who saw the Trinity as a danger to monotheism, denied that the Father and the Son were of one kind: God had created the Logos *in* time, not *before* time. This beginning made the Logos radically different from God, Who had no beginning; the Son, the Arians maintained, was not one with the Father but His image; Christ was not an incarnation in the literal sense but rather an epiphany.

Although I looked for quite some time, I found no satisfactory explanation of how – and whether – the different images of Christ are related to the struggle for the Trinitarian dogma; nor could I find confirmation for my attribution, suggested by the mosaics of Ravenna, of the beautiful to the Arians and the Almighty to the orthodox. After all, although the city lies in the West, it did belong to the Byzantine Empire from the middle of the sixth to the middle of the eighth century. The history is complicated, probably nowhere more complicated than in Ravenna, where the Goths and later the Lombards ruled for certain intervals. But, without simplifying too much, we may say at least that the doctrine of the Trinity has been uncontested, the Council of Nicaea in 325 and the Council of Constantinople in 381 notwithstanding, only since the sixth, seventh century. And that Ravenna shows, more impressively than any other place, how Jesus Christ, once the manifestation of God, finally became God.

'I saw my Lord in the most beautiful form, as a beardless youth with full, curly hair on the throne of mercy, his feet in the green, with golden sandals.' Almost exactly at the time when the advocates of God's Trinity were victorious in the West, a prophecy arose in the East that roundly condemned the Trinity. The Quran does not just confirm the biblical religions in general: it is especially close to Christianity, explicitly calls Jesus the *masīḥ*, that is the Christ, affirms all the miracles up to and including the virgin birth, and praises the

Christians' piety in almost tender words: 'And thou wilt surely find the nearest of them in love to the believers are those who say "We are Christians"' (5: 82). Those were not mere words: the deeds of the first generations of Muslims were equally appreciative. Otherwise the primate of the Nestorian Church in 650 would not have written in such amazement to a brother in faith: 'These Arabs not only avoid fighting Christianity, they even endorse our religion, they honour our priests and holy men and donate gifts to monasteries and churches.' But one thing is repeated time after time in the Quran, and since then in all Islamic theology: Jesus is not God. Even the *shahāda*, the Muslim profession of faith, must be understood as an immediate response to the Trinity: there is no God except God Himself. Would Islam have existed if Arianism had prevailed in the Council's heated debates? Or, earlier still, in the second century: if the Gospel of Thomas, which opposes the Trinity, hadn't been displaced by the Gospel of John? The quranic revelation, which refers many times to the Bible, and in particular to the New Testament with the Apocrypha, cannot have arisen in ignorance of the theological debates going on in Christianity.

Not that the quranic Christology is identical with that of Arianism, which stood fast by God's fatherhood and declared the Son to be, although not God, yet like God; but Islam in the early seventh century drew on an image of Jesus that in Christianity had just been covered over, like certain mosaics in Ravenna. In the Quran too the Messiah is a singular, indeed, a godlike person, the only one of all the prophets who is *rūḥullāh*: 'the spirit of God'. But God's form can only be beautiful, indeed the most beautiful, even if the eyes attain Him not, only in the dream vision of that prophet who comes after Jesus. In Islam the longing remained. Even the rationalist theologian and man of letters al-Jāḥiẓ felt in the ninth century that Christianity had at least a psychological advantage:

al-Jāḥiẓ attributed the special zeal with which the Christians worshipped God, unequalled in other religions, to the Christian doctrine that God had been incarnated as a living man. 'And for the same reason, those among us Muslims who imagine God in human form are more zealous in their worship than those who deny that similarity,' wrote the rationalist, who rejected all anthropomorphism yet respected the Sufis. 'For I have sometimes seen how such a man sighed with longing for God – how he sobbed on hearing of God visiting, wept on hearing of God watching, and fainted on hearing of the opening of the separating barriers. How much greater is the longing of one who hopes to sit together with his God and to talk with his Creator.' Did those who upheld the authenticity of the Prophet's dream vision know the young, beautiful shepherd with the full, curly hair who was Jesus in earliest Christianity? The Sufis, who often came together with Christians, must have seen their churches, and not just from the outside.

The cupola in the baptistery of the Arians displays a Christ – not a God – that I don't even want to show here, he looks so obscene to me. Between an adult and a very old man stands a youth with long, curly hair, naked, in the blue and white striped water. He is slightly pudgy, which gives him soft, feminine features, letting his shoulders hang down in an unmanly slope; he gazes dreamily to the side; he has also turned his body immodestly, pursing his full, red lips almost to a kiss. Although the water is up to his hips, his genitals are clearly visible and placed exactly in the centre of the cupola, his brown adolescent fluff, a round testicle pushed to the fore, his uncircumcised member, positioned in a white stripe, hardly by coincidence. As if drawn by a spotlight, the eye cannot help looking first at the Redeemer's phallus. The old man on the left, who represents the River Jordan, throws up his hand as if to say, 'Thunder! What grace! What beauty!'

And if we forget for a moment that the man on the right is John, he ceases baptising Jesus, and instead tenderly caresses the youth's long, curly hair.

The Sufis, and Ibn Arabi in particular, associate the epiphany of divine beauty, whether manifested in a male or a female body, with Jesus. That makes Jesus – and only Jesus – more than a prophet or messenger. In him God appears as in a mirror, or, more precisely, since the Sufis say God has many manifestations and a different one to every person, Jesus stands for God's manifestation in man, for all the divine beauty that is undeniably visible on earth. The *visio beatifica* is linked, in Islamic mysticism, to the 'Christian wisdom', *ḥikma ʿisawīya*. In Ravenna we can see that that wisdom, up until the sixth, seventh century, really was Christian.

God II

Someone asked what salvation meant to me: when in my life I had been saved. My first thought was to mention the usual situations: accidents that had miraculously left me unharmed or been averted at the last second; recovery after a dangerous illness; a reconciliation of lovers; and certainly, in my case, my travels, which had occasionally taken me into threatening situations. But in the end I spoke of my very earliest memory: the earache, no doubt medically harmless, but to me wholly unknown and therefore shocking, that makes me scream, and my mother – it must be night-time, or evening, because I can see the deep blue of the curtains – my mother takes me out of my cot and holds me in her arms, this feeling of all-embracing consolation, which doesn't banish the pain but makes it cease to seem like monstrosity itself, this feeling of not being alone with the pain – how long did I scream, I wonder, before my mother picked me up? – the security of being cradled in my mother's arms, of being concretely, physically close to her heart: someone is there for you; the sudden turn from bottomless loneliness and abandonment to safety and pure contentment, feeling the centre of attention and love – the more so as my father too came near and spoke comfortingly to me.

That, yes, that was salvation, that was salvation as every person has experienced it – ought to have experienced it – and treasured it in memory. The Quran teaches that the

need for God is innate in human beings, who experience it as a shock, as pain, but also as a rescue, otherwise they would hardly be so quickly comforted in their mother's arms. And, strangely enough, although the Quran strictly rejects Jesus' Sonhood, it affirms Mary's God-given motherhood, and the virgin birth causes orthodox Muslims fewer headaches than it does enlightened Christians. And yet the Catholics so wisely associate Creation with both parents: because God created all mankind in His image, He must be man and woman in One. 'God is father and mother,' said the short-lived Pope John Paul I in his only Angelus address (and was accused of heresy for it). Ibn Arabi, the Greatest Master of Islamic mysticism, who had more female than male teachers, goes so far as to claim that the beatific vision, which is necessarily communicated to humans through concrete earthly experiences – of nature, love, dream visions and, most strongly, sexuality – reaches its highest perfection in women. For women incorporate both aspects of the divine, the passive and the creative, conception and childbirth, *patiens* and *agens*. Men, on the other hand, are born but do not give birth. That means that Ibn Arabi explicitly attributes the passive aspect to God as well and conceives His relation to humanity as a mutual one in which we depend on Him, but He likewise depends on our love. 'Do not blame me when I call God a bride', Ibn Arabi writes, conscious that his teaching must be provocative in the context of a patriarchal world and its theology.

Because the man was created first, Adam and Eve were not complete as the archetype of human love, says Ibn Arabi, but must be complemented by Mary and Jesus: in this typology, Eve and Jesus are like siblings whose parents are Adam and Mary. That is why the Prophet named women first among the blessings dearest to him and left out men entirely. The mystics have often speculated about the fact that the highest attribute of God, mentioned most often by far in the Quran,

mercy, *raḥma*, has the same root in Arabic as *raḥim*, 'womb' (and remembrance of God, *dhikr*, which is a human attribute, has the same root as *dhakar*, 'penis'). When the Prophet says that Paradise lies at the feet of mothers, the mystics have not only understood it as an instruction to honour one's own mother (not one's father?) – no, they have always conceived the essence of God the All-merciful as feminine as well as masculine. 'What is most deserving of love and attention?' a young man asked the Prophet. 'Your mother,' the Prophet replied. 'And second most?' – 'Your mother.' – 'And third most?' Again the Prophet, who was an orphan, answered, 'Your mother.'

In Christianity, Catholic popular devotion and the Eastern churches have had a more accurate instinct for the feminine principle as constitutive of the human incarnation of God than most theologians, who emphasize the cross and the Resurrection, and a better intuition than feminist theology, which has had surprisingly little to say about Mary and prefers to bend the language (to the breaking point). 'Thou rigorous Judge of all sinners, Who threatenest us terribly', German churchgoers sing (or sang?) fervently in Mass, and then find consolation in Mary's motherly love. 'Mother of God' may be, strictly speaking, just an honorific, and yet in prayer – an experience that does not adhere to logic – it becomes a counterpart to God, although without entirely resolving the duality. The simultaneity of opposites is more distinctly audible in *theotokos*, the 'God-bearer', in spite of all the Catholic Church's efforts to rationalize the title, to make it plausible to reason. Byzantine theology has more readily admitted that religious experience can only be verbalized in paradox. 'Mary is the cause of all those who were before her,' said Gregory Palamas, the famous mystic of the Eastern Church, attributing a pre-temporal existence to the Mother of God. It was this Eastern, Oriental, and originally Gnostic Mariology

that influenced the Sufis: 'I am my father's mother,' says the *Thunder* found in Nag Hammadi; 'My mother gave birth to her father,' cried the enraptured Hallaj, who was crucified as a heretic; 'truly, that is strange.'

Even we feel the outermost vibrations of a truth that Gregory Palamas and Hallaj experienced in inner contemplation – just imagine leafing through your parents' photo album: are we not similarly amazed, or in my case shaken, every time we see how young our mother was when she bore us, much younger than we are when we first begin to think seriously about our mother – that is, only in the second half of our lifetime, as the painful awareness of her mortality grows from year to year and we can no longer ignore her infirmity? She is young, our mother, as young as the *Madonna of the Rose Bower*, no more than a girl, and, even to a fourth child like me, still a very attractive woman, and so she must be to know our fears and to be not only our guardian, our provider, our educator, but also to a small degree our sister, our friend and even our lover. For how much more vibrant, more powerful, more perilous and more all-embracing is maternal love than the father's love, which is why it is the mother's excessive sentiment, if anything about her, that literature regrets, and about the father, if anything, his remoteness. In his *Meccan Revelations*, Ibn Arabi recounts that, while he was writing about totality, he fell asleep and dreamt he saw his mother unveiling her pudenda and her breasts; he looked at her, and she smiled; after a while he realized that there was something forbidden about his mother's gesture – or about his gaze? – and he covered her with a white cloak: 'In the same way, I use beautiful words to cover a certain view of nature that reason is not permitted to express.'

The Madonna sitting in the rose bower before a damask curtain is young; her baby is just days or at most a few months old; but the peace that is in her face and her posture is not

Stefan Lochner (*c.* 1400–1451), *Madonna of the Rose Bower*, *c.* 1450,
oil and gold leaf on oak panel, 50.5 × 40 cm. Wallraf-Richartz Museum, Cologne.

that of a girl or a young woman who is simply ignorant yet of her son's martyrdom. She wears the crown, which means she is resurrected; she has already lived through a mother's worst possible misfortune. The peace that is in her face and her posture is redemption or, in Kleist's terms, the innocence we can attain only after having eaten of the Tree of Knowledge. Hence the garden, hence the golden background and hence the apple that Eve's brother is permitted; angels even offer him more apples.

In the centre, of course, exactly at the height of the observer's eyes, is the mother, who to Ibn Arabi is like the first human, and thus still more like God. Christ could never be represented in comparably precious symbols. You have to see the crown, for example, under a magnifying glass to comprehend the length to which Stefan Lochner went. Every pearl, every gem, every indentation in the precious metal, every space has its own form and a theological meaning: the gems form petals that correspond with the real, blood-red roses of the bower, and the sapphire at the crest reflects a window cross, referring to the sacrifice of Christ, 'the light of the world'. The extremely good condition of the painting, after more than half a millennium, is due not only to its perfect craftsmanship and careful conservation; the lasting luminosity also has to do, I read, with the extraordinary quality of the materials, the wood panel and the pigments. The ultramarine blue in which the dress is painted is made from lapis lazuli, a semi-precious stone that was mined only in Badakhshan: in Afghanistan! The only material that was more costly was gold leaf, which covers broad areas of the background. It not only represents the celestial light but glows itself as soon as a little light from the sun or a candle falls on the *Madonna of the Rose Bower*. The painstaking arrangement of the motifs similarly imitates the heavenly plan of salvation: in the centre of the picture, for example, the cone-shaped fold over Mary's navel,

with the child's navel lying exactly in its extended line; or the nine blossoms in the crown that stand for the ninth hour, the hour of Christ's death, and at the same time the number of planetary spheres through which the soul ascends to Heaven. I also read that the height and width of the rose arbour are exactly three by three Cologne inches, so that they symbolize the Trinity and at the same time the Heavenly Jerusalem, whose architecture is described as regular. And so much more! Every point and every line, every area and every colour is 'ordered in measure and number and weight', as the Book of Wisdom prescribes.

If the Greatest Master of Sufism claims that the contemplation of God is most perfect in women, the Christians' images confirm it. No one has ever succeeded in painting a halfway believable picture of the Father. In Stefan Lochner's painting, He is just a fairy-tale uncle looking down from some kind of window. Even Jesus is, at best, if a baby, as cute as a pudgy angel and, if an adult, just a man whose beauty takes on theological interest only in the form of the young shepherd. The Mother, on the other hand, although she is a mother, guardian, provider, educator, has an attraction as the Female in any portrayal, down to devotional postcards. In the most magnificent picture ever painted in Cologne, she reaches with her right hand for her son's wrist. Under the magnifying glass, you can see the gesture repeated in Mary's brooch: her right hand is on the raised right foreleg of the unicorn, which is equated with Christ. That, I read, was the official gesture of marriage and represented the Son and Mother as the Bride and Bridegroom of the Song of Solomon. To us too, she is supposed to be our sister and friend and to a small degree our lover. The Father only later came near and spoke comfortingly to me.

II

WITNESS

Cain

This picture is an extravaganza: as big as a movie screen, and its theme may be religious, but it's more Hollywood's notion of the 'Education of the Human Race'. Obviously in 1880 the Bible had not yet become a major motion picture, but Wagnerian opera anticipated Hollywood by a similar interval, so we must affirm after all that American film is, conversely, the continuation of 'total theatre', and of late nineteenth-century monumental painting, in our time. In any case, Fernand Cormon discovered the wide-screen format long before Hollywood. When you sit in the middle of the room, the canvas fills your whole field of vision, which is wide, not long. Even if you steal a glance at the person next to you, you remain subsumed in the action. That is the essence of the epic, which the wide-screen format seems to evoke automatically: an epic doesn't start at the beginning and doesn't stop at the end. We might say that the beginning is the Word itself and the end is the end of time.

Yet Cormon creates the impression of breadth not so much by the aspect ratio, which after all is a broadcast format for cooking programmes and talk shows today, and not at all by the sheer size of the picture. Michelangelo's *Creation of Adam*, to name only the most famous example, is much bigger without being epic, because everything is in it, from beginning to end. Cormon's picture is made vast, unimaginable, by the group of human figures walking

Fernand Cormon (1845–1924), *Cain*, 1880, oil on canvas,
384 × 700 cm. Musée d'Orsay, Paris.

through it, or hurrying, not just walking – marching in step, taking strikingly long strides, a band of people who have been fugitives, with no destination, for a very long time now. Where Impressionism, exhibited all around this painting in the Musée d'Orsay, always strives to penetrate the moment, which would be unlike any other just seconds earlier or later, Cormon evokes the years and the eons that these people have behind them and before them. Seconds? Minutes, days, *years* earlier or later, every moment of their lives is as dreary as this one.

That is not the way it's done in Hollywood, where even orthodoxy must be for sale. And I don't I mean that disparagingly. In all sympathy, the church festivals can be still greater extravaganzas. If they didn't promise a happy ending, if they weren't entertaining and comforting, the faithful would stay home. The church, the Catholic Church, does not ignore the wrath of God, but it rarely shows it in such Augustinian representation, as if it were directed at us – and, when it does, salvation is never far away in a Catholic church. Nonetheless, the story of Cain, as painted by Fernand Cormon in 1880, will not end well. Like their long shadows, the people's dark past precedes them on their trek. No optimism, no joy – not in their faces, nor in the landscape. This Cain is marked not by a superficial stigma but by his eyes, turned towards an inner desolation; his shoulders, pressed down by guilt; his finger, pointing to no attainable destination. It occurs to me: if we would understand the unrelenting obedience that Abraham later displays, we must imagine the relentlessness with which Cain is punished for violating God's commandment. Did the patriarch refrain from arguing with God perhaps because he was afraid he would share Cain's fate? At the same time, he belongs – it occurs to me on looking at a Cain who looks like a patriarch himself – Abraham belongs to a different and strange lineage.

The Bible says God's people are descended from Seth, Adam's third son. That would seem to suggest that Seth and his descendants are our ancestors, and hence Noah and Abraham, Isaac or Ishmael. Only the Bible doesn't say so in so many words. The Bible says that the dwellers in tents and the keepers of cattle, the players of harps and organs, the artificers in brass and iron – in a word, the world's ordinary people – are descended from Cain, who was after all the first to build a city. His crime is our history, the history of our civilization, which these outcasts have behind them and, sadly, before them too. Painted under the influence of the stone-age images that had been discovered a year before in the caves of Altamira in Spain, the picture seems to offer a vision, in cinematographic realism, of the prehistoric past: the body and the features of the primitive humans, their hair and clothes, their tools and weapons. Yes, they are we, Cormon seems to cry, achieving the dubious result that, a hundred years later, Conan the Barbarian comes along with the same lunging stride. And the young beauty, lying as if by chance with her bosom bare in a ray of light – how she invites our sympathy, she whose tender sleep shall be guarded from all the coarseness around her, even to the present day.

Do the wanderers know they owe their wretchedness to their father, who was not content to till the ground? Is that why they do not look at him, why their eyes are glued to the ground in wrath, their lips pursed in acrimony? Cain was young when he slew his brother; he had no tribe yet. By the time he found a wife, his murder lay in the distant past. There is no drop of blood remaining on his axe; he has not so much as touched the slain animals. I think they know, or at least they sense it; the father's guilt is plainer to see than any mark. And yet we follow him.

Job

Job is not scorned. I knew this picture only from 'The Biggest Art Collection You Can Buy!', a searchable DVD with forty thousand paintings that I salvaged from the stock of a bank-rupt bookshop in Ehrenstrasse, Cologne; 'Job' was the first search term I typed in, and I found multiple representations of the heap of manure on which he sat while his wife, for good measure, poured muck over him. Because Dürer's seemed to me the cleverest composition among the many paintings of this subject, with the background showing the splendour of Creation and the distress of mankind, I set out for Frankfurt, where it is part of the permanent collection of the Städel Museum. I accepted the hazards of my visit coinciding with the great Dürer exhibition – people queuing as if at the gates of Paradise, an infernal throng in the darkened galleries – for I wanted to call Job as a witness, the sooner the better, for my own Christianity. But how surprised I was when I had finally wriggled through to the picture: what Job's wife pours over him is not muck but clear water; it must be refreshing, or pleasantly warm. And she is not looking at him scornfully, as it had seemed on the small screen of my laptop, and as she was explicitly said to be doing in the DVD's description. Even the catalogue of the exhibition, which I was able to open after applying my elbows to make some room to my left and right, the catalogue too calls him 'Job Derided by His Wife'. But there is no derision – no, her gaze is rather attentive, very

serious, indeed mindful – not necessarily loving, there's no certainty of that – but clearly without malice. Is she his wife at all, this woman Dürer has painted so young, her face unlined, while Job is an older, almost an elderly man?

Yes, she must be his wife; no other woman is mentioned in the Book of Job. In any case, she stands by him, not groaning, but warming or washing her husband, whose skin is not bloody with scratching, not covered with open sores, who does not outwardly appear to be suffering – his bone cleaveth not at all to his skin and to his flesh, no matter what the Bible says. But, most importantly, Job is not complaining; he complains neither about his pitiless fellows nor against God's injustice; he closes his eyes and holds his face in his hand, evidently resigned – depressed, we would say nowadays, because he does not respond to his wife's attention with even the smallest gesture. There is not a hint of the dialogue between husband and wife that constitutes their encounter in the Bible: the wife telling Job to renounce God and die; Job, still a patient sufferer here near the beginning of the book, calling his wife a fool and lecturing her that they must accept evil and good alike at the hand of God. Later he complains that his breath disgusts her. Dürer transforms the couple's earnest conflict into a silent understanding, equanimity or at least indifference on Job's part and care or at least service on his wife's.

Dürer must really have been thinking of care, of soothing where there is no cure, when he replaced the muck with water: studiously perusing the catalogue in the middle of the

Overleaf: Left: Albrecht Dürer (1471–1528), *Job on the Dunghill*, *c.* 1503/5, oil on limewood panel, cut on all sides, 96 × 51.5 cm. Städelsches Kunstinstitut, Frankfurt am Main. Right: Dürer, *Piper and Drummer*, *c.* 1503/5, oil on limewood panel, cut at top, 94 × 51.2 cm. Wallraf-Richartz Museum, Cologne.

throng of museum visitors, I learned that he had painted the picture for the chapel of a thermal spa called 'Job's Bath', where leprosy and skin diseases were treated by flushing with the therapeutic waters. What a cynical name for a sanatorium: Job's bath! The catalogue says nothing about Job's subsequent rebellion, only that he endures all the afflictions God sends – all right, then, in this exegetic tradition one might name a therapeutic bath after Job to encourage the sick to resign themselves to their suffering. The wooden bucket is not scummy or dirty like one used to throw out swill or muck but the kind used in steam baths even today, right down to the hole that serves as a handle.

Only Job is not patient; even in the Bible he accepts his pain only in the beginning, in the first and second chapters. When his friends try to console him, his wailing flows from him like water: he would rather die than live, retroactively agreeing with his wife. In Dürer he is silent, but hardly at the end of his patience – the Lord gave, and the Lord hath taken away; blessed be the name of the Lord – rather out of apathy, or again depression, because he does not say a single word in answer to God's blows. Meanwhile his wife gives him a look like that of a nurse, both objective and concerned, with no discernible emotion, concentrated on the therapy she is administering. Job may not respond, but he must feel her mercy on his skin.

Odd that her gown is still radiantly pink and her face shows no trace of fright, although her house too burnt down, or is burning at this very moment. Nor has Job any soot on his skin, much less burns; and the fire in the background is bigger than a single house; the flames blaze up to the clouds as if from a volcano. It must be a whole settlement or town, a catastrophe striking more people than just Job. Someone else in the background is fleeing from the inferno, hands raised skyward in horror.

What luck that my visit coincided with the big Dürer exhibition: the picture next to Job is one I know from Cologne, where it ordinarily hangs in the Wallraf-Richartz. I had never paid it any notice, never taken any serious interest in the musicians before a beautiful landscape, the drummer with Dürer's own face and blond curls. Not until I saw the musicians beside Job and his wife did I realize that the two paintings belong together, that they form a single picture, as we can see by the outlines of the dungheap, the trailing pink gown, and the mountains: the catalogue had been bumped out of my hand but explained, when I recovered it, that the pieces were adjacent panels of the same altarpiece.

Professionals, judging by their minstrel's attire, the musicians are playing for Job in spite of the fact that he has no money and in any case no intention of paying them. Looking at the two pictures as one, we see that the musicians are standing diagonally behind Job's wife, who may have hired them; they have followed her to the dungheap in spite of the stench so that not only Job's body but also his soul might be refreshed, warmed and cleansed. Nor do they deride and abhor Job, as the Bible says all his fellow men do.

Evidently, neither Job and his wife nor the musicians have anything to do with the fire, which must have just broken out, otherwise the man in the background would not be fleeing in panic. Job seems to have been sitting on his dungheap for a long time, and his wife seems to have no cares besides him. And the minstrels will drum and pipe before the gates of a different town tomorrow. These must be the sort of houses that burn down every day. And now I recognize the little figures that I hadn't even noticed at the Wallraf-Richartz: people and pack animals being attacked by armed horsemen. If those were Job's servants and beasts, he would be looking that way. They must be the sort of servants and beasts that get attacked every day. This is the world as God has arranged it,

on the two wings of the altar, such a splendid Creation and such great distress.

And yet it is comforting, this picture Dürer painted for the chapel of the hot springs; it comforts the sick, although not in the same way as the Bible account and its exegetic tradition – for while Job here too is suffering, he is not eliciting scorn from his fellows, at least not from his wife. If she wanted to see him die, as the book so mercilessly recounts, she would not be ministering to him, body and soul. God may have forsaken us – yet man is not lost as long as we have one another.

Judith

That look is insolent. First Caravaggio follows the biblical book's assertion that Holofernes is already asleep when Judith remains alone with him. In doing so, he dispenses with the drama that Hebbel later wrote out for the stage. Caravaggio, for whom ordinarily nothing is too coarse in his pursuit of realism, here reinforces the strait-laced source by dressing up Judith in her Sunday best, her braids faultless, her white blouse dazzling, her complexion glowing, not a trace of fatigue, exertion, fear. For days she has been in the tyrant's camp, and at the feast he gave in her honour she must have joined in the revels exuberantly enough to vanquish all mistrust, so that the attendants had no qualms about leaving her alone with the sleeping man. It is morning. Even if she hadn't touched the wine, she couldn't possibly look so fresh. From evening on, Holofernes must have been pawing her, he probably danced with her, sullied her blouse with his wine, his sweat and his greasy fingers. She has nothing in common with the fanatic celebrated in the Bible who would sooner die than touch the corn, the wine and the oil that have been consecrated to the Lord. A young widow, she scolded the elders of her own people because, on the thirty-fourth day of the siege

Overleaf: Caravaggio (1573–1610), *Judith and Holofernes*, 1598/9, oil on canvas, 145 × 195 cm. Galleria Nazionale d'Arte Antica, Palazzo Barberini, Rome.

– the supplies were running out, there was no more water, the death of all the inhabitants was imminent, the enemy force of one hundred and eighty thousand soldiers outnumbered them – they had advised surrendering the fortress. Judith's plan to go alone into the enemy camp to kill the mighty Holofernes is too daring even for a suicide attack – it practically amounts to sacrificing herself with no chance of striking the tyrant. Judith is no realist. She arrives at her conviction that she can save Judaea not through calculations but through prayers. Offering her body to Holofernes to get close enough to him and then after the deed, if it succeeds at all, being killed by the guards, or worse – she risks all that without hesitation – is better than touching the corn, the wine and the oil that are consecrated to the Lord.

Caravaggio leaves her none of her inspiration, her physical state, her excitement, on her lips not even the prayers that the Bible tells of, as she beheads Holofernes. He makes it look effortless. His Judith is impassive as if she were working in the kitchen. Fountains of blood spurt, flesh surges out, Holofernes' half-severed neck yields; a gurgling, a groaning from his open mouth, his eyes cast their last glance; the horror is painted with such naturalism we can't bear to look – but Judith only knits her brow, puckers her lips into a hint of a pout, pushing them out just so far that it's not clear whether the slight alarm in her face is an honest emotion or one last big taunt: 'Oh, poor you!'

This Judith is not self-sacrificing, she is getting things done. Where the biblical Judith, beside herself, smites Holofernes 'twice on his neck', Caravaggio has her taking him by the forelock, pulling his head back and slicing through his throat as if it were a piece of cake. Holofernes' face, on the other hand – I suppose dying probably softens the most brutal features but, still, look at his face – turn the page with the picture ninety degrees if you have to, unless you're standing in front of the

painting in the Palazzo Barberini, and cover up everything else; look just at his face: you couldn't call it handsome, really, and yet you don't see in him the bestiality of a commander who has already conquered all the countries of the West. If we didn't know it was Holofernes, we might take him to be a martyr, human as Caravaggio paints the martyrs' deaths, or we might be reminded of the remark in Jean Paul's *Siebenkäs*, just before the speech from the top of the universe, that some tyrants are really messiahs: after all, they take the people's sins upon themselves, or make them suffer so that they can be redeemed. The unthinkable happens: Holofernes becomes a victim, and thus Judith a perpetrator. You stupid cow! I think, as Caravaggio no doubt thought in evil moments about Fillide Melandroni, the notorious Roman courtesan who was his model for Judith; you stupid goose, you're cutting a man's head off and you don't even bat an eyelid. Doesn't Holofernes have a certain similarity with Caravaggio himself? Oh yes, if you put him next to the famous self-portrait that used to be printed on the hundred thousand lire note: the eyes, mouth and nose could be almost the same, and the hair too.

Caravaggio only follows the source when he feels like it: witness the handmaid, who in the Bible waits outside the tent, but here, because Judith has everything planned out, is standing beside the bed spreading her apron, ready to catch the head. Judith is pretty; Judith can't be painted any other way than pretty; brutal, sadistic, but pretty – and Caravaggio makes her handmaid all the more abhorrent. Again, look just at the face; put paper over the rest of the picture: the oversized ears that have no doubt listened at many doors, the chunk of a nose that has spent a lifetime being stuck in matters that were none of its business, the corners of the mouth drawn down by decades of resentment, the eyeballs bulging with excitement – no, this carping crone is not the attendant of an angel, even an avenging angel: she is a foretaste of Hell.

Still more insolent is Judith herself, though, her eyes, the taunting, just slightly disgusted look of sarcastic sympathy, with the wrinkled upper lip, as if she was as malicious as the lovers in Persian literature imagine their beloved to be, and the Sufis God: 'He torments them with destruction after having created them.' No wonder the devout Christians were upset by Caravaggio's Christianity: the faces his saints make – Peter's inglorious expression in death, Abraham looking almost angry at the angel who releases him from murdering his son, the Christ Child as a spoiled rapscallion stepping on a lowly serpent, and here Judith, such a rescuer as no nation would find fitting, least of all a people of God.

Elizabeth

They are not beautiful; Elizabeth must not be beautiful if God is to prove, beyond the very last doubt, that nothing is impossible to Him. For that is certainly the intention of Luke, the only evangelist to tell of Elizabeth, and so prominently at the beginning of his Gospel, when he doubles the impregnation by the Holy Ghost: to counter the doubt of Mary's chastity, awakened by Matthew and ignored by Mark, by pointing to a miracle that was definitely incontrovertible. After all, Mary's virginity was believable, but by no means knowable. Moreover, the assumption that a young and by all accounts attractive woman had not yet slept with her husband before they moved in together, her beloved husband no less, although the gardens or the nights of Nazareth must certainly have offered opportunities for a rendezvous, goes against all human experience. A person who is convinced may believe that proposition, but belief will hardly suffice to convince a person of it. Elizabeth, on the other hand, is not only vilified by all and sundry for her infertility since Zacharias took her to wife; she is also far too old to get in the family way, 'well stricken in years', as the King James Version puts it – a polite way of saying she is withered and gaunt.

Mariotto Albertinelli is not so polite. He could have taken the easy way and emphasized Elizabeth's age to demonstrate why her pregnancy, in contrast to Mary's, can only be the result of a miracle. Only that wouldn't have reached the essence of

the 'Visitation', as Mary's visit to Elizabeth is uninvitingly called. The essence of the visit is a mutual understanding and no doubt a solidarity between two women who had become practically sexless. What little is visible of Elizabeth's body under her wide garments, under her headscarf, pulled up far over the crown of her head, and under Mary's shadow, is almost irritating in its homeliness: straight as a ruler her lips and the bridge of her nose, her cheeks flaccid, her chin a shapeless knob, her arms plump, her hands too brawny. She is not even ugly but simply devoid of all sensuality. Mariotto Albertinelli – whose fate it was to live in the shadow of his brilliant friend and companion Fra Bartolommeo – Mariotto Albertinelli realized that Elizabeth's age was not sufficient to prove God's power. Old women get pregnant in the Old Testament often enough. Elizabeth needs to be more than untouched: she has to be untouchable.

What is more, not even Albertinelli's Mary is beautiful, although other artists are so fond of painting her perfection in physical terms – right in the next room in the Uffizi is Botticelli's *Annunciation*, for example, in which Gabriel comes creeping up like a lecher, whereupon the lily-white Mother of God turns her hips away in such a coy contrapposto as if she were posing for a lad mag. Obviously that draws attention: if even the gaze of an angel, then that of any man must fall upon her abdomen, which she withdraws with such lascivious modesty. And if Botticelli had tangible reasons for giving Mary the marketable appeal of a cover girl – all commissions, whether secular or ecclesiastic, were from men – even I realize that I can't help imagining Mary not just as a mother but as a woman.

Albertinelli does not refute her physical perfection; he simply disregards it. What little Mary shows of her body is

Mariotto Albertinelli (1474–1515), *The Visitation*, 1503, oil on canvas, 232.5 × 146.5 cm. Galleria degli Uffizi, Florence.

conspicuously safe from male desire, her face more or less pretty – Mary can't be, mustn't be painted any other way than pretty – but her expression: as if the world were no longer any concern of hers, her drooping eyelids, pale cheeks, expressionless mouth, her upper lip just so slightly protruding that, if she cared about her appearance, she could just as easily retract it. This Mary is, if not asensual like her older cousin, then at least devoid of all refinement. And look at her hands: just as bulgy as Elizabeth's, and with still longer fingers. Fra Bartolommeo for one painted handsomer madonnas.

I admit my way of looking at them is not the only one – what looks unapproachable to me may be just what another person finds exciting. But in any case, Mary is not even in the centre of Albertinelli's *Visitation*. He's the only painter I have found who puts Elizabeth in the middle of the picture, the visual focus on her head with the snow-white veil, which heightens her empty expressionless features; below it the green gown, the sun shining on it as if in scorn for male desire, and brighter still her orange mantle, whose folds Albertinelli has arranged so ingeniously, as if he wanted to step out at last from the shadow of Fra Bartolommeo. The sun shines in Elizabeth's face, not Mary's, which is lightened by a cause unknown to nature, much whiter even without the sun's light than her and Elizabeth's hands.

And another thing: only in Albertinelli does it look as if Elizabeth was the visitor, bowing towards Mary as she does with such an ostentatious lunge forward and looking as if she is the one who has something urgent to relate, a wordless expression of sympathy perhaps. For we see nothing of the two women's joy, which according to the Bible infects even the child in Elizabeth's womb, only submission to the strange and certainly higher will that is being done through them. Does the angel not say, in answer to Mary's question how she is supposed to conceive a child, not having known a man,

that the power of the Highest shall 'overshadow' her – that is, place her in shade, in the dark?

I think that's right. Of course I prefer to imagine that the truth is beautiful; I prefer to look at the bewitching *Advocata* or the handsome young man Velasquez makes of the Redeemer; I am, if you will, quite catholic in arranging my beliefs to suit me. And yet I know that the reality is otherwise; I have seen it in enough people through whom a strange and perhaps higher will was done. They had deep furrows in their faces, young though they may have been; their faces were contorted, not infrequently their tongues hung out of their open mouths, or they threw their heads back and forth as if possessed, when they weren't rolling on the ground like epi-leptics. What disturbed me the most were the eyes that had seen more than I could: they were empty. Elizabeth's pupils too have rolled up so far that, instead of looking at Mary, she is seeing the black inside her own eyelids. That it glows, that blackness, is only knowable; it is impossible to believe.

Peter

Asked why he refused to study the masterpieces of Raphael and of classical antiquity, Caravaggio is said to have pointed into a crowd of people, saying, I have richness enough here. Among his paintings in Rome, those that struck me at first were the crucifixions, the burnings, murders and martyrdoms and, most deeply, the *Deposition of Christ*, *Judith and Holofernes* and the *Crucifixion of St Peter*, which I found a little bit more shocking perhaps because I encountered it not in a book or a museum but in a church, where it hung in the very same alcove for which Caravaggio had painted it in 1600, a few yards away from the Campo de' Fiori where, in January of the same year, Giordano Bruno was burnt at the stake, and it is possible to stumble upon it by chance, before Mass or after shopping in the pedestrian zone, between acolytes chattering as they carry something from one place to another and foreigners in short trousers casting a brief glance as they walk past the alcove where Peter is being crucified.

No book illustration can suggest how sculptural the painting is, how aggressively it leaps out at you. As an image, in the Cerasi chapel in Santa Maria del Popolo, it is flat, flatter no doubt because you can look at it only in a limited perspective, standing below and to one side, and yet it is more vivid than life itself – or, shall we say, than YouTube. Public executions of murderers, heretics, Lutherans and Jews were almost a weekly spectacle in Rome under Pope Clement VIII. How

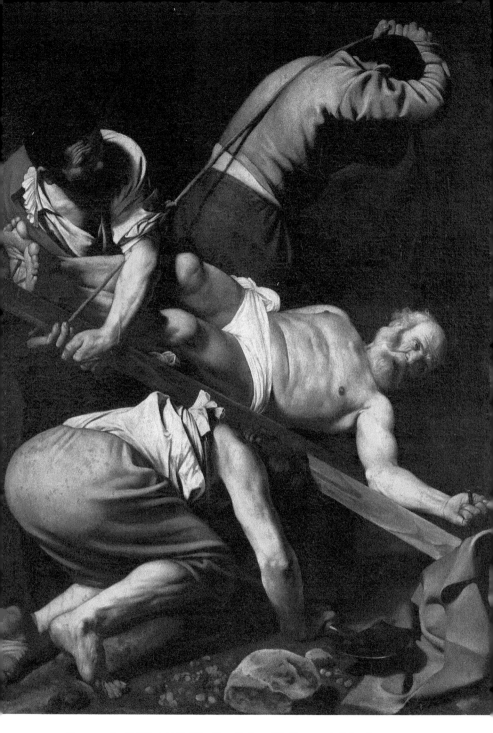

Caravaggio (1573–1610), *The Crucifixion of St Peter*, *c.* 1604, oil on canvas,
230 × 175 cm. Cerasi Chapel, Santa Maria del Popolo, Rome.

often was Caravaggio standing in the crowd? Today anyone can observe on the Internet the faces people make while they're being executed. What richness.

The sinews, the wrinkles in the clothes of the four figures and in the blue-grey cloth at the lower right, the whiskers, nipples and abdominal folds of St Peter, his dirty fingers and the almost black soles of the feet that the hangman at the bottom displays at the visitor's eye level, the hangman's illuminated bottom, not improved by the lighting, the grain of the wood, the sheen of the nail and the spade, the physical exertion that a crucifixion involves on the part of the executioners, the bread-and-butter job it must have been to them – today everyone acclaims Caravaggio's coarse realism, the same thing his critics used to object to: he wanted only 'to prove to the beholder', Jacob Burckhardt scolded, 'that all the sacred events of old time happened … prosaically.' That's true, of course, since outside of salvation histories and romances, everything happens prosaically; you could even say that the prosaic takes on its strongest appearance, obscuring everything else to most observers, by way of contrast – that is, wherever holiness or love really occurs. After all, there was no film music at the crucifixion of Christ, but the young people must have hooted and howled like football fans, and the pedlars hawked their apples. The reproach turns against its author because it goes to show how much better Caravaggio understands holiness than Jacob Burckhardt does.

But what distinguishes this painting is more than its striking naturalism – and I am not thinking of the symbolism, such as the arrangement of the four figures to form a cross, their intertwining, as if to form a single body, the placement of red, green, blue and yellow at its four beam ends, or the composition of light and shadow – it is more than the finesse of its aesthetics and religious history, which we can read all about today, four hundred years later. What I mean is the

look on St Peter's face, which speaks for itself, two thousand years after the fact. He is dying as human beings die: helpless, alone, surprised.

Peter's name means 'the rock'; he was saved when he tried to walk towards Jesus on the water; he was present at Jesus' transfiguration. Because he of all the Apostles had the most ardent passion, Jesus did not reveal to him who had betrayed Him – for Peter would have torn the traitor to pieces with his teeth. When Jesus was arrested, Peter struck off the ear of the high priest's servant. Yet he felt himself unworthy to wash Jesus' feet. No fewer than three times did he deny Jesus; the Gospels describe him as vacillating, St Paul criticizes him as a hypocrite, and Jesus himself calls him 'Satan: for thou savourest not the things that be of God, but the things that be of men' (Mark 8: 33); Peter wept so often for his weaknesses, his timidity, his doubts that his face seemed quite eroded by tears; and yet he was the rock upon which Jesus would build his church, 'and the gates of hell shall not prevail against it' (Matthew 16: 18). He was the first Apostle to see Christ resurrected, and he gave the sermon on the first Pentecost and converted the first non-Jew, the centurion Cornelius; he was thrown into prison and set free again. He healed a man at the Temple gate who was lame from birth and a man in Lydda who was sick with the palsy. Other sick people were cured by his mere shadow. In Jaffa he raised Tabitha from the dead. After the beheading of James the brother of John, he was thrown into prison again, and an angel appeared; Peter's chains fell off, he walked out unhindered by the guards and had to knock twice at the house of Mary, the mother of John Mark, because, although the maid knew his voice, the others within didn't believe her. He led the congregations in Jerusalem and founded the Christian mission. He is said – and here the Bible ends and legend begins – he is said to have been present at Mary's assumption and to have carried her

bier together with St Paul. He is said – more of his miraculous powers – to have healed the high priest's hands that were paralysed because he hung on to the bier trying to prevent the burial. According to Catholic doctrine, he later travelled to Rome and converted the people to the invocation of Christ. It was no ordinary man who was put in prison for the third and last time under Nero; it was, as the catalogues of the Apostles confirm, all of which put him first, a man so superhuman that only a Messiah could surpass him, his persistence in spite of weakness, his belief in spite of timidity, his persuasiveness in spite of doubt. He admonished the young congregation to bear persecution joyfully, for the suffering of the faithful honours God. Even in extremis he showed unprecedented humility in asking, out of reverence, not to be crucified like Jesus, but with his head downward. And yet he died: Peter too died an ordinary death.

In Caravaggio, Peter does not weep, he does not complain, least of all does he whine for mercy; but on YouTube, too, people keep their composure under the gallows or before the muzzle of a rifle. Even a tyrant like Saddam Hussein kept his composure as no one would have expected, and in a firm voice called on God and the nation as the trap opened under his feet. Nor can we see any sign that Peter doubted God's mercy. What is happening must happen; he seems not to contest it, especially since he knew of his end long before, knew 'by what death he should glorify God', namely girded and with outstretched hands (John 21: 18–19). And yet Peter is afraid. He doesn't let the hangmen see it, but horror is written in his face, his open mouth. He certainly doesn't regret having obeyed God more than people, but perhaps he regrets having had the courage to be crucified head down; the pain must be tearing him apart already; we can see by his eyes that he is dizzy, and all his blood is about to rush to his head. He is probably going to vomit, Mr Burckhardt. He is surprised; that

is perhaps the most distinct impression; in spite of all insight, all knowledge, and a faith that literally moves mountains, not even he can grasp the fact of having to die now, having to die thus; that is no doubt why he raises his head, to be certain that it is really a nail that is driven through his hand. It is also a last instinctive and futile spasm against gravity. Peter, the rock, is human. To reveal this truth, which everyone knows and which is written nowhere, no naturalism can suffice, no camera, not even the eye. You have to experience it.

Jerome

Suddenly I'm not sure any more whether St Jerome is really beating his breast with the stone, as the Vatican Museum's audio guide says he is. True, there's something dark on his left breast that could be a contusion, but it could also be just the shadow of the hand he's holding before him – and wouldn't the wound be bloody, or open to the bone, if Jerome had really been beating his breast over and over for years in the desert of Chalcis? Besides, his arm is stretched out straight, not bent to bring his fist against his breast. Jerome is holding the stone more as if, aimless and morose, he wanted to fling it away, not at a specific something, just away. And, finally, the expression on his face, the only part of him that is drawn in sharp detail, is anything but penitent. Angry, exhausted, impatient, he has his mouth open and his brow furrowed, his eyes turned towards Heaven or towards nothing. As if he wanted to ward off that something, his other elbow, the left, is turned outwards and his left hand is guarding his chest. Even the lion lying at Jerome's feet like a pet roars out in surprise or warning.

The lion? The lion comes along only in Bethlehem, I remember, not in the desert, as the audio guide claims. And Jerome wasn't in the desert of Chalcis for long, and he certainly wasn't an old man there. Is there a mistake in the audio guide – or in the painting?

He could have had a good life: the son of well-to-do

parents in the old Roman province of Dalmatia who sent him to the capital to be educated, he engaged the most expensive teachers in Rome, surrounded himself with a very hip circle of friends, often indulged in sinfulness, as he would later confess without giving details. At the age of thirty, thirty-two, he still had no profession, couldn't even name a career goal when asked – not necessarily a ne'er-do-well, being too erudite, too brilliant, but evidently a *flâneur*. He tramped around Gaul with one of those friends, apparently on a pleasure trip. For reasons he later did not care to disclose, a resolve grew in him as he travelled to renounce all pleasures and become a monk. In the fourth century after the birth of Christ, becoming a monk was a far more radical resolution than today, and perhaps for that very reason it was a regular fad among young Europeans: concretely, it meant leaving your home, family, language and culture forever, moving to the Orient, surviving as a hermit in the desert, and finally dying with no one around to bury you. Not a hippie trip – there was no *Lonely Planet* back then – more like survival training without the trainer; a retreat that by no means brought inner peace, nor was meant to; it was intended as penance, and so the hermit's practice consisted of one punishment after another.

Jerome went back to Dalmatia to announce his decision to his family, found four more men who wanted to make such a radical change in their lives, and set out with them on what turned out to be a bad trip through Thrace, through Bithynia, through Galatia, Cappadocia and Cilicia, until they finally arrived at Antioch, now Antakya in southeastern Turkey. At the end of their strength, two of Jerome's companions died; the other two turned back. And Jerome, now completely alone, fell ill with a life-threatening fever.

Wrestling with the decision to continue deeper into the desert, Jerome was surprised by a dream vision: he saw himself pulled up before a judge's seat and accused of his worldly

Leonardo da Vinci (1452–1519), *St Jerome in the Wilderness, c.* 1480,
tempera and oil on walnut panel, 103 × 75 cm. Pinacoteca Vaticana, Rome.

predilections – to begin with, he still read secular books! The judge resolved to punish Jerome severely.

> Now I began to wail so woefully, Have mercy on me! that my voice could be heard over the blows of the scourge. Then the onlookers finally threw themselves at the Judge's feet and pleaded for me: Might He take pity on my youth and give me the chance to repent of my error. If I ever went back to reading secular books again, then He might castigate me. I began to call His name, swearing, Lord, if ever I possess and read pagan books, then I will have renounced Thee. After this vow I was released, and returned to the world.

When he awoke, Jerome testifies, he had bruises on his shoulders and could still feel the blows.

So Jerome went to the desert of Chalcis in eastern Syria, which was the closest desert to Antioch, found a cave, set up housekeeping and began his hard penance. Clad only in rough sackcloth, he wept for many days and beat his breast with a stone until he swooned, he wrote. In the end, though, as I said, the days weren't as many as all that: Jerome had to admit that he did not have what it took to be a hermit; he was tormented by sexual desires and kept seeing himself surrounded by a troupe of beautiful girls. He also missed his friends and his social life and was repulsed by his dirty, sunburnt, emaciated body. Jerome managed only three years in the desert.

Chastened, he returned to Rome and had himself ordained a priest, but on the condition – since when can a candidate for the priesthood place conditions on his ordination? – on the condition that he would not have to do pastoral work. The solitude and renunciation of the monastic life remained his ideal, and he wrote several books about it – but he never lived as a hermit again. Jerome's rise to become the leading

advocate of asceticism, and then the most celebrated scholar of his day, almost pope and, posthumously, a Father of the Church, this unparalleled Catholic career began after he had turned his back on his ideal. Could that be why he was such an unsparing cleric – unsparing not only of himself but still more of others – as his contemporaries complained? For, highly though his scholarship was praised, his character seems to have been difficult.

Even the hagiographers note that he was remarkably choleric, vain, ambitious and envious. 'I have never spared the false teachers, and it was a wish close to my heart that the enemies of the church might be my enemies,' he wrote, referring to the churchmen themselves, on whom he heaped vituperation. He reviled St Ambrose himself as an 'ugly jack-daw' and a 'croaking raven'. His intransigence on theological questions is as legendary as his obsession with virginity – if Christianity had heeded Jerome, it would have died out for lack of children.

As violently as he denounced his fellow Christians' human, all-too-human weaknesses, he himself kept company with Roman matrons, and his chastity was extolled with the curious argument that it came especially hard to him as a con-noisseur of feminine beauty. His virtuousness so annoyed his fellow Christians that they drove him out of the city several times, and once burned down his house. 'I know no doctor whom I hate so much,' Luther confessed, complaining that the Church Father spoke of nothing but 'fasting, food, virgin-ity'. The eminence of his writings is evident in the fact that he was revered during his own lifetime as a saint in spite of his glaring character faults, which hagiography makes no attempt to deny.

Jerome spent the second half of his life as an abbot in Bethlehem, where he befriended the legendary lion: the savage beast is said to have become tame after the saint relieved it of

a thorn in its paw. Note, however, that this episode takes place not in the desert of Chalcis, where Leonardo da Vinci ostensibly situates Jerome's old age, but in the quiet yet not completely isolated town of Bethlehem during a scholarly but also social life, with an ascetic, but not exclusively ascetic, day-to-day routine. As the abbot of a monastery, in any case, he wouldn't have been clothed in coarse sackcloth. In fact, most artists – Bosch, Correggio, Dürer and Antonello da Messina, for example – show the penitent Jerome with his mantle of office laid on the ground beside him: after his penance he will put it back on and return to the city. The audio guide, which even in the Vatican is fallible, seems to have overlooked the church shimmering through a gap in the rock. It must be the Church of the Nativity.

The longer I look at the painting, the more I think I detect in Jerome's attitude the pose, perhaps a quotation, of a classical statue that represents a fighter rather than a penitent. I persist in my view, in any case, that he has not been beating his chest with the stone and, judging by the outstretched arm, is not about to start. But is his facial expression really one of anger, exhaustion, impatience? He could have brought his hand to his breast to point his fingers at himself, proud of the pain he is causing himself. Leonardo has drawn in detail only his face, as I noted, and the area between his shoulders, his lower leg – a powerful leg by the way – too muscular for the hunger artist Jerome is said to have been. Explaining why everything else is seen as if in soft focus, the audio guide says Leonardo left the painting unfinished because he was dissatisfied with it. That may be, but now the picture is what it is and has its own truth, which may well be a perfected truth: the indeterminate state of affairs concerning Jerome's chest, the muscular leg, the pained, perhaps all too ostentatiously pained face. Leonardo da Vinci has captured that moment in the life of a saint at which he claims to be one. The lion sees it.

Ursula I

One thing that can be said with some certainty of Ursula is that she was not as calm as the painting would have posterity think when the angel announced to her in Cologne that she would be tortured, defiled and ultimately butchered, she and all her companions, eleven thousand in number and all of them virgins, so the accounts say, but after all they also say 'receive the crown of martyrdom' when what they mean is mass slaughter. In any case, the picture offers posterity no clue of the obsession with which Ursula left Brittany, alone, to save her father from the wrath of the English king, gathered first ten friends and then eleven thousand virgins around her, converted them to Christianity and trained them in warfare. Golden tresses, chubby cheeks, button nose, yes, in the painting she has all that, in addition to the notorious pout, but none of the fire, no violence, none of the inexplicable, supernatural or, to put it precisely, extrasensory sex appeal that allowed her appearance – no, not even that: allowed the mere rumour of her appearance – to enchant kings, queens, princes of all parts of Europe, the pope and four bishops, making them drop everything.

They renounced kingdoms, idols and the papacy just to be with Ursula, to follow Ursula's faith, serve Ursula's mission, although not even the handsomest, boldest, cleverest youths could dream of ever possessing Ursula. She was resolved in that matter as in everything else and inculcated in every one

Master of the Legend of St Ursula (active in Cologne *c.* 1486–1515),
An Angel Appears to St Ursula, *c.* 1492–1496, oil on canvas, 124 × 114 cm.
Wallraf-Richartz Museum, Cologne.

of her eleven thousand virgins never to surrender to anyone
– No man, never, do you hear me? No one, that's what she
must have said in whatever language it may have been, Breton
or Germanic, Latin or the Old or, perhaps, Middle High
Cologne German of that century – Never, or else we are lost,
betrayed, delivered into the hands of the enemy. What did
they do together? Well, 'They ran hither and they ran yon,'
the accounts say; 'simulating the conditions of war, they pre-
tended to flee the field of battle. They took part in all sorts
of contests, trying whatever came to their minds and leaving
nothing neglected. Sometimes they came in at midday, some-
times barely before dark' – no wonder all the men were wild
about these women, eluding men by thousands and thousands
(and religion was the only possible justification in those days),
and no wonder others didn't let them live, not a single one of
them.

Ursula, Ursula – did the name sound as harmless and
homespun back then as we find it today, or as I find it at least,
having been very partial in my last school year to an Ursula
who played the violin? Ursula, Ursula – one thing that can be
said of her is that she marched into disaster with eyes wide
open; with her eyes wide open she took her friends with her,
enlisting them so persuasively that her friends went along
with their eyes wide open. She let them all in on it, eleven
thousand young girls, all of them knew what would happen,
and all of them went along with it, perhaps because death
enchanted them like a siren's song – and then what could
become of their lives, what kind of life could they have lived?
Ursula, Ursula – how did the angel feel as he delivered the
prophecy? That is a crucial question. And what language did
he speak? It would be crucial to know the words in which
Ursula explained their impending martyrdom to the virgins
so that they did not lose heart. The hands are also crucial: the
hands of the angel, which look much older than his face, and

the hands of Ursula, which are much bigger and stronger in proportion to the rest of her body; yes, Ursula's hands most of all, they captivate me. They are not harmless, that is obvious; these hands take action, and they know what to grip and how tight. And likewise the angel's hands are not without feelings, nor without history. They are hands that have done many things, and almost never gladly.

Hence we must assume that the Master of the Legend of St Ursula knew of Ursula more than he betrayed in his painting, more of the nature of angels, who, we must hope, only pretend to be so unfeeling. Perhaps it was not decorum that made the artist paint Ursula the way it was customary to paint women's piety, her gaze humbly averted, her infant's brow, as if taking her innocence literally. Perhaps it was the awareness that neither Ursula's beauty could be represented nor her or the angel's sentiments in the moment he reveals the future to her. For if they could, then those sentiments could be asked and learned, because to us (the picture may have had a different reception in its own day), or at least to me (surely my eyes do not see enough), the faces conceal all emotion. The painter shows of Ursula what her time, or posterity, or in any case I, who conceive Ursula as a violinist with odd manners and funny trousers, will never understand about her.

Ursula II

Now that Caravaggio's *The Martyrdom of St Ursula* has been restored, the faces are clearly visible and a hand has appeared in front of Ursula's stomach, trying in vain to avert the disaster, the right hand of a soldier who, since the restoration, is also wearing a reddish hat and holding a lance in his left, which identifies him as a soldier, a pagan soldier, evidently, who nonetheless tries to prevent the murder. Since its restoration, the martyrdom is once again a disaster for everyone present, with the possible exception of Ursula herself, who looks at the arrow as if it were an amulet or a guest. She is the exact opposite of the gold-tressed, plump-cheeked, button-nosed pouter in Cologne, an altogether secular figure who does not leave it up to the imagination to figure out why kings, queens and princes in all parts of Europe, the pope and four bishops succumbed to her, and eleven thousand virgins joined her, running hither and yon, to quote again the telling words of the tradition, taking part in all sorts of contests, you understand, and neglecting nothing, but nothing, that came into their minds, returning sometimes at midday, sometimes so late that even the men of today's world would go berserk.

Caravaggio is not interested in virginity, neither that of the eleven thousand, who are a mere fantasy, as art historians are quick to assure us in every catalogue, as if the people of Cologne had ever believed it literally, nor that of Ursula. Admitting, conceding, making it clear from the start that it

is only *my* fantasy, to forestall any reprimands from the specialists, the fantasy of a father who, when his children travel, begins missing them before they leave – couldn't Ursula, with the red mantle bulging over her belly, be pregnant? Then she wouldn't be searching with her fleshy hands, which enhance her sex appeal still further by a kind of counterpoint, for her wound, as on a closer look she is not, but feeling for her child, whether it is still alive. And the soldier would not be holding his hand too low to avert the arrow, but instinctively protecting her abdomen. Since *The Martyrdom of St Ursula* was restored, his mouth has been open and his look is no longer one of resignation, submission to secular or celestial authority, but is shown in the exact moment, the jet of blood only a few centimetres long and hence only in motion for tenths of a second, before he has had time to resign himself or, more probably, to crack, perhaps to take his lord by the throat, his secular or his celestial Lord.

The bearded man behind Ursula now has a greater resemblance to Caravaggio, although without the barely scarred wounds that had disfigured his face since his Maltese enemies attacked him, on 24 October 1609 in Naples. He is the only one who already realizes, as if he had foreseen it, what has happened to Ursula – Orsola, Orsola, as it sounded, perhaps strangely and mysteriously, in the Italian of the time, and in any case not as quaint as in English today; what is more, he emits a loud groan, the unscarred bearded man, as if *he* had been shot, not Orsola, or as if the arrow had pierced through Orsola and the child, their child then, and into his heart as well. Did Caravaggio, at the age of about forty, not want children? I, at the age of about forty, can't imagine he didn't, my second daughter having taken her first two unaided steps

Overleaf: Caravaggio (1573–1610), *The Martyrdom of St Ursula*, 1610, oil on canvas, 154 × 178 cm. Palazzo Zevallos Stigliano, Naples.

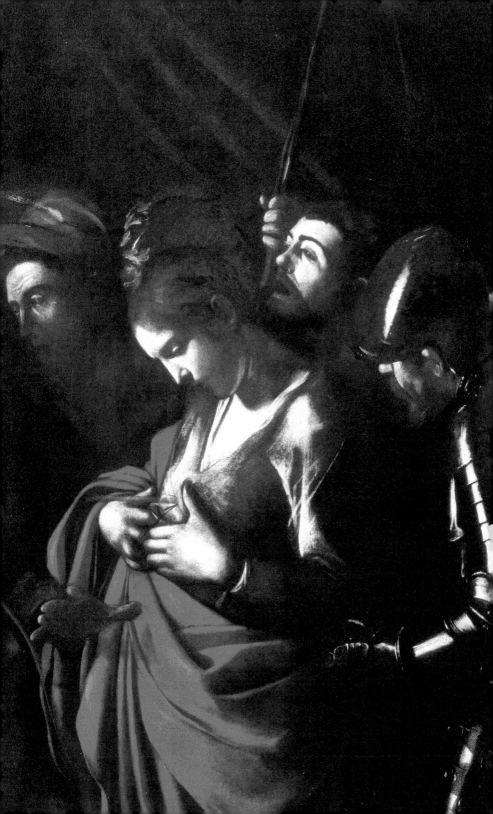

yesterday, and three this morning. Caravaggio's martyrdom – admitting, conceding, making it clear from the start that it is a martyrdom only in his own fantasy and that of his posterity – was consummated a few weeks, at most three, four months later, on 18 July 1610. That he felt himself to be truly persecuted is, according to recent findings, still undoubted.

Since its restoration, *The Martyrdom of St Ursula* shows no fading mastery, no surrender, no farewell, but rather an outcry and a rage – not the rage of the damned, but that of the fugitive, the starving, maligned, a thousand times vexed, but still quickly beating heart. The scene is now dimly lit as if by a lantern, and not just in spots as if in a studio, and its lacunate, almost sketchy quality comes to light as clearly as in the other pictures Caravaggio painted during his four-year odyssey across half of Italy, to Malta, and back to Naples. The colours are so few, as if he had had with him only a tiny or an incomplete palette, and the fields, rather than monochrome like silk, are coarse like the ground on which Caravaggio often slept. The ephemeral quality of the lines and dead-colouring, which corresponded with his own condition, produces the effect that YouTube sometimes leaves on the viewer's mood when someone has used their phone to record a disaster, a murder or an execution, often but not necessarily surreptitiously. The ephemeral quality is necessary; it has never been possible to represent the holy without it, although Caravaggio's earlier realism is evidence to the contrary. After *The Martyrdom of St Ursula*, he set out again, was arrested again, lost his luggage, including those paintings which he did not bequeath on his death because they were no longer in his possession, and his paints; he wandered mad on the beach or, as recent findings disappointingly suggest, rode comfortably up the Via Aurelia towards Rome in the hope that the pope would personally pardon him, fell ill on the road and died an ordinary death, which according to recent findings is still wretched enough.

When we arrived in Naples, we did not hope to see *The Martyrdom of St Ursula*, although I was keenly interested in Cologne's patron saint. The books said only something about a private collection, the art guides did not mention it at all, and our hosts knew nothing about it. Only because we went to the bus stop, in spite of the pouring rain, instead of spending a few euros on a taxi up the hill to the Capodimonte, did we discover the notice in the display window of a bank saying that here, after many years out of the public eye, 'Caravaggio's last painting' would be shown to the public once again, although according to recent findings, as the bank's arts patronage department pompously announced, two more works followed it. Since *The Martyrdom of St Ursula* has been restored, Ursula surpasses even the *Madonna of the Pilgrims* in beauty, whom she no longer resembles only by her fleshy hands. Perhaps Caravaggio painted his earlier model once more from memory, and from pain, the model for whose sake he had fought with a notary in Piazza Navona in 1605, a dream of a woman, with whom perhaps not the pope, but kings, princes and Caravaggio too would have been happy to beget a child.

Even the helmeted soldier at the right is no longer a mere suit of armour since *The Martyrdom of St Ursula* has been restored. He doesn't seem to realize that she has carried her obstinacy to the very end, instead of submitting to the secular ruler, as any reasonable person would have done, especially with a child in her womb. Is the soldier scolding her, as I often scold my wife, for not taking enough care of herself? Did he ask her a question? If she collapses now, he will catch her.

Since *The Martyrdom of St Ursula* has been restored, the murderer is at last recognizable as a lover, enraged because his beloved has refused him. If Ursula is a symbol of the Divine, he destroys it by an excess of desire. At the same time, his hand is guided by God, who has brought to him an Ursula,

Orsola, more beautiful than a Madonna, with whom another ruler, the celestial Ruler, begat a child, if that is not a fantasy. This shall not be! the picture cries; that shall not be, to kill such a one, which can no longer be prevented.

Bernard

Already half persuaded that the painting completely reverses the meaning of the tradition, my Catholic friend raises the question whether Pietro Perugino was aware of the ambiguous – oh, all right: the absolutely obvious, unambiguous – indecency of the looks, gestures and postures, not only of Mary but of the two angels who appear before Bernard, as if they had made a wager as to whether he, whether even such a saintly man, could be seduced. Seduced? Yes, shagged, that's all, I tell my friend, half persuading him.

Mary's finger, to name just one of my arguments, her right index finger, which the art historians have pronounced to be 'guiding, instructing', is by no means outstretched, but bent just enough to suggest the curvature by which that finger will point to Mary herself, saying, 'Come on, come on, and then your eyes shall be opened,' especially as her thumb and middle finger already form a circle, to ignore the obscenity of which, to ignore it in Italy no less, you would have to be either blind or a Protestant. To say nothing of Mary's other hand – as if it were really 'resting' in front of her body or just pragmatically 'holding' her cloak, as the art historians euphemize. First of all, the cloak appears to be tied behind her hand, as those of the angels are and as was simply the custom, documented in so many other paintings, leaving both hands free; second, and more importantly, even if Mary did have to hold her cloak, why is she holding it exactly where no

man and especially no saint should be looking, pressing her fingers moreover on the point just above or at the edge of her pubes, depending how wide Mary's pubes – If so, then she's not Mary! my friend interjects – how wide the woman's pubes are, then; call her the seductress if you prefer, a manifestation of the Devil perhaps, her body slightly turned, her feet in a sidestep, her hips slightly tipped, her genitals practically held out towards poor Bernard.

Perugino simply ignores the real nub of the tradition, placed at the centre of *The Vision of St Bernard* in the two exemplary works by Matteo di Pacino and Filippo Lippi, which is that Mary dictates a message to Bernard. Neither does this Bernard have a quill in his hand, nor is Mary's mouth open as if she were speaking, and her index finger isn't pointing ... oh, never mind her index finger; we already talked about Mary's finger. Look instead at her face, I urged my friend when he was less than half persuaded; look at Mary's eyes – no, she's not a she-devil, maybe she's not Mary, but that's no devil – this beauty's eyes are so transfigured that she seems to be the one having a vision rather than St Bernard, whom Perugino portrays as sobriety itself. Is she in love? In a trance? Or is she, unconscious of her seductive power, disinterestedly carrying out the terms of the wager as to whether he, whether such a saint, can be seduced?

To answer that, we have to know – and Perugino certainly knew it – that there is a background story behind Bernard's attempted seduction. Not even Jerome, indeed no other saint in Christian history, waged such a difficult struggle against his sexual desire. I'll just quote the beginning of a paragraph from the *Legenda aurea* to give an impression of the intensity of his tribulations:

Once, for instance, Bernard was gazing rather fixedly at a woman until suddenly, blushing at what he was doing, he rose

as a stern avenger against himself and jumped into a pool of ice-cold water. There he lay until he was almost frozen, but by God's grace the heat of fleshly lust was wholly cooled in him. About that same time a girl, egged on by the devil, jumped into the bed where he was sleeping. When he became aware of her presence, he moved over calmly and silently, leaving to her the side of the bed he had been occupying, and, turning to the other side, went back to sleep. The woman put up with this expectantly for some time, then began touching and teasing him, but he remained motionless. Finally, impudent though she was, she blushed with shame, felt a flood of horror mixed with admiration, got out of bed, and hurried away.

And, as I said, that is only the beginning of a paragraph, one which goes on to fill another two and a half pages of small print with similar scenes. Bernard subjected himself to an all the more zealous, indeed a zestful asceticism, which we should not imagine as something like simply keeping to a diet today; asceticism in medieval monasteries meant scourging oneself most vigorously, meant ravenous hunger, life-threatening thirst, systematic sleep deprivation and self-inflicted injury. Bernard suffered, as a result of his insufficient, unvaried, mostly raw diet, from constant nausea, so that the smell of his breath was unpleasant to the other monks, especially when they sang together in the choir; nonetheless he would not miss any common prayers and had a container installed in a recess in the floor by his place in the apse of the church so that he could vomit during Mass. If the bishop, after the young monk had wasted himself to the point of paralysis, had not intervened and ordered him to moderate his self-castigation, Bernard probably would have died. In the end he was so immune to all sensations that he could not tell the difference between butter and raw animal fat and didn't notice that he drank oil instead of water – 'he was not aware of it until he

wondered why his lips felt oily.' You have to bear this prior history in mind, I said to my friend – Perugino, as I say, certainly did so – to find some plausibility in the enterprise of the three young women who have lined up in front of St Bernard, comely down to their conspicuously bare feet. 'You may think your chastity is a small thing – but I do not!' Bernard later confessed in a sermon to the monks in Clairvaux, 'For I know what its enemies are and how much strength is needed to resist them.' And in fact, his vision of Mary occurred during the period of crisis that forced the bishop to intervene.

'But then it wouldn't be Mary,' my friend interjects again.

'Perhaps it was Mary, for that very reason,' I reply.

That wouldn't have been her motive, but she certainly would have been able to seduce him, and then many thousands or hundreds of thousands of deaths would have been averted: for Bernard was not just the grand master of inner struggle whom Christians revere even today; he was at the same time the most important, the most persuasive preacher of the particularly bloody Second Crusade. Six out of seven men who heard him preach in the marketplaces of half Europe are said to have enlisted to go to war – six out of seven! What charisma, what persuasiveness, what rhetorical fire this man must have had! Just as Bernard rode a whole day along the shore of Lake Geneva without noticing it – in the evening his travelling companions mentioned the lake, and Bernard asked them where it lay – Ayatollah Khomeini too, during his long years of exile in Najaf, never once noticed the Euphrates, which flowed just a block from his house, and is still praised today for his lack of interest in all earthly things. It is this lack of human feelings – certainly remarkable, taken by itself, if not admirable – this absolute immunity against the little, apparently unimportant impressions, indeed against all feelings and especially against their personal interests, that seems to enable people to commit the greatest inhumanities.

Pietro Perugino (*c.* 1448–1523), *The Vision of St Bernard*, 1489/90, tempera on chestnut panel, 173 × 170.7 cm. Alte Pinakothek, Munich.

In Paris in 1977, when Khomeini was given the news of the murder of his eldest son, he asked, with no emotion discernible in his face, what else was new. Outside the church, Bernard has been called a 'premature Grand Inquisitor' for the ruthlessness with which he persecuted dissenters such as Abelard and William of York as heretics, and called not just for war against the unbelievers but purposely for their random slaughter, their extermination 'in the hereditary land of justice': 'A knight of Christ, I say, kills with a good conscience, and dies still more serenely.'

'And yet Bernard is still sacred to the Church,' I mumble as if incidentally.

'Well, he was also a kind of premature Calvinist,' my friend answers, responding to my accusatory undertone, and points to the restrictions on spiritual music that Bernard imposed in the already austere liturgy of the Cistercians and to his aversion to all kinds of aesthetic ornamentation. St Bernard distrusted images three hundred years before Calvin.

I am not sure whether that is meant as an excuse, and, if it is, I would find it rather unsatisfactory, but I don't ask. Instead I return to our painting. If one of the three beauties is in love with him, then it is more probably the one in the middle, who is looking not at Mary – That's not Mary! my friend insists – but, yearningly, at Bernard, only at Bernard, while the one with the biggest secret to keep is the one farthest left, with the broad face and the expression of self-assurance, perhaps calculating or perhaps just cheeky, about her mouth. If ever anyone hatched a scheme to lure Bernard away from his desk, it is she, the rascal, and the one in the middle, the pining lover, was in denial, refused to believe that even such a saint could be seduced by Mary. That's not Mary! What do you suppose is written in the book the rascal is holding in her hand? Is she going to record the result of the wager, the amount won or lost? What would the stakes be? She is

definitely up to something, with her eyes looking in the other direction, as if someone were over there watching. Although she would then be the she-devil and be carrying the lily, the symbol of purity, in scorn.

No, no, my friend says steadfastly, they are angels, and Mary is an angel too for that matter, and God has sent them to test Bernard, who proves his sanctity by not wavering for a second, not even in the face of an angel, repelling the suggestion of Mary's finger – You said it wasn't Mary! – with both hands, calm and at the same time resolute (a 'humble gesture of welcome', the art historians brazenly lie). Not even the other two saints Perugino depicts, the Apostles Philip and Bartholomew no less, would have been so steadfast: they turn their eyes away, Philip, with the cross, wistfully; Bartholomew, with the knife, ashamed. Yes, my Catholic friend says, suddenly persuaded of something else, Pietro Perugino knew what he was painting, and his vision of St Bernard is more pious than the art historians teach. But that's not Mary.

Francis

I have not found it mentioned anywhere that the ecstasy of St Francis, a frequent subject of painting, is also the moment of his stigmatization. When the painters depict him receiving the miraculous marks, as Giotto and Ghirlandaio, Cranach the Elder and van Eyck do, Francis suffers or tolerates the operation, looking unmoved or courageous, but in any case not excited; and when ecstasy is written in his face in Giotto's other painting, and in two by Murillo, and together with shame in Guercino, and unabashedly again in Caravaggio, we can only guess, unless we know from the hagiography, that it has no other cause than his wounding: an excessive, an inhuman pain such as Jesus suffered on the cross, the piercing of the hands and feet with brownish, hence rusty, nails, the thrust of the lance in his right side and, although they are not explicitly mentioned, no doubt the thorns too, twisted onto his skull, the dizziness, and through it all the thirst, the emotional distress, the slavering crowds and, most terrible of all, the abandonment by God. The Passion is suggested at most by the holes in the garment of the rapturous Francis, by the skull or by the violin music that the angel, 'a beautifully radiant figure', actually played so 'supernaturally sweetly' just before the stigmatization, by St Francis's own account, 'as if all the beauties of Paradise were fused into a single sound'. In the pain, we must note – as though his bones were being broken by his own muscles contracting in torment – Francis's

soul trembled 'with such deep enjoyment that it almost left my ravished body'. And Francis goes on to recount that his soul really would have broken loose and rushed upward to Heaven if the angel had played but one tone more. 'When I came to, I cried: Let me suffer and renounce. And again I said: Now I can bear it. If I can enjoy such blessedness while I am still in dust and flesh, how will it be when my soul has left this miserable sack?'

Georges de La Tour painted no angel and no holes. Nothing points to the Imitatio Christi, which is nonetheless clearly represented, since La Tour keeps more closely than all the others to the hagiography, more closely even than Giotto and Ghirlandaio, Cranach the Elder and van Eyck, who actually call their paintings *Stigmatization*, although they conceal the 'desire' and the 'sweetness of grace' reported by Thomas of Celano, Francis's first biographer, commissioned by the Franciscans themselves. Francis does not receive the stigmata outdoors but in the little mountain chapel at La Verna, where he was 'filled unto overflowing, and as never before, with the sweetness of heavenly contemplation, and was kindled with a yet more burning flame of heavenly longings', as St Bonaventure writes in his famous *Legenda maior*, and Francis – although portrayed as solitary in Giotto's other painting and in the two by Murillo, and ashamed too in Guercino, and unabashed again in Caravaggio – Francis is not alone during his ecstasy but asks his brother monk Leo to take the Bible from the altar and open it three times in succession in the name of the Holy Trinity; when Leo opens it to the Passion each time, Francis realizes 'that, as he had imitated Christ in the actions of his life, so, before he should depart

Overleaf: Georges de la Tour (1593–1652), *The Ecstasy of St Francis*, oil on canvas, 154 × 163 cm. Musée de Tessé, Le Mans.

from this world, he was to be conformed to Him likewise in the sufferings and pains of his Passion.'

Of course there is the ecstasy of St Teresa, which is sexually more explicit, not only because Gian Lorenzo Bernini's representation of it is more explicitly sexual. 'The pain was so severe that it made me utter several moans,' Teresa of Avila reported, and, at the same time, 'the sweetness caused by this intense pain is so extreme that one cannot possibly wish it to cease, nor is one's soul then content with anything but God. This is not a physical, but a spiritual pain, though the body has some share in it – even a considerable share.' How often I stood, during my Roman year, in front of the life-sized sculpture in Santa Maria della Vittoria, and each time I wanted to incorporate Bernini's ecstatic Teresa, moaning with lust, if not crying out loud, in my personal Christianity. It was an obvious inclusion, since I have been thinking for so long now about the beatitude, and searching for it myself I admit, in which pleasure and prayer, sex and God feel like one, and for the Islamic mystics indeed are one. It was probably that obviousness that deterred me each time.

For Bernini to use prayer and God simply as a pretext, evidently, to portray pleasure and sex – well, that alone wouldn't bother me; the greatness of art is that it goes beyond the artist's intentions. But he makes the ecstasy of Teresa too seductive to be true; he not only shows the saint excited but wants to excite the viewer still more, and in so doing he misses the moment in which the self, losing itself, finds itself. For whatever reason, God made us look our ugliest precisely when we are filled with the greatest beauty, not only our features distorted and tormented but our whole body contracted as if in convulsions. The highest ecstasy, sadly so rare, ritually evoked in some traditions, and then lasting often minutes, or in Tantra even hours, appears almost like epilepsy, quivering, twitching, thrashing with our arms and

legs as if we were no longer ourselves, and perhaps we are not. But the sight is not all! The sweet viol we seem to hear, the supernaturally sweet music, is to bystanders an unbridled moaning and helpless gasping and repulsive grunting. No wonder children are shocked when they see two adults, especially their own parents, in the act of love, or even when they hear their cries from the next room. The children are right; there is something bestial about it – as Brother Leo also notices, gazing fixedly at the candle instead of at Francis or at the opened Bible. He seems to be praying, not in obedience to the saint but for him, as for a sick man. Francis meanwhile seems to be uneasy about his rapture. His pleasure is entirely inward, he seems to be ashamed in his enjoyment, as if he had, in an unfitting moment and against all intention, an erection in front of strangers' eyes; his shoulders are drawn forward, and so his body, unlike that of Bernini's Teresa, is not turned obscenely outwards towards the viewer. Although something is objectively happening to Francis as he receives the stigmata, in contrast to Teresa, who simply feels pain, his ecstasy is not as physical as all that, or else he is not letting its bestial aspect out.

No, not just Bernini's sculpture, but Teresa's own testimony seems to me, seems even to someone like me, for all its veracity, too one-sided to be a valid description of ecstasy beyond her own individual experience – no wonder that, two centuries later, it inspired a not merely sexually explicit but blatantly pornographic novel, the erotic confessions of *Thérèse philosophe*. From a Christian point of view, that may have been a malicious distortion of Teresa's intentions. And yet the novel, which is otherwise fairly intelligent, is not without some relation to her experience, in which the body has indeed a very considerable share. A pornographic Francis, on the other hand, is not possible, at least not a fairly intelligent one.

The epitome of active piety, of loving one's neighbour and also one's enemies, of a childish innocent who understands the language of the birds, of a man without possessions who, given a cloak, gives away not just half of it, of the resolute pacifist seeking dialogue with the sultan, and finding it, in Egypt, in a vain effort to stop the Christians on their crusade – Francis imitated Jesus from the very beginning 'in the actions of his life', and not, like the women mystics of Catholicism, primarily in contemplation. More important to him than the individual experience of God and personal perfection was service to human beings. That was why he did not do penance to purify himself, did not scourge himself, was an ascetic out of frugality, not for an ulterior purpose. His is not a believed pain, nor is it self-inflicted; hence, for all its reality and, if you like, blood, it is not a desired pain like that of sadomasochism. Francis's pain befalls him; it is not wounds that are inflicted on him but scars, the marks of wounds, stigmata. Not only did he not want them, but he shows them to no one, makes Leo swear never to reveal his secret. 'We may not keep silence concerning the thick veil wherewith he covered those marks of the Crucified, meet to be revered even by the highest Spirits, nor concerning his carefulness in hiding them,' writes Thomas of Celano, who was able to interview Francis's companions. The saint was always anxious not to the show the rapture that his conversations with God caused him: 'Finally it was his custom to rise for prayer so stealthily and gently that none of his companions noticed either that he was rising or that he was praying. But when late at night he went to bed he made a noise and almost a din, so that his going to rest might be heard by all.'

Because few people saw them with their own eyes, sophisticated times have been quick to dispute the stigmata. Yet the secret that St Francis made of his suffering speaks for the authenticity of his ecstasy. The self that loses itself is not found in the erotic novels that celebrate pain today.

Peter Nolasco

How nice for St Peter Nolasco that the Apostle his namesake appears to him in the flesh to console him for a cancelled trip to Rome and to encourage him to take up apostolic work in Spain, as the panel beside the painting informs us; simply marvellous, because it doesn't happen every day, even to a saint, that an Apostle, and his namesake to boot, floats down from Heaven in person to speak to a single believer. And this on the comparatively minor pretext of a cancelled pilgrimage and general encouragement. And on his cross, no less. And Peter Nolasco, who probably owes his canonization as a saint to the apparition of the Apostle his namesake, is truly awestruck, fully aware of the grandeur of the moment, the grace of such a distinction, as we can see by his earnest, tense facial expression, and by his hands, which seem physically to grasp the apparition of the Apostle his namesake, to capture it, so that he can carry it in his heart for the rest of his life; that is how glorious it is for St Peter Nolasco and would be for any other believer. Only Peter himself – the Apostle – who appears to his much less important or at least less known namesake: has anyone ever thought about him, asked themselves whether he considered the meeting to be such a grace? Yes, Francisco de

Overleaf: Francisco de Zurbarán (1598–1664), *The Apparition of the Apostle Peter to St Peter Nolasco*, 1629, oil on canvas, 179 × 223 cm.
Museo del Prado, Madrid.

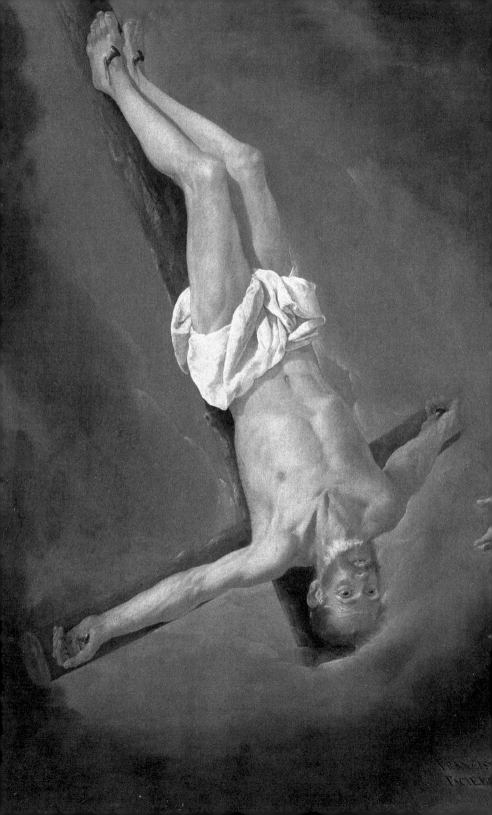

Zurbarán must have asked himself that question, and he gave an answer that may make him appear less orthodox than he was reputed to be in early seventeenth-century Spain.

The Apostle, as Zurbarán painted him, is floating down from the clouds, true enough, but he can hardly be arriving from Heaven, his watery pupils, almost bulging out of his eyeballs, filled with stark undisguised horror, his beard ragged, the little hair left to him standing on end, whether from gravity or from fright, the lips slightly opened baring the gap in his teeth without allowing him ever to emit a word, and certainly not a word to his namesake, who doesn't interest him at all, whom he pays no attention, probably doesn't even notice. Zurbarán's Apostle is visibly in a different here and now, in his own time and place, even though he has been dragged to Earth; he has been hanging upside down on a cross for twelve hundred years now, without dying, without decaying, without rotting; he doesn't even pass out, can't even sleep, his wounds not healing but continuing to bleed for eternity – the worst thing that could happen to a person, and to an Apostle, no less. He probably can't even vomit any more, Mr Burckhardt.

When I imagine Jesus or Mary or one of the Apostles, or indeed any of the righteous after the resurrection, I imagine them released, mild, kind, and so light that they float inches above the floor. Zurbarán's Apostle also floats, his body surrounded by clouds a cubit above the ground, yet not because he feels light, but because he is nailed upside down to a cross, on which he flies through the universe like a rocket, sent presumably by God to appear to this or that saint. Not even the fallen angels Harut and Marut spent eternity in such a horrific state: they were upside down, but not with nails through their hands and feet. It is Hell, nothing less, Hell itself to which God has banned the Apostle, and if even the Apostle is damned, what will happen to other people, real sinners?

Only this holy Nolasco, whom I liked less and less the longer I stood in front of his life-sized picture in the Prado, is so full of his fantastic vision, probably more awestruck by his own distinction than by the grandeur of the moment, that he is utterly indifferent to the torments that the Apostle his namesake is suffering, never wonders for a moment whether it is really so nice, so marvellous, to be crucified for twelve hundred years, upside down no less. Apparently unmoved, at any rate showing no trace of pity, of sympathy, concentrated only on his own experience, his eyes cast down to the floor, as if in meditation, rather than on the poor Apostle, the holy man spreads his arms, his robes snowy white, the fingernails on his strong hands neatly trimmed, his cheeks clean-shaven – a functionary before the martyr.

On the wall across the room was a similar painting by Zurbarán, this one of Christ crucified, and at his feet stands an unnamed donor, a merchant apparently, but with his face turned towards the viewer with a smug, contented expression, so that the crucified Christ in the background suddenly strikes me as a trophy, a quarry, the stuffed skin of a hunted animal. And are not the saints, the prophets, also victims? But not of God: victims of people, killed by people, sacrificed for people, passed around like trophies, used, sold, held up as a pretext for war by people? No one wonders how Peter feels, how Jesus, Mary and all the others whom God sent, and so perhaps tested, perhaps damned, otherwise no doubt they would not have cried out when they received the first revelation, wouldn't have fallen down as if struck by lightning or writhed on the ground as if having epileptic fits, flailing about, as the Old Testament prophets are reported to have done, and Muhammad in similar fashion. 'And when I saw him, I fell at his feet as dead,' John remembers in terror of the vision of God the Son, 'and out of his mouth went a sharp two-edged sword' (Revelation 1: 16–17).

Jesus crucified can be seen in another painting in the same room of the Prado, this time with an artist at his feet, either Luke, according to the panel beside the painting, or Zurbarán himself in bitter self-recognition, the painter looking up at the cross in delight at finding such an exciting, expressive, live model, his palette ready in hand, instead of helping the agonized victim, giving him water, calling for help, someone who can pull the nails out of his hands and feet, or, if there is no help, if God on Earth will not help even His own son, then throwing his hands up heavenwards in despair, or beating with them on his own head, because then God on earth will presumably help no one. Or does He punish only those who are closest to Him, cynically letting the functionary, the wealthy merchant, the artist triumph? 'This work subtly refers to the idea that art's greatest merit is its potential for use in the service of religion,' the panel proclaims further, apparently referring to some other painting.

Peter Nolasco is declared a saint after his vision; the wealthy merchant is no doubt forgiven all his sins; rewards and praise are bestowed on the artist. The Apostle on the other hand will continue to fly through the universe nailed to the cross, unless God sends him down to earth again. I did not speak lightly of vomiting – there is something that distinguishes Peter's stunned expression from all other paintings that depict his crucifixion: he doesn't seem to be dizzy any more. His eyes are staring straight ahead; his pupils are not rolled up under his eyelids, or askew as Caravaggio has them. Either he has grown accustomed to living upside down, or else, where the Apostle Peter is now, there is no up and no down.

Simonida

The question is whether she would still have enchanted me
– and when I write 'enchanted', I don't mean some kind of
smoke-gushing zap-bang, some sort of metamorphosis, or
even an emotional state that anyone else would notice; no, all
I mean is a feeling, or at most a sense of being touched, but a
touch apprehended with the senses, as physically as a sudden
gust of wind – the question is whether I would have felt her
breath, would have paid her breath any mind, if she hadn't
been blind. It was dark in the church, almost as dark as night;
the window under the high vaulted ceiling was tiny; beyond it
the early morning sky hung heavy with storm clouds; and, to
make things worse, I saw her only by the light of my phone, by
now a medieval model, as my daughter is fond of telling me,
she who only laughs at my weakness for medieval churches,
with no torch light of course, although the display lights up
in colour. In vain I had shone the light into the church – and
then I pointed it at the nearest wall, a pillar or an arch in the
middle of the room near the entrance where she seemed to
have been awaiting me for a long, long time. The very first
pale ray of light fell on her almost circular face, on the black
spots that I took at first for empty, ghostly eye sockets, the
little, pensively smiling mouth, the globes affixed to or hang-
ing down from her ears, giant earrings apparently, and then
the crown, which must be incredibly heavy; behind her head
the halo, looking like a rising or setting sun, so yellow and

glowing and deep, before I moved the phone display over her body, down her splendidly colourful, so richly ornamented robe, and diagonally upwards along the arm raised to her bosom. She is inviting me, the thought crossed my mind, as I studied her raised hand under the multicoloured but uniformly weak rays of light; her extended fingers, with the fingertips pointing back at herself, are inviting me, for I have finally discovered her here in the darkness.

Of course I knew in one half of my brain that I was no discoverer. It was early, it was a weekday, it was raining and blustering; the few people in Kosovo who still visit churches – the remaining Serbs, pilgrims and employees of international organizations – will prefer more convenient visiting hours. In the other half of my brain, however, I thought I had landed in the next world. It was quiet, it was empty, not a single candle was burning – and in the monastery courtyard there was not a monk or a nun to be seen anywhere, no light behind any window.

If I try to explain today the impression I had of meeting the living dead, it also has something to do with the location of the monastery, with its immediate neighbourhood, in which, over the course of seven hundred years, and most of all in the last fifteen years, not a stone has been left in place. Not Gračanica, but other Serbian monasteries in Kosovo rise in the midst of an old cultivated landscape, so that getting there through the gorgeous scenery already puts the visitor in a reverent mood. There even the foreign soldiers who guard the monasteries, because the new state has no appreciation of anything Serbian, heighten the expectation of entering an extraordinary place, a silent, remote temple that is at the same time part of the world's cultural heritage; in the monasteries themselves you meet not tourists, nor churchgoers except on

Queen Simonida, c. 1318, fresco in Gračanica Monastery, Kosovo.

Sundays, but always monks or nuns, generally praying or otherwise busy. Gračanica, however, lies in a suburb of Priština, barely noticeable along a main road, surrounded by new buildings with façades of bare concrete blocks, garish shopping centres, fast-food restaurants, surrounded by neighbours who no longer have a hostile or any other attitude towards the monastery, no foreign soldiers, the courtyard gate unlocked; anyone can go in. As spectacular as the church building looks, with its five cupolas and countless roof vaults, especially in this faceless suburb, no one cares about it. Gračanica doesn't look like a sanctuary that needs to be guarded against the course of time. On a rainy Monday morning, it looks like the holy itself, forgotten.

To the left of the young queen, the light of the display fell on a white-bearded king whose face also seemed to have two empty sockets. As if in a surrealist painting, the old man was holding in his hand the church in which he stood. Later I would read that the young woman was named Simonida and, in 1299, was given in marriage, as a five-year-old, to King Stefan Uroš II Milutin by her father the Byzantine king Andronicus II to cement the friendship between Byzantium and Serbia. So the old man beside her was not her father or ancestor, but her husband. I would read further that Simonida was raped by Stefan for the first time at the age of eight, and after that repeatedly until she fled to Byzantium, her genitals bleeding; that she begged and pleaded to be allowed to enter a convent, but her father forced her to return to her husband, whose lust had positively shredded her womb; that Simonida was twenty-six years old when her husband died, and childless of course – no embryo would grow in such a mistreated body – and she finally entered a convent, where she died fifteen years later.

Holding out my phone in front of me like a candelabrum, I searched the church's three separate chapels and countless

niches. Hardly any of the saints, prophets, Apostles painted on the walls had eyes left in their faces. The church was filled with an army of blind people, people blinded, as if they had seen too much evil on earth during the marriage of the sainted Stefan. But I had not yet read what kind of a saint the white-bearded king was, to what martyrdom he subjected his young wife; I saw only black spots in place of eyes and felt that a curse lay upon the church.

'That was the Turks,' says a black-robed nun, veiled up past her chin and down past her eyebrows, whom I met later in the monastery courtyard. 'Turks scratched the eyes out.'

'But why?' I ask.

'Turks eaten the eyes,' the nun told me, with her smattering of English.

'Because of the prohibition against images?' I asked, already doubting whether she would understand me.

'They think eyes are medicine,' the nun answered, 'they think magic.'

With a torch the nun lent me, I went back to the pillar or archway and saw to my amazement that the sun had set behind Stefan. I aimed the cone of light directly at Simonida's face and saw that one of the two black spots only half covered her eye: she could still see, she could see me! Then I discovered the wand that Simonida held in her other hand, and believed in her magic.

Paolo Dall'Oglio

From one second to the next, the driver and the two nuns in the back seat become nervous. They say nothing; I can tell by their necks stretching towards the windows, the driver's neck right out of the side window; I can tell by their fearful looks, and by their breathing, which betrays the racing of their hearts. They must have seen something troubling, but the parking lot of the Mar Musa monastery ahead of us is empty, the bare, jagged mountains rising steeply behind it, the land all around us flat, as if undressed. I too crane my neck out of the window on the passenger side and discover below the monastery, which looks as if chiselled into a gorge five, six hundred feet above us between clay-brown cliffs, a few dark figures with white cloths around their heads. And, yes, the figures are carrying rifles. I know that three monks are – were? – expecting us in the monastery. The armed men may have already penetrated the compound. We would have no way to help them, I can see that, in the middle of the Syrian desert where hermits fled almost two thousand years ago to escape the world, St Jerome right nearby, in the middle of a country turned Muslim, in the middle of a war in which army and rebels have different motives for kidnapping or killing the members of a Christian order, who are completely unprotected and surrounded by a lawlessness in which criminals are a still greater threat.

'They could be hunters,' one of the nuns in the back seat whispers to me.

The driver stops right in front of the gate and checks, leaving the motor running, whether the lock has been broken open. No, it hasn't, he assures us; that suggests hunters, the nun explains, hunters from the neighbourhood, because fighters or robbers would have come with a car to carry off the monastery's last possessions. The monastery has already been robbed three times, although after the first robbery there was hardly anything left to steal: the livestock, the tools, even much of the furniture taken. I already know better than to ask any questions about the thieves, much less about police, investigations, or protection.

The founder of the order, Father Paolo Dall'Oglio, is one of the few Christian leaders in Syria to denounce the state's massacre and defend the people demonstrating for freedom. He urged his own church not to draw a line between its fate and that of the people as a whole: if the future of the Christians really depended on aligning themselves with injustice and oppression, then their future was already finished. In 2012, Father Paolo was banished from the country for his criticism.

If there is one thing I admire about Christianity – or perhaps I should say about those Christians whose faith not only convinced but conquered me, robbed me of all my reservations – if I were to take just one aspect, one attribute as an example, a guideline for myself, it would not be the beloved art, or the whole civilization, music and architecture included, or this or that rite, rich though they may be. It is the specifically Christian love, which is love not just for one's neighbour. Other religions are loving too, exhorting the faithful to compassion, indulgence, charity. But the love that I perceive in many Christians, and most often in those who have dedicated their lives to Jesus, the monks and nuns,

exceeds what a person could achieve without God: their love makes no distinctions.

Of course the idea that all people are brothers, 'of one substance, like the limbs of one body', as Saadi puts it, is found in Islam too, and active compassion, especially in Sufism, goes beyond the boundaries of one's own community. But, significantly, even the Sufis give a Christian connotation to compassion with strangers, to those of different persuasions, to the members of different communities – and that is what is meant by loving one's enemies, not a sheep's love for the butcher – and they explicitly refer to the example of Jesus. Although they are not Christians, they perceive their love as 'Christian'. And yet there remains something for which I have no explanation, theological or otherwise, because no other religion but Christianity raises such an absolute claim – no man cometh unto the Father but by this one Son – and thus shows such a distinctly excluding aspect. The rigid, uncompromising sentences with which the Redeemer damns the vast majority of humanity, prophesying eternal hellfire for them, are just as much a part of the Gospel as his kindness which, intriguingly, consistently destroys all divisive partisanship. If I were mistrustful, I would think the Christians offered their love in this world as a consolation for the fact that only they can hope for mercy in the next. But I am not mistrustful any more; I am thankful every time I experience a love that makes no distinctions.

The love that Father Paolo taught the eight monks and four nuns of his community goes beyond the universal to return to the particular, to a very particular love: the monastery Mar Musa stands out by its love for Islam. That sounds mad, paradoxical, but that is exactly how Father Paolo sees the duty that was revealed to him in prayer almost forty years ago. Born in Rome, he entered the Jesuit order at twenty, and during his spiritual exercises he saw the word 'Islam' written

on the horizon. He was surprised; he had no clear notion of Islam and didn't know what the vision meant. But the Superior General of the order, after talking with the young Jesuit, sent him to Beirut to learn Arabic and study the Quran. Paolo Dall'Oglio joined the Near East Jesuit Province and wrote his doctoral thesis on hope in Islam.

In the early 1980s, Father Paolo heard of a ruined monastery in the Syrian desert and went there to perform his exercises, in summer, for ten days. In prayer and meditation, he felt that that was where his purpose lay, among those ruins. Back in the city, he motivated other Christians to go with him to rebuild the monastery and fill it with new life. A community came into being, first of monks, later of nuns as well; their friendship with the inhabitants of the surrounding villages grew; Christian–Muslim seminars took place regularly as young Christians from all parts of the world and more numerous Syrian Muslims answered the invitation to share for a time the monastic life, and especially the silence of the cloister, with the nuns and monks; first a small guest house was built, then a bigger one, because the numbers of visitors increased, eventually reaching fifty thousand a year. Without watering down the Catholic rituals, Father Paolo gradually wove elements of Muslim and especially Sufi practice into the day-to-day religious life of the community, such as *dhikr*, the melodic repetition of epithets and devotional formulas. He often referred in the catechism to the quranic perspective, and during Ramadan the members of the order fasted, as if it was perfectly natural, along with the Muslims of the neighbouring villages. Thus Mar Musa became a place not just of dialogue but of shared life and prayer between the religions: a place filled with the 'love of Islam and faith in Jesus', as Father Paolo titled one of his books.

Leaving the motor running, the driver opens the gate and waves first to the figures on the slope before he honks

the horn to announce us. The figures wave back and begin descending the mountainside. My first thought is that they could be tricking us, but now the nuns seem to be relaxing minute by minute, letting go the fear of being robbed, kidnapped or killed. And, as it happens, they are hunters, I reassure myself too when I finally see the figures closer up, Bedouins, apparently, with black-and-white cloths around their heads, their faces unshaven, tanned like leather, and very friendly. The nuns invite them to come along into the monastery to drink tea, have something to eat, and join them in prayers if they wish.

In a ghostly silence broken not even by birds, we climb the path to the monastery. When we get to the top, the scene is almost as still: although no one is there whom I could disturb – the guest wing, the meeting room and most of the cells are empty – I lower my voice, greeting the monks almost in a whisper. Nature is so close all around that I seem to be instinctively afraid of disturbing God. Then I step onto the terrace and find craggy mountains falling steeply away like cliffs to my left and right, the shimmering brownish sea of the desert below me, the shining dark blue sky above, the warmth of the westering sun on my neck. I feel as if I am standing in the middle of the Bible, in three dimensions, more exalted and sublime than even the greatest artist could have painted it or Hollywood produced it. If a group of people were to appear on the horizon, I would assume at a glance they were the people of Israel being cast out or called back by God.

I take off my shoes and step, alone, through a low doorway into the chapel, which was carved into the rock or built in a cave around the year 600. The room, illuminated by tiny openings in the ceiling and otherwise equipped only with candles, its floor covered with Oriental carpets, looks at first like a mosque, and yet it is early Christian, as the nun reminds me – in the seventh century, after all, churches had no pews,

Paolo Dall'Oglio, still image from a television interview,
Raqqa, Syria, 28 July 2013.

and the lines of sacred architecture were round. The walls are completely covered with enchantingly beautiful, carefully restored and thus vibrantly coloured frescoes – all the walls except one, which has no pictures at all. It bears an inscription in Arabic script, *bismi llāhi r-raḥmāni r-raḥīm*, the first words of the Quran: in the name of God, the All-merciful, the Compassionate. Muslim pilgrims can pray here facing exactly towards Mecca.

JULY 2013

Father Paolo is visibly emotional. It is the evening of 28 July 2013, 10:34 p.m., as a timestamp on the video betrays, in the Syrian city of Raqqa, which is ruled by rebels. In the background we see a crowd and Syrian flags; we hear a speaker and slogans chanted in chorus, accompanied by cheers, clapping, car horns. In the foreground, Father Paolo, talking to the camera in a loud voice so that his viewers can understand him over the din, begins with the Islamic greeting and appeals, in perfect Arabic, to the unity of the opposition, and of all Syrians for that matter. This unity must not disregard the differences between the different ethnic groups and religions, he suggests by a pun: *Raqqa qimmati r-riqqa* – Raqqa is the pinnacle of *riqqa*, gentleness. God willing, he says, the creation of a new and, at last, a free Syria shall begin here in gentle Raqqa, a Syria in which all people can live together in peace, regardless of their cultural and religious differences. At the last words, he brings his arms to his chest and then throws them up as if carried away by the general excitement. Hands reach into the frame from the left and right and pound on his shoulders; we hear clapping and cheering. Father Paolo looks around, smiling, before the video cuts off, the YouTube video I replay again and again because it is his last sign of life.

Father Paolo embodied the utopia that Syria could be and, in some places, at some times, actually was. There is probably no Christian in the world who has done more in support of Muslims, who has met them with greater loyalty, deeper understanding, and a more detailed knowledge of the Quran. He conceived the imitation of Jesus to mean devoting his life to Islam, a vocation he saw written on the horizon forty years ago. I could not name a Muslim who can champion the message of the Quran more persuasively and credibly than he. When the revolution broke out in Syria, Father Paolo opposed the church hierarchies, opposed the majority of Christians in the country who at best derided and mostly despised his sympathy for Islam, and declared his solidarity with the majority of the people who were being oppressed, tortured and massacred for aspiring to freedom. Father Paolo loved not only his neighbour but also those whom his neighbours considered strangers, contrary believers, at least members of a different community, and who are considered as enemies today. By kidnapping him of all people, these Muslims are giving Christians every reason – more, they are practically forcing Christians – to fear Islam as their enemy.

And yet Father Paolo himself prophesied this development. Again and again, he called on the world community in letters and articles, and, after his exile, from lecterns and before parliaments, to protect the peaceful demonstrators and especially the Sunni residential areas where the regime was sending murdering Alawite militias. For the regime systematically fomented sectarian hatred, which allowed it to pose as the only conceivable force of order. 'Assad's ethical code is simply this: either he stays in power, or the country will be destroyed,' said Father Paolo after the outbreak of the revolution, and called on the United Nations to send observers, not just a few hundred, but fifty thousand, spread all over the country, to put an end, finally, to the massacres. Otherwise,

the peaceful rebellion for democracy would transform into a religious war, and the extremism would continue to escalate until it destroyed the cultural diversity that has evolved in Syria. He considered the Syrian churches' tacit or explicit pact with the dictatorship to be not only morally unconscionable but suicidal.

Father Paolo affirmed the people's right to defend themselves, by force of arms if necessary, and watched as the Free Syrian Army fought with captured machine guns and homemade catapults, while the Islamists, many of them foreigners, obtained money and the latest weapons systems from the Gulf states – in other words, from the West's allies. In 2011, he summed up bitterly:

> Once the Islamist danger in Syria had been defined by the regime and its supporters, the international community felt legitimized to maintain a wait-and-see attitude: since there will be no democracy in Syria, there is no reason to work for the democracy of Syrians. We are faced with a paradox; this attitude has created the conditions for the spreading of radical Islamism.

As right as he was in his warnings and his appeals, Father Paolo is now proof of the intransigence of those who cared nothing for Syrians' freedom and set no hope at all in Islam.

Father Paolo felt uneasy when he went to Raqqa. Friends with whom he had always stayed in the city, Muslim friends, had asked him to try to help two relatives who had been kidnapped by the 'Islamic State in Iraq and Syria'. Father Paolo had been successful once before in negotiating with jihadists, but that was at a time when the kidnappings were still countable. In the meantime, ISIS had taken 1,500 people captive in Raqqa alone – and not soldiers or government officials, but secular political dissidents, members of the Free Army,

Christian bishops, moderate Islamists. Even today, ISIS rarely attacks government troops, preferring to take control by violence in those areas that have already been conquered by other rebels. And, conversely, the government troops practically never attack ISIS positions, such as its headquarters in the centre of Raqqa, which every inhabitant knows. Instead, the bombs land in the residential districts. 'Without oversimplifying matters,' Father Paolo said in the same interview, 'I would say that the activities of Islamic extremism were, from the very beginning, part of the state's hypothesis that the uprising was simply terrorism funded by foreigners.'

Father Paolo told his friends he would come to Raqqa if ISIS would agree to negotiate with him. He knew that the word of the jihadists could not be trusted, that they claimed theological justification for lies, deception and treachery if it served their holy war. On Saturday, 27 July 2013, he sent an email from Raqqa to Sulaymaniyah, where the foreign members of his community had taken refuge after their expulsion from Syria, saying he was all right and would be meeting the delegation from ISIS the next day. And in fact he seems to have met with the jihadists: immediately after the video was made, in the same night, Father Paolo was kidnapped. He had reached the pinnacle of gentleness.

DECEMBER 2013

He knew the danger, says Sister Carol, who had reassured me at the gates of Mar Musa that the armed figures could be merely hunters. He was perfectly aware that he was risking his life. But, to a man like him, his life was already in God's hands – *is*, Sister Carol corrects herself, because she cannot believe Father Paolo is dead, his life *is* in God's hands. I am meeting with her in Rome at the Catholic Gregorian University, where

we have pulled two chairs up to a long, old-fashioned wood table in one of the upper corridors. It is Advent; every hour a different ensemble plays festive melodies in the entrance hall, sometimes classical, sometimes jazz. Young clerics, novices, nuns, students go by constantly behind our backs, laden with books and rucksacks, all busy, knowing nothing of the world we are in at the moment. For my part, I forget while talking with Sister Carol the peace in which everyone around us is living.

In Sulaymaniyah, Sister Carol once went to church alone and found Father Paolo deep in prayer. That was shortly before his trip to Raqqa, while he was waiting to hear whether the jihadists would accept him as a negotiator. She had a feeling something was going to happen. But, when he had finished his prayers, he smiled at her encouragingly. He seemed to be already on his way to Raqqa.

I shouldn't imagine Father Paolo as a purely spiritual, completely detached ascetic, Sister Carol adds, he was – no, he is a man who loves with his whole heart, so he is devoted to people and to the world. It was incredible how he could listen, and it was always amazing to find that he heard more than you thought you said.

I ask her how else she would characterize Father Paolo.

'He had hope,' Sister Carol answers without hesitation.

'Hence his dissertation topic?'

'Yes, we talked about that before his trip to Raqqa. He said if we, Christians and Muslims, did not share a common theological hope, our dialogue would be meaningless. That was why he made the 18th Surah, which is about resurrection and is recited in the mosques every Friday, the core of his dissertation. In every person he met, he was interested in their potential – the hope that each person is.'

There was a boy from the area around the monastery, quite an unruly rascal, who boasted of his stealing. Father

Paolo befriended the boy, cared for him at the monastery, and gradually became so fond of him that he was practically an adoptive son. After a while the boy began stealing again, inside the monastery too. Anyone else would have given up on him, been insulted by his betrayal. But Father Paolo still believed in the boy and continued to take care of him. 'He saw people not just as they behave in this world; he saw them as they stand before God.'

Thus Father Paolo had seen Carol as his sister before she became one: she is Lebanese, grew up during the civil war among all the prejudices that Christians and Muslims harbour against one another. Before the warring parties finally laid down their arms, Carol decided to emigrate to Europe. Whatever the peace would look like, she thought, it was clear that the Christians in Lebanon would not be able to maintain their dominant position. Politically, that was understandable, but, for herself, she did not want to live as a Christian among a Muslim majority. After studying in Germany, she decided to dedicate her life to Jesus. In preparation for her vows, she sat alone in the chapel, writing down her vows of poverty, chastity and obedience. Without her noticing it, her hand wrote a fourth vow. When she looked at the paper, she read: 'Lord Jesus, I offer You my life and my death for the salvation of my Muslim brothers and sisters.'

'That was a shock,' says Sister Carol. 'I couldn't understand that at all: me, of all people.'

At the time, she reassured herself that her obligation was to love Muslims, not Islam itself. That at least seemed plausible to her as a Christian. Later she came across the work of Father Paolo and decided to go to Mar Musa. After the evening Mass, she asked Father Paolo for an inscription. 'For Carol,' he wrote for the stranger in his book, 'Love, friendship and the common path in Jesus that will lead you to a passion for Islam and to firmer faith in Jesus, the Redeemer

of all people.' That was not the love for Muslims with which Sister Carol had reassured herself: Father Paolo had prophesied for her a passion for Islam.

'At first I thought my vocation lay in forming a bridge between Christianity and Islam. But, in the meantime, Islam has become my own body – the body of the Christian that I still am. Islam is brother and sister to me, friend and husband, father and son. I feel myself completely at one with its destiny.'

'But it never occurred to you to convert?'

'No, never. Perhaps I am something you don't yet find very often.'

Her identification with Islam seemed extreme even to some members of the community at Mar Musa – and more so to ordinary Christians. But those who had known her earlier, and kept an eye on her path over the years, never expressed any doubt that her vocation came from God.

I ask whether war, extremism and now the abduction of Father Paolo haven't challenged her love of Islam.

'The love is unbroken,' Sister Carol replies, 'only of course now I suffer from the situation, as all believing Muslims do too, especially from the internecine struggle between Sunnis and Shiites. And at the same time I am worried about my fellow Christians, for whom the war is spelling disaster, possibly a complete exodus, as there has been in the Arab regions of Iraq.'

Sometimes she feels at odds with God when she sees all the suffering that has been visited on the Syrian people, but she prods herself each time to accept reality, including the outward disruption of her own community: only six monks and nuns, divided between two abbeys in Syria, the foreign brothers and sisters in Sulaymaniyah, Father Paolo kidnapped, she and another sister in Rome. And yet she feels the community more strongly united than ever and tries to think

of the Church in Jerusalem, which also had to scatter in all directions. So many blessings grew out of that dispersal, and that makes her hope, as after all Father Paolo too has always hoped. She uses the time in exile to study Islam academically, and the Chaldean patriarch in Sulaymaniyah has directed the members of her order to teach the Christian refugees to live with Muslims again as brothers and sisters in spite of the bitterness, the expulsion and so many harrowing experiences. The community in Syria shelters people fleeing from the surrounding cities, which were first terrorized by jihadists and then reconquered by the state, with 335 dead at last count in Nebek alone, 17 kilometres from Mar Musa. Only two of the dead are Christians, Sister Carol adds, and can hardly fathom how often her fellow Christians in the West refer only to the Christian victims.

'I've learned from Christianity that one must never count the dead on one side only,' I comment.

Her insistence that Father Paolo is alive is more than just a feeling. ISIS seems not to want to kill at least the well-known prisoners and hasn't issued any ultimatums, hasn't demanded any ransom, hasn't offered them in exchange. Apparently they see the captives as a shield to deter other rebel groups from attacking. Besides, there are communications from captives released by ISIS: on 30 November there was a message on Facebook from an activist from Raqqa saying Father Paolo had been seen in the jihadists' prison and was in good health.

Sister Carol's phone rings. Now, after we have been talking the whole time in German, I hear the soft, deep Arabic of the Levant in the corridor of the Gregorian University, and rather loud at that, because there is another ensemble playing Christmas songs downstairs. 'Father Paolo is an Arab too in his heart,' Sister Carol says almost proudly after ringing off.

SEPTEMBER 2014

We are standing on the roof of the Monastery of the Virgin Mary: Sister Friederike, who was also in the car at Mar Musa two years ago, Father Jens Petzold, who leads the community of Mar Musa in exile here in the historic centre of Sulaymaniyah, and I – whether by coincidence or not, all three of us members of the same generation of West Germans, politically socialized in the German peace and ecology movement of the early 1980s. A few weeks ago, the 'Islamic State', as the jihadists now call themselves, conquered half of Iraq. Millions fled, the Christians and Yazidis mostly to the Kurdish part of Iraq, almost all the Shiites to the south. The Monastery of the Virgin and the surrounding residential buildings are also packed with refugees; there are so many of them that half the nave of the church has been curtained off to house a few more families. It is evening, fairly late now. A moment ago everyone was crowded together in the yard for dinner, then those whose turn it was cleared away the things and did the washing up. At first the machos struggled with the idea of participating in housework, Sister Friederike chuckles – the movement of her generation was not only for peace and ecology but also for emancipation – but now they do the washing up without grumbling. It was almost like a holiday picnic: so exuberant, lively conversations at all the tables, the clatter of the big pots in the kitchen, the shrill cries of those whose turn it was to serve – Who wants some more? – and the children romping between the chairs. Everyone here knows that they've been comparatively lucky in this disaster: a roof over their heads, a mattress for everyone, enough to eat, medical attention, the church administration behind it and, in the monks and nuns from Mar Musa, very down-to-earth, energetic hosts who were like siblings to them from the first day.

After the washing up, as every evening, they set up a video

projector, a laptop, loudspeakers and a screen in the yard. But the film that's being shown today doesn't quite seem to grab people: it's a Lebanese comedy about a Muslim–Christian village in which the women band together and come up with a thousand tricks to keep their men from fighting over religion, fairly well done and funny enough that I had to snicker now and then myself. But naturally Hollywood movies are more popular, and their subject matter is innocuous. Muslim–Christian relations are not exactly a hot topic among Christians who just had to flee headlong from Muslims. It wasn't *the* Muslims, says Father Jens, and the refugees affirmed the same thing when I talked with them at dinner: they were outsiders, with many foreigners among them – North Africans, Syrians, Chechens, Europeans too, and even Chinese. But it was in the name of Islam that they robbed, expelled and killed. And only very few of the Muslim or, to be more precise, Sunni neighbours with whom they had lived together so well up to now had stood by the Christians. More had unashamedly helped themselves.

Now Father Jens, Sister Friederike and I looked down from the roof of the church into the courtyard where the refugees were not interested in the film. They preferred to talk, with their backs to the screen, or keep a benign eye on the children who were tiring themselves out playing. The sound is still turned up loud, so the Arab film voices rise to the star-filled sky, the stupid men's voices and the wily, conciliatory voices of the women.

'And what do they think about the Muslims now?' I ask, although I know the answer.

'They think that's just the way the Muslims are,' Father Jens replies. Of course he exhorts them in sermons and conversations to seek understanding, talks about the reasons for the violence, and reminds them of the peaceful coexistence between religions in Iraq. But it is not only the refugees'

fresh and very traumatic experience that argues against him, he says; the preachers the refugees hear on the radio, regular hate-mongers, Father Jens says firmly, also argue against him.

Father Jens, having had little chats with everyone in the courtyard, is exhausted. Like Sister Friederike and all the other brothers and sisters, he decided to join the community of Mar Musa because he sought the seclusion of the monastic life, in harmony with nature, and of course the nearness to Islam. But now he has landed in a city centre and finds himself the warden of a shelter for several hundred Christians, most of whom he likes, and who are unstinting in their gratitude, but who are also foreign to him – the Assyrian Christians of Iraq have always been conservative and withdrawn with regard to the members of other churches – and have no sympathy for his concerns. The northern Iraqi dioceses have instructed the parishes to receive only Christian refugees. I can understand that to a certain extent. It's a fact that capacities are limited, the parishes already overburdened with the hundreds of thousands of Christian refugees; but because I see every day now what distress the Yazidis for example are in, very few of whom have found a roof over their heads – and soon it will be autumn, and with the autumn will come bitter cold in Kurdistan – because I have come through many Kurdish villages where the people, in spite of their own poverty, are sheltering refugees regardless of religion in their simple houses or their village schools, I am saddened by the distinction that apparently has to be drawn.

'Well, now would be much too soon to seek encounters with Muslims anyway,' says Father Jens, who misses the spirit of Mar Musa so much more than I. His interest in Islam was not a charitable act, much less an instructive one, he said; to him it was a gift, an enrichment of his own life and faith.

And Father Paolo?

There has been neither any new sign of life nor any indica-
tion of his death. Many of the refugees, who have only been
here a few days, at most four weeks, don't even know his
name.

Among Father Paolo's writings, I would like to call attention
to a lecture he gave during peacetime to his own original
community, the Italian Jesuits. In it he defends something
that all of us who suppose ourselves to be mediating between
religions customarily reject: syncretism. Aren't religions, all
religions, in their origins and their essence deeply syncretic,
Father Paolo asks his fellow Jesuits. 'Where has there ever
been a completely original culture, not fermented, tor-
mented, goaded, grafted and fertilized by external elements?'
Of course there are forms of syncretism that we meet with
scepticism for good reasons, because they amount to false
equivalences, arbitrariness, interchangeability, the superficial
adoption of dominant cultures, and bad taste. But many of the
reactions to such ramifications of a shallow cultural globaliza-
tion are no less questionable, including the frantic struggle
for purity, originality, distinction, unequivocal identity.

Catholicism owes its strength and continuity to its consen-
sus in seeing others as brothers in Christ, not in spite of, but
through their cultural, ethnic and spiritual difference; this
diversity and universality is what makes the Church a united,
living, mystical and historic community. Ignatian spirituality
in particular, which has its focus in the often unpredictable
dynamics of the Exercises, and hence in the mystical rela-
tionship to Jesus, is founded on mutability, on a constantly
renewed and continuously changing experience of the divine
incarnation. And then Father Paolo quotes an Arabic proverb

to his Jesuit brothers – *Laysa ḥarāman illā l-ḥarām* – nothing is prohibited except what is sinful.

'What we are doing is nothing less than a radical inculturation of the Christian faith in a Muslim context,' Father Paolo explained:

> And by radical I mean something that goes beyond the folklore of vestments, rugs on the floor and bare feet in church and the fluent use of Muslim religious language. What we are doing is placing ourselves in the axis of the destiny of those we love. What we are doing is becoming a seed cast upon the earth so that it might bring forth fruit, becoming yeast to leaven the dough for the nourishment of many. We are trying to wed Islam with Jesus of Nazareth living in the Church, amid the dramatic, contradictory and pain-filled Muslim world of today. We are striving to renew the blessings that Abraham received for his son Ishmael, blessings that were asked anew, announced anew and realized anew in Muhammad, the Arab prophet, the descendant of Ishmael.

How, his Christian brothers would certainly ask, should they deal with Islam's strict rejection of the Trinity, the Incarnation, the Cross – and with the contemporary reduction of the quranic teaching in many Islamic institutions to legal regulations, with the sometimes polemical, aggressive or indignant attitudes of those who speak for Islam? Not with rational arguments, or not only, Father Paolo answers. The response must be love, Christian love, as Father Paolo calls it in this passage. 'The Christian heart has arguments not known to human logic, and presages changes unforeseen by the historians and exegetes.' The rise of Islam, which has shocked the Church for fourteen centuries and raised a number of existential questions about divine providence in human history, cannot be interpreted simplistically on the

basis of mutual exclusion but only on the basis of love, which alone can overcome contradictions, not by suppression but by friendship and gradual transformation.

> What shall we make, for example, of the Muslim rejection of the Cross? A sterile polemic? Or an opportunity to read the Quran ourselves and interpret it, with exegetic justification, in the light of testimony and martyrdom? For a faith in which precisely this mystery is central, it seems appropriate to recognize Ishmael's rejection as analogous in a way with Israel's rejection.

It is a fact, Father Paolo continued, that many, remarkably many Muslims felt at home in the Christian community of Mar Musa. Their sympathy and openness was possible not because the monks and nuns mimicked Islam, denied their own convictions, or were in conflict with Christian faith – the Catholic doctrine they upheld was orthodox in the best sense of the word, complete and wholehearted – no, the Muslims felt at home in the monastery because it was culturally, linguistically and symbolically integrated in their world, the Islamic world. The desire of the nuns and monks of Mar Musa was to participate in that world and to love it, beginning with Muhammad himself, peace and salvation be upon him and his community.

'Do I see myself as a Muslim?' Father Paolo asks towards the end of his lecture, which the Jesuits have translated into English and placed online. 'I think so, by evangelical grace and obedience. I am a Muslim because of Jesus' love for Muslims and for Islam. I can only be Muslim according to the spirit, and not according to the letter.' Even now he sees, he wrote, the mystery of the living God with Mary His mother at work in the religious world of Islam. He sees that many Muslims accept him, Father Paolo, for what he is, a monk, a

disciple of Jesus, who is in love with Islam. Not that it is easy for Muslims to understand his faith in God incarnate. But they perceive their encounter with the community of Mar Musa as an annunciation of the final harmony in God. 'We do not feel as if we have lost Christ. We have the impression rather that we have lost ourselves for Him and in Him.'

MAY 2015

He taught us hope, both in this world and for the next.

III

INVOCATION

Vocation

It could be anyone, any of the four men sitting around the little table, or the boy. It could be now, as Caravaggio teaches us by dressing the biblical crew, as today's auteur theatre directors would, in contemporary costumes, contemporary to Caravaggio that is, the Apostle in frills. Levi, as Matthew is still called in the Gospels of Luke and Mark, is so deep in concentration on counting the taxes he has collected today that he has not yet noticed the stranger pointing at him, or else he has noticed and is not looking up because he refuses to believe it. Or is a different one Levi? In four hundred years the viewers have not been able to agree even on that, sometimes identifying the bearded man as the future Apostle, sometimes the one counting the money, seeing the three index fingers as pointing sometimes at the one, sometimes at the other. Apparently it's a matter for each observer to decide, and I should therefore ask myself why, from the first glance, I saw the one who is paying the least attention to the Saviour as the one chosen. Jesus' companion Peter, in any case, seems to be reassuring the other tax collectors that he doesn't mean them; they can go on collecting taxes, day in and day out, feeding their families by preying on other families, leading ordinary human lives. Only to Levi Jesus says, 'Follow me!' Not a word more does the Bible tell us

Overleaf: Caravaggio (1573–1610), *The Calling of St Matthew*, 1600, oil on canvas, 322 × 344 cm. Contarelli Chapel, San Luigi dei Francesi, Rome.

197

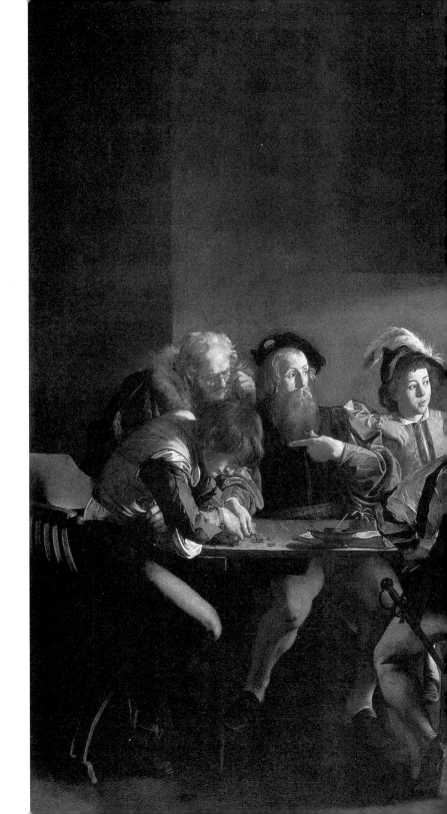

about the vocation of Matthew: no reason, no explanation, and least of all any preaching or proselytizing, only: 'Follow me!' And Matthew arose and followed him. In the Bible, the break with everything that had made up Levi's life up to that second is so abrupt and total that it can be understood – if not trivialized as hypnotism or clouded by the word charisma – only as a miracle. But Caravaggio is not interested in the miracle itself, because it cannot be represented, or if it can, it suddenly looks comical or in any case unnatural, as it did the one time he himself painted it, in the picture of doubting Thomas sticking his finger in Jesus' side as if it was full of air. Caravaggio is interested only in people. Of all painters he has the keenest eye for what the appearance of the Celestial means to terrestrials: it blows them apart. Caravaggio's pictures show, not revelation, but many variations on the torment of those to whom it is revealed; anyone who has once lost himself in his paintings would not call it 'glad tidings'. 'If you knew what I know, you would laugh little and weep much,' says the Islamic Prophet, who foamed at the mouth and thrashed about him in pain when the angel appeared to him, so that many thought he was possessed, epileptic or mentally ill. 'Is not my word like as a fire? saith the Lord; and like a hammer that breaketh the rock in pieces?' says the prophet Jeremiah (23: 29).

In *The Calling of St Matthew*, Caravaggio captures, just once, the moment immediately before the calling, not the fact of being called. The picture itself offers no clue as to what is about to happen – which is what defines the situation. Of the five people sitting or standing around the table, Levi is the last one you would imagine, if you didn't know, as the man walking off after the stranger, his eyes glassy and his mouth hanging open like a sleepwalker's. Or, because the man counting money at the left is not necessarily Levi, perhaps we should say rather that you can't imagine it of any of them. That would mean that any person could be chosen. 'Really,

him?' asks the bearded man, while his bespectacled neighbour finds the coins more interesting. Or else, as other viewers have thought, the bearded man is saying, 'Really, me?' The man in the foreground with the feather in his hat seems to understand nothing at all. He looks at Jesus only because the boy is kicking his shin under the table: 'Yeah, what about it?'

If you only look at the four men and the boy, covering up Jesus and Peter with a sheet of paper if you like, you can imagine all kinds of things drawing their attention – a fight at the next table, the innkeeper collecting a tab, or a superior calling them to duty – but not the Redeemer in Person approaching. Their amazement is not great enough for that; it's really just a sitting up and taking notice, a 'What do you want?' That would mean the miracle is not the appearance of the Saviour; the miracle is that someone notices it – and, if I am not mistaken, it is the one who pays the Saviour no attention at all. The men will be stunned only when their colleague, from the next moment to the moment after that, abandons his family, his profession and his view of the world.

That is Caravaggio's calculation in using contemporary clothes and the ambiguous direction of the pointing finger; that is his agenda in conceiving *The Calling of St Matthew* as one painting in a cycle that decorates a side chapel of the church of San Luigi dei Francesi in Rome. As if in warning, *The Martyrdom* on the opposite wall portrays where the calling leads. The cycle originally consisted of just these two paintings, which sufficed to state the essentials of the saint's life: random choice and sacrifice. The finger could point at anyone, any time. The door behind me could open and the person standing there could blow my life apart – the motif that German Romanticism loved: I had just left the house, not a thing on my mind, when suddenly ... except that most of us are the others, the three other men and the boy, who watch the miracle happening and don't see it.

Prayer

As a child I thought Christians, all Christians, prayed with their hands folded and their heads bowed, and it always bothered me. The posture for prayer seemed to me to be an advantage of Islam – I can't say a decisive one, but one that is intuitively clear, indeed physically obvious to me: upright, the chest expanded, the forearms raised and spread, the palms open towards Heaven, looking forwards: you can't cast yourself down unless you're standing up. I remember as a child trying out both the Christian and the Islamic prayer posture, often in rapid succession, my head going up and down as if on a string, my hands alternately folded before my stomach and opened upwards with my forearms extended, and I was always relieved to be a supporter of the better club, so to speak, or driving the more desirable car. Christian prayer, I thought as a child, is not even good for the body, with the shoulders mechanically pulled up, which gives you a stiff neck with time – and, after all, human beings are not so unworthy that they might address God only in the attitude of penitence (all right, I don't know whether I used arguments of existential theology at the age of nine, but I really did practise Christianity and Islam as gymnastics).

Later I saw Christians praying in all kinds of positions, the brothers and sisters in Rome with their torso upright and their chests expanded, their forearms raised and spread, their palms open towards Heaven, looking confidently forwards, and I

realized that the difference between the two religions cannot be connected to a gymnastic exercise. And yet, of course, the folded hands and the bowed head still characterized Christian prayer. Most Christians prayed like that, at least in the Western world, whether in church or in private devotions, whether in my surroundings or in films. You only have to do a Google image search for the keywords 'Christian' and 'prayer' to see batteries of folded hands and bowed heads. It did not strike me as a contradiction that the most famous representation of a Christian praying, Albrecht Dürer's *Study of an Apostle's Hands*, shows a different position, with the hands placed together in their full length, but it doesn't appear as a contradiction in Google's image search either. Most likely I intuitively imagined the head that isn't shown in the Dürer drawing as bowed, so the stiff neck remained an inherent danger of Christianity.

I don't know how many dozens or hundreds of works of medieval and early modern art by Christians I had looked at inattentively, or at least without paying attention to the attitude of prayer, before I stood in front of Hans Memling's little *Portrait of a Young Man Praying* in Madrid. Like Dürer's Apostle, the young man holds his hands together in front of his chest with fingers outstretched, pointing diagonally upwards, yet he is not at all bowed, has not bent his neck or even tipped his head; back straight, eyes opened wide, looking straight ahead: there can be no humility without dignity.

The word 'pray' in its oldest sense means to ask, to beseech; thus prayer is associated with an appeal, a plea. That is not the case in Arabic, nor in Persian: informal, personal prayer, *du'ā*, means literally 'call', not 'plea'; furthermore, that 'call', which has the lexical connotation, through the root *d–'–ā*, of 'summons', 'invitation', suggesting a gesture of taking notice, of attention. The young man does not seem to be asking for anything, much less pleading; his lips are not moving and he

doesn't look as though he were speaking silently to himself. He seems rather to be savouring the moment – not so much the spatial present, in spite of his open eyes, as the simple fact of existence, here and now, just so; not just with his senses but also with his heart; he is wide awake to both external and internal circumstances; he is neither absent nor lost in contemplation. Yes, he can see the world, but he sees it as a sign. He is the perceiver, that is the important thing: it is not he who is speaking to God; the world, or God, is speaking to him. That is also what distinguishes this picture from Dürer's hands, whose leanness and welts of poverty and age indicate need, and so suggest prayer once more as supplication, pleading. Nothing identifies Memling's young man as needy: the sumptuous gold stitching, outstandingly painted incidentally, as you can see only when you look at the painting close up, the gold cords and the black fur cloak with its arm slits, as well as the Oriental rug on the balustrade and his hair style – all indicate material wealth; the skin of his hands and face looks healthy and well nourished; his gaze is serene, peaceful, guileless. The need that is indicated by the fact that he nonetheless puts his hands together in silence for a few seconds or minutes is that of the human condition, the knowledge of a connection to something transcendental or, to put it more precisely, the connection of a part with the whole. Of a drop with the ocean, as the mystics prefer to say.

As I sit now at my desk in Cologne, a book of portraits by Hans Memling before me that I ordered from my hotel in Madrid, opened at the *Portrait of a Young Man Praying*, I put my palms together with the fingers outstretched and immediately remember – as I have known from travels in Asia but also, I admit, from the pilates classes I attend regularly because my spine is no longer quite straight – I remember that the young man's prayer posture generates a kind of energy in the body, at least a pleasant tension in the torso that makes you alert and

Hans Memling (*c.* 1435–1494), *Portrait of a Young Man Praying*, *c.* 1485/94, oil on wood panel, 29.2 × 22.5 cm. Museo Thyssen-Bornemisza, Madrid.

aware, especially when your palms have met in front of your forehead and sunk down, pressed together, as low as it is still comfortable in front of your chest. Of course I don't mean to claim that the young man is practising yoga, much less pilates; I mean to say only that his prayer posture, even if he simply put his palms together in front of his chest, is evidently based on a deep, probably pre-Christian knowledge of the energy channels and the tension control points in the human body which, while it is different of course, makes just as much sense to me gymnastically as outstretched forearms with the palms open upwards. Why did the Christians ever start praying with their fingers folded and their torsos bowed?

Because the Google image search is weighted towards the present, gathering a tedious number of snapshots and press photos, I slip 'The Biggest Art Collection You Can Buy!' into the computer, the DVD I salvaged – I'll gladly repeat it, I'm so delighted with the bargain I found – for just €9.99 in the clearance sale of a bankrupt bookshop in Cologne's Ehrenstrasse. Searching for the keywords 'pray', 'prays', 'praying' and 'prayer', I reach the conclusion, scientifically still very tentative I admit, that the transition from parallel to interlocked fingers must have taken place in the sixteenth and seventeenth centuries, because both Titian and Rembrandt painted both prayer positions. Not until the eighteenth century – and, because the DVD stops where modern art begins, I can offer as evidence only a painting by one Giovanni Battista Piazzetta, *St Ursula Praying*, and a drawing by a Julius Schnorr von Carolsfeld, *Jesus and the Sleeping Disciples on the Mount of Olives* – not until the eighteenth century – that is, in the course of the Enlightenment – did people praying look homogeneously as submissive as in the Google image search. All the other people I find praying, as I browse through the DVD, have their hands together in front of their chests, fingers extended. But Hans Memling himself, who

probably painted more people praying than any other artist, supplies the most impressive evidence: Gilles Joye praying, the master of the Legend of St Ursula praying, Tommaso Portinari praying, Mary Baroncelli praying, Willem Moreel praying, Barbara van Vlaenderberch praying, Jacob Obrecht praying, the *Man Praying Before a Landscape*, Maarten van Nieuwenhove praying, more young men praying and countless donors praying, and all of them hold their hands as I do at the end of my pilates class, although their spines are straight.

Sacrifice

He would have done it. For a long time I located what was monstrous, abhorrent, menacing about faith – about the faith in just one God – in the twenty-second chapter of Genesis, between the second and the third verse. That's right: not in the second verse, not in the third, but in the abyss of heartlessness that gapes between the two. The second verse reads: 'And he said, Take now thy son, thine only son Isaac, whom thou lovest, and get thee into the land of Moriah; and offer him there for a burnt offering upon one of the mountains which I will tell thee of.' The third: 'And Abraham rose up early in the morning, and saddled his ass, and took two of his young men with him, and Isaac his son, and clave the wood for the burnt offering, and rose up, and went unto the place of which God had told him.' And between them: nothing. No hesitation, no question, no sorrow for the son, no pity for his wife, no regard at all for any earthly judgement. He would have done it without batting an eyelid.

What shocked me was not the divine command itself – revelations have a ring of truth that commands surrender to the fatal power that is God. What bothered me was not so much the prophet's obedience – being human, he is of course weaker, unknowing, dependent. But if one thing made religion seem – not just strange – alien to me, it was the elimination of all feeling that occurs between the second and third verses in the twenty-second chapter of Genesis.

Of course, God commands, man obeys. But, between the two, the great, big space of choice opens up which can be surrender only if it is not blind. The aspect of the covenant that the unbelievers and the pious alike have trouble understanding: one who would cast himself down must be standing up, and one who lies prostrate stands up again with increased confidence.

Still more often than the Quran, which is spoken from the mouth of God, the books of the Bible tell of this dialectic, and that man raises his voice to God not only in praise but also in lamentation. It is as happy and as horrible as love – which is what it is. If there was no resistance for man to surrender, he would be no more than a dog – no, a machine, obeying at the push of a button. But the patriarch, from whom the children of Ishmael are also descended, stood in opposition to that kind of faith, my faith. Perhaps I could have accepted unfeeling obedience as an extreme variety of love, as I accept the sadism in the Book of Hosea or the mercilessness of the Apocalypse, if God had not declared Abraham a model for all the faithful. What could love desire less than to cut one's child's throat? Here He pronounced the most absolute lack of feeling to be most pleasing in the sight of God. Only Caravaggio persuaded me to accept the abyss that gapes between the second and the third verse.

His Abraham is an administrator, nothing more, a stubborn caretaker in the house of God, intellectually limited from the start, well-fed, ruddy-faced. He sticks to order – an order which may make sense in day-to-day life, but he sticks to it, point by point, even though extraordinary circumstances have rendered it absurd, patently inhuman. He hears the command to sacrifice Isaac – and without a moment's hesitation he

Overleaf: Caravaggio (1573–1610), *The Sacrifice of Isaac*, 1602/3, oil on canvas, 104 × 85 cm. Galleria degli Uffizi, Florence.

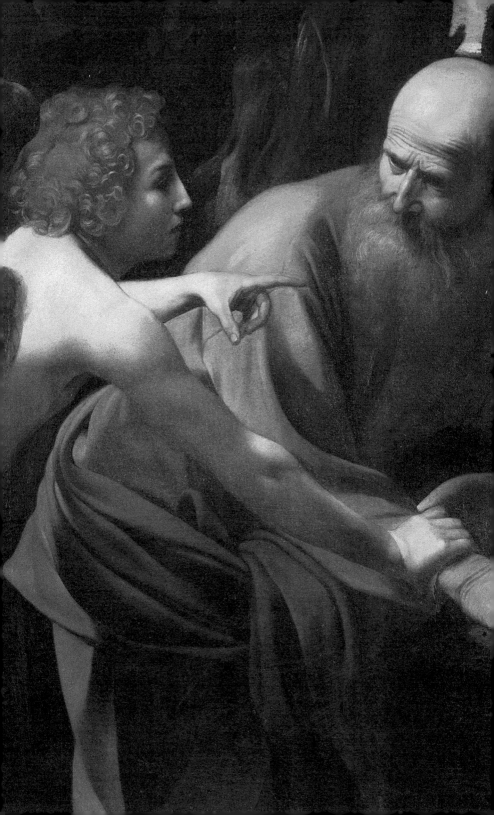

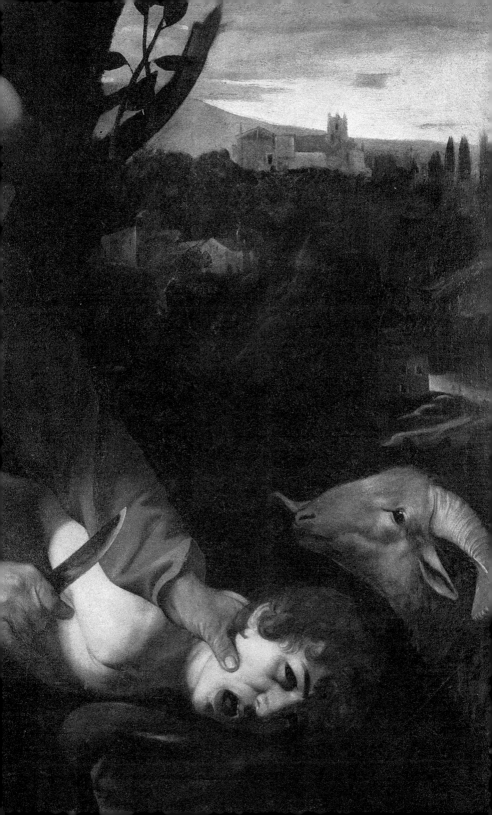

presses the boy's skull down on the rock, his thumbnail neatly trimmed on the thumb digging into the boy's cheek. With the other hand, the right, he holds the handle of the whetted knife, without trembling, at the boy's throat. The angel stopping him at the last minute leaves him nonplussed, almost indignant, looking neither relieved nor glad. No – his brow furrowed, he hesitates; he wants to be sure he has understood the word of mercy correctly, presses his lips together perhaps to suppress a word of protest, a word that didn't occur to him when he received the command to kill. The angel must grasp his forearm tight to stop Abraham from cutting the boy's throat after all; evidently his word alone is not enough. 'Not your son!' he seems to cry, aghast that Abraham really would have carried out the command, and points towards the sheep extending its neck willingly towards the knife. Yes, it was a test, but a test of maturity. God has tested your worthiness to follow Him.

Sufficient evidence for my interpretation is found, I know, neither in the Bible nor in the Quran. I base it on the love that God reveals in those scriptures, and still more clearly in His creation. I base it on my own fatherhood, the image of the divine Fatherhood; on my sonhood, which I experienced as unlimited benevolence. I base it on the darkness that Caravaggio has painted in the face of this father and on the horror in the face of this son. Therefore no matter how many verses the scholars list that praise the patriarch's obedience, directly or indirectly, I will continue to assert that the story recounts the abolition of human sacrifice, which was indispensable for a belief in just one God. The crux of the story is not that he would have done it – but that he must not do it. It is a Christianity of my own, just as, before, I arrived at an Islam of my own. I base it on the son, because he is looking at me.

Church

My thick art guide contains all of eleven lines about the church at the top of the Spanish Steps, the Santissima Trinità dei Monti, six lines of which are about the façade, the steps and the building next door. A buoyant nun, sky-blue habit and dark-blue veil, orthopaedic sandals and red cheeks, French, under thirty, showed us the anamorphic frescoes and, in a long gallery, the reflecting solar clock that tells the time, in Roman, Byzantine and Arabic reckoning, not just in Rome but in Iceland, Paris, Constantinople, Alexandria, Babylon and, at the very edge, Sepahan, the old Persian Isfahan. 'That's where I come from!' I was tempted to cry. It was not a swell of patriotism that surged through me, but the feeling, illusory of course, of having something to say that would please the church, and in particular the souls of its astronomers, who had gone to such effort. I may well have been the first Isfahani to stand under that map of what was once the known world: after all, the gallery is closed to ordinary travellers, and the Trinità dei Monti can't be considered a particularly important sight to see if even my thick art guide can spare only eleven lines for it, including six for the façade, the Spanish Steps and the building next door. I would have been saying, or trying to say, that, after such a long time, an estimated five hundred years, a person was walking through that back – or upper – in any case that remote wing of the convent of Trinità dei Monti who actually cared what time

it was in Isfahan. It would have been a bit of a fib, since I was not born in Isfahan myself, but both my parents were, and harmless fibbing to make someone happy is not just permitted but right.

The picture I liked best was a detail in the monks' refectory, which is the size of a sports hall, with its walls and ceilings completely painted, rather explicitly painted to be frank, late baroque or early rococo, for all I know, since the art guide doesn't even mention it and I found the buoyant nun's talk increasingly difficult to follow because my head hurt from the flu I had brought with me from Cologne, my sinuses blocked, my coat pockets full of snotty tissues, a chronic yawn announcing circulatory problems from being on my feet so long, and so, chronically yawning and snotting up more tissues, in my head the steady pulse against the top of my skull that I know from migraines, I was immune to her raptures over summer idylls, plump angels and joyous feasts. Only one detail captivated me, in the middle of the opposite wall, where it catches the eye: the wine steward in front of the table where Jesus Christ is dining with Mary. The steward's head is turned towards Jesus, but he is turning his torso and the amphora towards the hall where the monks ate, as if offering to serve them the same wine as the Holy Family – as if the monks were five thousand. The illusion is heightened by the steward's left foot, which seems to be stepping out of the picture. A little stair used to lead up to the picture, I heard the gushing nun say, and it looked as if the steward already had his foot on the top step to come down to the monks: 'And they did all eat, and were filled,' as Mark 6: 42 promised.

Perhaps the child in me, or my love of theatre, is the reason why I like little tricks like that. The anamorphic frescoes are more spectacular, but the wine-bearer stepping out of the wall seems to be the only one who has a purpose, who expresses a message, a very Catholic one: 'Brothers, tuck in!'

It is blood of His blood, and not sacredly charged like that next door at Mass, not sacrament, real presence, eating God, but instead both manifest and tongue-in-cheek. In another church to which my Catholic friend took me – I think it was Sant'Ignazio, but once again I find no mention of the important part in the art guide – you look into the nave from the entrance and think you see a huge cupola over the altar. As if coincidentally, there is a model of the church on display that conveys an impression of how colossal the cupola looks from outside. Then you slowly proceed, looking around here and there, until you are standing in the transept, just a few yards from the altar. And you look up: the ceiling is practically flat – just minimally vaulted, the colour dark grey. The cupola is non-existent. There was a model of it; they planned to build it, but then someone realized that it would be taller than that of St Peter's. And besides, the money was running out. So they just pretended the church had a dome. It couldn't have been more beautiful if it had.

The Trinità dei Monti, the buoyant nun admitted, could not claim any architectural peculiarities. The carpet, special as it was, could not be called a treasure since it was machine-woven, like those in the cheap Turkish shops in my neighbourhood in Cologne, and had rather a lot of stains besides. Nonetheless, I would have liked to ask why it was spread before the altar, but the buoyant nun was already presenting more illusions. In a side chapel, the baby Jesus painted on the wall behind the altar is so radiant that, when the priest stands before it during Mass, it looks as though the priest's head is glowing with the divine light. A simple trick, and consequently not a bad one, but one which shouldn't have taken fifteen minutes to explain. Even my Catholic friend whispered, 'Now she's really getting a bit pedantic.' But I wasn't looking at the baby Jesus any more.

One at a time, at long intervals, men and women in

ankle-length white robes, the women with white veils, were coming out of a room at the far right corner of the transept and kneeling on the carpet with their backs to us, the men on the left, the women on the right. They seemed to be mumbling something, and from time to time one or another of them bowed her or his head almost to the floor. Others were swaying with their upper body to the rhythm of the words they were reciting. I could hardly believe it: suddenly the church was a mosque. Of course they weren't Muslims – although Sufis often wear such robes, white and covering the ankles, the women veiled, the sexes separated but side by side, the men on the left, the women on the right – they only looked like Muslims. They were the brothers and sisters of the buoyant nun, who suddenly took leave of us and walked away at a brisk pace. A short time later she came out of the room at the far right corner of the transept, now in a white robe and veil, her face concentrated, remote, and knelt on the carpet to pray, her face to the altar. She was the last.

The four brothers and seven sisters stood up, the oldest two with a groan, which is also something heard at Friday prayers, and began singing in chorus, Italian, French and Latin songs, if my ears did not deceive me – the reverberations blurred the consonants, old songs, that much was clear, their tone sad and humble – not very different from the Sephardic songs we heard as students in Cairo, only these were sung in chorus – heartache of the Mediterranean. No one stood at the altar; all prayed facing the same direction. Long after my friend had gone, my excitement at the illusion of seeing Muslims praying gradually subsided and, in its place, I felt a stronger feeling of gratitude that the Catholic sisters and brothers were sharing their worship service with me. My headache was, well, not gone, that would be fibbing, but receding at least, and I no

A sister of the Community of Jerusalem, Cologne.

longer needed to blow my nose. That was no miracle, I'm not claiming it was, and nonetheless I was glad, I was glad at that moment to be where I was, to hear what I was hearing, to see what I was seeing. 'Labour not for the meat which perisheth, but for that meat which endureth unto everlasting life' (John 6: 27).

If the Prophet says the ways to God are as numerous as the breaths a person draws, and the mystics insist that the languages, customs and traditions by which God is praised are as infinite as God Himself – that is exactly what it was, the impression that the ways, in their diversity, lead to the One. My grandfather, who, as I mentioned, travelled in Europe in 1963, would have immediately found a corner and spread out his own prayer rug. Later he would have had a buoyant talk with the French nun. The seven sisters and four brothers assemble every day, three times, for a total of three hours or more, longer still on Sundays, and take time beforehand to kneel on the beige carpet before they sing together; sometimes at noon a few visitors sit behind them in the pews, praying with them or just watching, almost never in the morning or evening on weekdays; the hours in front of the altar are the rhythm in which their days' work is done – that is what it means concretely, what it can mean, to consecrate one's life.

On seeing them, men on the left, women on the right, I could understand in a way that there is a vow of celibacy, in monasteries I mean, since otherwise the relations between the sexes could be counted on to demolish any order, however sacred; but, at the same time, the obligation to abstinence would deter me from the monastery and for that matter from spending my life in such a quiet, frugal and diligent way as these steadfast nuns and monks, even in a different language, with different customs, in a different religion. So I was not tempted to dedicate my life to God like the seven sisters and

the four brothers, and yet I envied them, who three times every day sing songs that enraptured even an unbeliever like me. And I am not at all sure they would see me as an unbeliever. At certain points in their singing – I could not make out a rule – they all bowed, some only slightly, but others low, resting their hands on their knees. The illusion was perfect. It was no illusion. They are sisters and brothers.

Play

In a glass cylinder such as this, a kind of display case in the round standing on a gold pedestal, I would have liked, when I was a child, to keep a rare find brought home from the forest, a butterfly, a crystal or an especially fine marble; between the ages of about five and six, a football trading card, which would have fit perfectly between the plates of the luna. No sooner do I confess my childhood associations than I notice that the lid looks like a ball cut open – I mean to say, like a football, and the six Apostles have the size and the knee positions of flick-to-kick figures. No, I'm not serious; don't worry, I'll be the first to admit that my comparisons are not excusable even as childish fun. And yet, I can't help it: to me the monstrance made by a master goldsmith in Cologne around the year 1400 for the parish of St Columba is more like a toy than a container – which is what its purpose is – a particularly precious toy of course, one that would be passed down from father to son. The needle-like turrets on the lid, for example, look more purposeless, more purely ornamental, than any child could design for a sand castle, and how much more so the medallions hanging down like gold medals awarded to school champions. And the overall shape is something like that of the humming top that spun all around my nursery.

I am afraid the monstrance spinning through a nursery sounds just as irreverent as the trading card in the luna, which reminds me – oh God, I had better not mention this

association too, but can I help it if the luna has exactly that shape? – which reminds me of the Islamic crescent. What should I do? I really don't believe in the Eucharist, and if there is anything about it I would express without sounding disrespectful, it is awe and, intuitively, approval, affirmation at least, that other people actually see the body of Christ in a disc of bread and taste, bite, swallow, digest and excrete it, and not just symbolically – that would really be mummery, intellectually sanctioning the patently incredible, impossible, by a cheap trick – but with their own eyes, on their own tongues, between their own teeth, through their own throats, in their own stomachs, through their own intestines: the body of a man – a God-man, certainly, but that only makes it all the more implausible to the uninvolved mind – who died two thousand years ago in Jerusalem.

It seems to me that Catholicism lacks, or has repressed, any idea of how absurd everything is to Jews and Muslims, and in large part even to Protestants, that distinguishes it from monotheism. Stop! my Catholic friend would cry, insisting that he most certainly believes in only one God. That is true, I would cry back at him, but, to my mind, which has the same claim to validity, no more and no less, as his, it is true only at its core, in principle, at the source: almost everything that has been laid around the core of the belief in one God, the principles that have been added, even in the first centuries, shows traces, if not explicit signs, of paganism. Now it sounds disparaging again, I am aware, but it is not so intended, or, to put it another way: what I mean is something I would also say of a large part of Islamic practice, especially Iranian popular piety. The veneration of the saints, the cult of the martyrs, the Shiite idea of redemption, the intercessions, the amulets, the ecstatic rituals are not really compatible with a strict monotheism, nor is Satan, as if he were only a symbolic embodiment of Evil; to some Sufis, not even Heaven and Hell

were compatible with God's omnipresence, even though they are so forcefully described in the Quran. Very few people are content to live their lives in accordance with principles that are only abstract – that is, not capable of being experienced with the eyes, tongue, teeth, throat, stomach, intestine; and when they do, the result is often dangerous, as in fundamentalism, which is ostensibly a return to the source, to the core, to the principle, although that implies – to my mind, all right, only to mine – all the more presumption, to the point of self-apotheosis.

Of course, Catholicism is not, or not only, popular piety: it has evolved into a highly sophisticated edifice of faith – and the cornerstone of still more magnificent cultural achievements – with a strict theological hierarchy, reasoned down to fine nuances, not experienced but elaborated and dogmatically fixed. Into a phantasm of faith? Many if not most confessions believe in miracles, but only Catholicism, because it pretends to be so rational, ordered, scientific, evokes in me the wonder and disbelief that Caravaggio painted in Thomas's face. For it has an undeniable attraction, exerts an attraction even on an unbeliever or a believer in a different faith like me, when, so much more ceremoniously, methodically, than in any popular ritual, down to the most inconspicuous movements, over a much longer time, in so many more places by so many more people daily, or weekly, or even only once a year at Christmas Mass, the impossible is pronounced real, as if it were the most natural thing in the world: 'Take, eat: this is my body' (Mark 14: 22). Only the attraction was never exerted on me by the objects, however magnificent, no more than by spaces, enchantingly beautiful churches, glorious altars; I experienced it only in witnessing the actual event, the gravity and

Monstrance, Cologne, *c.* 1400, gilded silver, enamel, quartz, gems, pearls, coins, 88.5 cm high. Kunstmuseum Kolumba, Cologne.

the ceremony, the tension preceding and the peace following it, experienced it as concretely as a breath of wind or a warming ray of sunshine, although I can't believe it. The containers are only containers. And if it is the people who transmute the bread into flesh, the wine into blood, then only they can convince me.

But I always saw the containers too only from a distance; as an unbeliever, or a believer in a different faith, I am grateful just to be allowed to attend a Mass, and I usually sit, to keep a fitting distance from the Communion, in one of the back rows. Only now in the museum, paying attention for once to the utensils, I realize that this monstrance at least, in which the parish of St Columba worshipped the Host from the fifteenth century on, is more than just a container. There is a book by Romano Guardini in which he appreciates the liturgy explicitly as play, comparable to a child's play or an artist's creative work. The act of sacrifice and the spiritual meal could be performed so much faster to accomplish their purpose, so many words could be saved in the consecrations, the sacraments offered in a simple wave of the hand – what is the use of the huge deployment of a High Mass, what is the use of all the prayers and rituals, the painstaking ordering of utensils, vestments, movements, colours, sequences and times? 'The liturgy has no purpose,' Guardini notes, 'or, at least, it cannot be considered from the standpoint of purpose.'

When I observe my daughter, lost to her surroundings as she arranges her trading cards, when I observe myself brooding late at night over a sentence structure or a paragraph break although I am certain that no reader, not even an editor, would notice the difference, I might ask myself the same question: what is the use? And yet I know perfectly well that the sense of her action and mine consists in proving the question of purpose unimportant, or at least secondary. Is that not true of other actions, even day-to-day ones? Yes, in my

understanding of the holy, certainly. That is why some Sufis railed against Heaven and Hell so that no one might love God, serve God, to earn a reward or to avoid punishment. But we love God, serve God, wherever and however we love someone for their own sake, do something for its own sake.

And so I imagine the Cologne goldsmith who received the parish's commission around 1400 knew perfectly well that no one would ever notice the delicate limbs of those Apostles that are hidden behind columns or appreciate the veins in the wings on which the luna rests, because even the faithful would not see the monstrance close up, and even the priest during the procession would have his mind on other things besides the splendid craftsmanship. Least of all does the photograph show what effort a Cologne goldsmith around 1400 put into the veins in the wings, which are those of a swan or similar animal, which is visible only when you step right up close to the monstrance, and around the swan or the similar animal are three more tiny ones, just hatched, which are definitely quite unnecessary for the bread to be worshipped as flesh. But they are convincing.

Knowledge

I would have thought there would be at least one among the tourists who would stop in front of St Peter's tomb, even if no one drops to their knees in reverence any more, as I do, pretending to tie my shoelaces as I recite the second Fatiha. We are 137 metres below the cupola of St Peter's and exactly five metres below the altar, acoustically insulated from the rest of the underworld by automatic glass doors, in a corridor, a regular lane in fact, a lane of the dead, walls of brickwork on either hand, inset windows and doorways with stucco ornamentation leading to family mausoleums full of sarcophagi and urns in niches. The more stately mausoleums have the distinction of an antechamber in which slaves were buried. The crypt is dim, warm and damp, the humidity about 85 per cent, as the priest guiding us through the necropolis informs us – to ensure that the tombs remain so well preserved for another two thousand years, he adds in explanation, grinning triumphantly.

While the pagan inscriptions stand out by their strict order and refined characters, the Christian epitaphs are terse and look almost as if they were carelessly scribbled. Did the belief in one God bring with it an acceptance of the transience of the body? *Bene merenti*, the Christians write concisely: 'well deserving, or still more laconically: *deposito*, 'died', or *dormit in pace*, 'sleeps in peace', in place of what would later become customary, *requiescat in pace*, 'may he rest in peace'. A widower

reminds us down to the present day of the beauty and inno-
cence of one Aemilia Gorgonia, who died much too soon at
the age of twenty-eight years, two months and twenty-eight
days, and Flavius Istatilius Olympus was 'a good person,
friendly to all, always a joke on his lips'.

The floors are covered with mosaics, the walls painted red,
white, green and azure; many motifs are Greek or Egyptian,
because Roman society was multicultural, as the priest points
out several times: bearded satyrs chasing lightly clothed, full-
breasted maenads, goat-legged Pan blowing his flute; in other
crypts people together with their dogs flattened in pharaonic
bas-relief, and before us the wall behind which Peter is sup-
posed to be buried, in a niche a shallow glass container no
more than twenty centimetres long holding some white parti-
cles which must be bone fragments. 'Is that all?' exclaims one
of the tourists pertly, as if not only the priest's credibility but
that of the church were forfeit, the Catholic Church's at any
rate, if the remainder of St Peter's skeleton should be lost.
Behind the wall are eighteen more glass containers, the priest
says, resuming his victor's grin. Then he lets the archaeologi-
cal clues that indicate the authenticity of Peter's tomb rain
down on the tourists like a volley of arrows.

First, invocations of Christ, Mary and St Peter on a
third-century wall; second, a compartment behind the wall
containing first-century bones from the skeleton of one man;
third, the deceased's age, calculated to be sixty to seventy
years, his rugged build and his slightly above-average height
of 1.66 metres; fourth, the missing feet, which may simply
have been hacked off by the Roman soldiers taking him down
from the cross; fifth, the probable veneration of the body,
since it was shrouded in gold-embroidered purple; sixth, the
inscription *Petros eni*, 'Here is Peter'; seventh, eighth, ninth
I no longer take down – and not even the priest interrupts
the tour for a moment to say a prayer or make the sign of the

cross, which I cannot do for him. He speaks of clues where Shiites would have spared the shilly-shallying and built a glittering palace with a silver fence around the sarcophagus, on which a green silk drapery would have covered up all doubt – and merely entering would have worked miracles! My grandfather in his memoirs was not referring to such parlour tricks, however, when he opposed the new fashion of supplying scientific explanations and proofs of all the miracles that God had granted His prophets. It sufficed, he wrote, to observe Creation, the uniqueness of every person and every animal, of every plant, to discover miracles enough, the wonders of civilization, of the senses, of pleasure – the wonders of love: 'How can science explain the fact that no two people's palms are ever the same? How can it explain what a single person can create and what an overwhelming feeling that person can have for another?'

In the Vatican, the traces of God are subjected to petrographic analysis and forensic measurement, and scientific experts express probabilities in decimal percentages: truth here is not simply asserted but proved with the spade and the computer, and archaeology is declared the basis of exegesis. Even its back courtyards exude a respectability like no other religious site I have visited anywhere in the world: the libraries, the archives and the mosaic laboratory with offices where the people wear white coats over their priestly vestments; the clean-shaven, mostly well-combed theologians in the spotless lanes and long corridors with the sobriety and the assiduity of ants. The belief that was once the most far-fetched has become the most scrupulous.

'There is not, has never been and never will be incontrovertible evidence that Peter lies here,' the priest explains in forthright terms. Although there are many indications, no civil registry certificate is extant. Then he smirks as if he had dispelled the tourists' childhood belief.

But wouldn't the priests' diligence in weighing the arguments for and against the presence of Peter's true remains behind the stones have elicited Grandfather's approval, indeed his admiration – which would have given way immediately to shame for his own credulity? The tablet at the entrance to St Peter's Basilica showing an unbroken list of all 267 pontiffs from Peter until today, including question marks, is also unique in the history of religions, I assume. Such continuity alone – not imaginary, ostensible or reconstructed but real, documented by the year and probable day – speaks for the Catholic Church, whether or not it too has been petrographically analysed, forensically measured, and its probability expressed in percentages by scientific experts. Although the Church would vigorously deny it, it has in a sense rehabilitated, or at least taken seriously, the misprized Apostle Thomas who wanted more than just to believe the truth, wanted to know it, to see it confirmed by his own experience.

It is the Gospel of John, and only the Gospel of John, that brands Thomas an unbeliever: only the Johannine Thomas doubts that Jesus could bring the deceased Lazarus back to life and sees Lazarus bound for certain death: 'Let us also go, that we may die with him' (11: 16). Only the Johannine Thomas responds to Jesus' announcement that he will soon die with helpless desperation: 'How can we know the way?' (14: 5). Only the Johannine Thomas misses the resurrected Jesus' meeting with the disciples and then mistrusts their report: 'Except I shall see in his hands the print of the nails, and put my finger into the print of the nails, and thrust my hand into his side, I will not believe' (20: 25). And only the Johannine Jesus returns to scold Thomas for not believing in the resurrection: 'Reach hither thy finger, and behold my

Overleaf: Caravaggio (1573–1610), *The Incredulity of Thomas, c.* 1603, oil on canvas, 107 × 146 cm. Picture Gallery, Sanssouci Park, Potsdam.

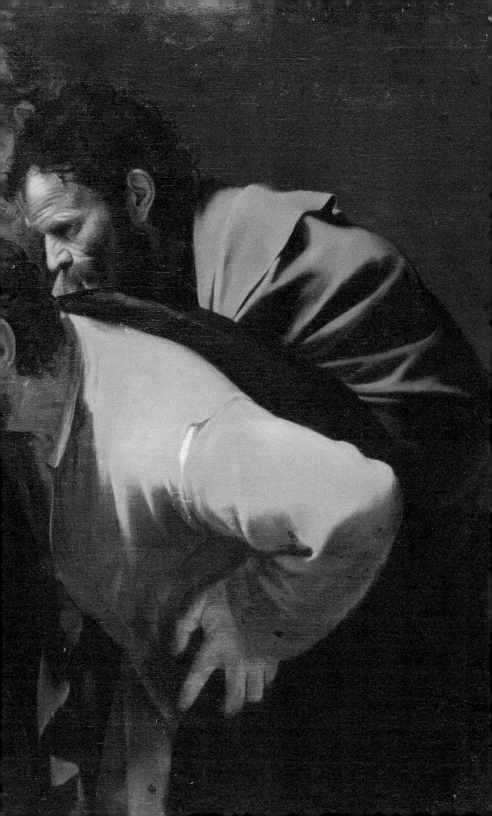

hands; and reach hither thy hand, and thrust it into my side: and be not faithless, but believing. And Thomas answered and said unto him, My Lord and my God. Jesus saith unto him, Thomas, because thou hast seen me, thou hast believed: blessed are they that have not seen, and yet have believed' (20: 27–9).

If we look to the Gospel of Thomas, which was probably similarly widespread in the beginning and which, like the other texts found at Nag Hammadi, my Catholic friend considers as a temptation to be repelled, the contradiction to John looks different: Thomas is not simply being slow-witted, he is emphatically proposing that God can be perceived – in other words, we can see, experience, and more than just believe God: we can know Him. For the divine Light which existed before Creation shines, says the Jesus of the Gospel of Thomas, in every person, in every creature, and even in lifeless matter: 'I am the light that is over all. I am the All. The All came forth out of me. And to me the All has come. Split a piece of wood – I am there. Lift the stone, and you will find me there' (77).

The Gospel of John, which developed in competition with the Gospel of Thomas – both written seventy, eighty years after Christ's death, if not later – criticizes, practically ridicules the aspiration to know God. After having made Thomas look a fool, John confesses explicitly that he is writing 'that ye might believe that Jesus is the Christ, the Son of God; and that believing ye might have life through his name.' Thomas for his part is not interested in a simple dichotomy between knowledge and belief, and certainly not in a proof that is petrographically analysable, forensically measurable and found to be one hundred per cent true by scientific experts. He is saying that the truth is not something external or supernatural, something absolutely different from us, which we must believe unseen, trusting in the word only, and hence in the authority of its interpreters. 'If those who lead you say to you:

"Look, the kingdom is in the sky!" then the birds of the sky will precede you. If they say to you: "It is in the sea," then the fishes will precede you. Rather, the kingdom is inside of you, and outside of you. When you come to know yourselves, then you will be known' (3).

I would like to recommend to my Catholic friend that he read the first three gospels, just for the sake of experiment, as if the Gospel of John did not exist. Then there would be little left to divide the Bible definitively from the Quran; only the Crucifixion, actually, which has never been a great obstacle, of course, to the Sufi literature. And if you replace the Gospel of John – just for the sake of experiment – with the Gospel of Thomas – if you imagine, that is, that the followers of Thomas had prevailed instead of the followers of John – then my own personal Christianity would be more than a chimera. For then the other gospels suddenly appear differently, talking about the Son of man and quite definitely about God within ourselves. 'And when he was demanded of the Pharisees, when the kingdom of God should come, he answered them and said, The kingdom of God cometh not with observation: Neither shall they say, Lo here! or, lo there! for, behold, the kingdom of God is within you' (Luke 17: 20–21). Modern Bibles, including the revised Luther translation since 1984, give this passage a Johannine interpretation when they situate the kingdom merely *in your midst* – that is, in the space between people in which Jesus dwells. Yet Luther himself sensed that the Greek *entos hymon* referred to an inside: internal to or, in his German translation, *inwendig in* a person. I don't want my Catholic friend to discard the Gospel of John; I want to persuade him not to dismiss Thomas (and, with him, the composer of the Gospel that bears his name) as simply unbelieving, as the stupid man Caravaggio paints him as, and to see that the Apocrypha are not simply negative, a temptation, but can broaden faith – and so increase it!

But how did I end up here? That's right, I was thinking of the truth that they're searching for with spades and computers at Peter's tomb. Is that not exactly what the Gospel of John reproaches Thomas with in calling only the other ten Apostles blessed, those who did not see and yet believed? Although knowledge to Thomas no doubt meant something different from archaeology, Grandfather would have been amazed nonetheless at the priest's meticulous weighing of the pros and cons as to whether Peter really lies buried behind the stones; and then his amazement would have given way to admiration and, with his admiration for such a painstaking investigation, the shame at his own credulity, the credulity of the Shiites, who don't think twice before building a glittering palace with a silver fence around the sarcophagus, on which a green silk drapery covers all doubts. But then I would have reminded Grandfather of his own words: that it suffices to observe Creation, the uniqueness of every person and every animal, of every plant, to discover miracles enough, the wonders of civilization, of the senses, of pleasure – the wonders of love. 'Let him who seeks not cease seeking until he finds. And when he finds, he will be dismayed. And when he is dismayed, he will be astonished. And he will be king over the All' (Thomas 2).

In Caravaggio, it is not only Thomas who looks, but two other disciples also look at the hole in Jesus' side, and they are very much interested, their brows furrowed with excitement and curiosity. And Jesus looks by no means angry or annoyed, as if he were about to pronounce the three of them unbelievers. Drawing his cloak aside like a stage curtain, he guides Thomas's finger into the wound and seems to be interested just as much in showing that God is within us.

Tradition

Before I enter the church, I have to report to the North Atlantic Treaty Organization. Two Italian soldiers killing time in a shipping container guardhouse demand my ID and ask who I want to see. Then they talk to someone on the telephone, one of the monks I assume, nod to me, write down my particulars and issue me a visitor's badge, instructing me to wear it visibly on my jacket. It is almost eight o'clock on a Sunday morning and I am late; the driver had trouble finding the Dečani monastery in western Kosovo, which is not signposted, despite its World Cultural Heritage status. The new nation, in which American flags are waving everywhere, doesn't seem to be very proud of its oldest heritage. There are roadblocks and a NATO tank on the way to the monastery; lonesome though the military guards may look, they don't invite visitors.

Through a gateway that leads two, three yards through the perimeter wall, I enter the courtyard: a well-tended lawn, the surrounding monks' cells on two storeys, the church in the middle, captivating in its size, in the harmony of its proportions, but most of all in the two different kinds of stone that it was built of seven hundred years ago – pale yellow onyx, as the abbot will later explain, and reddish breccia. I am surprised to see Romanesque colours and forms in a historic heartland

of the Orthodox Church, and not far from the Kosovo Field, where the fate of the Serbs was decided several times. The abbot will explain that my impression is correct: the master to whom the sainted king Stefan Uroš III Dečanski entrusted the building of the church came from Italy. Did the Italian soldiers outside in the guardhouse container know that? Would it interest them?

This Stefan has a turbulent biography: while still a child, he was handed over to the Tatars as a hostage, and later he was accused, justly or unjustly, of wanting to usurp the throne of his father (the Stefan Milutin who had raped the eight-year-old Simonida). Stefan III was blinded, banished to Constantinople and thrown in prison there. Seven years later, his father rehabilitated him and named him his successor. Before he was crowned, Stefan took the bandage off his eyes – and was able to see again. Perhaps out of gratitude, perhaps because of his particular love of colours and forms, Stefan wanted to erect a special treasure for God and man. He roamed the mountain range that overlooks the great plain of Kosovo in search of the most idyllic spot and discovered a river and sufficiently broad meadows in a valley between two wooded mountains, a pleasant climate and a landscape that could not be more beautiful. He engaged a famous architect from far away and supplied him with two of the noblest kinds of stone so that no eye must put up with monotony.

I imagine travellers of seven hundred years ago, or only one hundred years ago for that matter, reaching the foothills of these mountains not only physically exhausted but more fatigued by the dreary plain they had marched through for days and weeks. When they finally spied the monastery in the distance, they could not yet guess what a sight its high walls, like the veil of a princess, concealed. Finally the heavy gate opened. The travellers walked or rode the two, three yards through the passageway, almost a tunnel, and only then saw

Visoki Dečani monastery, Kosovo, built 1328–35 by Fra Vita.

the church: suddenly, right in front of them. They must have fallen to their knees in fascination and wonder. Such forms – each window symmetrical with one, but only one counterpart, the staggered roofs like a pair of trinities, the circular bell tower with its silver dome. And, most of all, the play of the two stone materials with their infinite shadings. What draws people to a church, travelling days and weeks across country? In Dečani the answer is more than just theological. The thirst for beauty must have been a part of it. What a shame, I think, that you can get here so quickly today, relatively quickly in any case: seven hours full of potholes from Belgrade to Priština, because Serbia makes the connection to the republic it lost as difficult as possible, and an hour longer than planned from Priština by taxi, because the new state does not signpost the way to the Serbian monastery.

As I remember the way here, I recall the Balkans in general, or what I have travelled of them in the past few days. As a foreign visitor I don't want to sound disrespectful, and yet, if I want to describe my impression of Dečani, I must also speak about the aesthetic wasteland that covers this part of the world like a heavy, deathly drought. The three-storey gabled houses that the Kosovars build today are as practical as their jogging suits: all to the same plan, perhaps downloaded from the Internet, with satellite dish, but without render or paint, the grey concrete blocks bare. Just as almost all the restaurants offer only fast food, the radio plays only local instant versions of Western popular music in which all that counts is a catchy refrain. Because no one seems to listen to it, and because the drivers rarely do anything when the reception is bad, I assume the music is there to numb the sense of taste. As if the Kosovars had lost, to a still greater extent than other peoples of the Balkans, all the feeling for form of which a hint can still be seen in the old city centres, everything new is reduced to bare function. Just as comfort seems to be the only

thing that counts in housing, the sole purpose of eating is to be sated, and of music, to drive out the silence. Priština especially, where independence brought unbridled capitalism and led to an unregulated building boom, is an utter hotchpotch.

It's not just the ugliness per se. The housing estates of socialism or the pedestrian areas of German small towns can certainly match Priština for tastelessness. It is what many Kosovars enjoy as freedom when they wave the stars and stripes: namely, the absolute arbitrariness of form; anything goes, and the more money they have, the cheaper the effects. Accordingly, the state treats itself to the biggest flights of fancy in constructing its history, up to and including Bill Clinton: because his order to attack dealt the Serbs another defeat on Kosovo Field, he now stands waving in Priština as big as Mickey Mouse in Disneyland, except that his backdrop consists of prefab concrete estates. National elections here are won with promises to get the first McDonald's opened.

People whose only other experience is watching television may be glad of the fountain illuminated by disco lights or the blinding white monuments with all the kitsch of a fantasy film. But those who are still part of a tradition, any tradition, will find themselves looking around for an object on which the eye can rest, a sound that refreshes the spirit, or a food that someone has taken more than five minutes preparing. No, even one hundred years ago, the sight of the church that Saint Stefan Uros III Dečanski had built seven hundred years ago cannot have evoked a greater sense of wonder.

EVERYTHING IS A SIGN

As I enter the church, I hear only the prayer, the constant alternation between the litany of one voice and the chorus of many. But where are the monks? It takes a few seconds

before I realize that I am in the narthex – that is, an ante-chamber such as Byzantine churches ordinarily have, only narrower. In Dečani the antechamber is big enough to hold a flock of pilgrims – to house them, in fact, in bygone days, especially in winter, when all the cells were occupied and the tents draughty. I imagine the pilgrims, who may not have attended as many prayers as the monks – after all, the monks spend five, six hours a day in church even now, and seven hundred years ago perhaps longer – I imagine the pilgrims remained sitting in the narthex during some hours of prayer, or lying, or eating, dozing, dreaming or talking in whispers. Then they would have been constantly hearing the litany, a gently rocking, humble singing such as I used to hear, this too now a quarter of a century ago, in Cairo, when the Quran was recited in the mosque whose outdoor loudspeakers were hung from the balcony of my bedroom. It does something to you, even more perhaps when you are dozing, whispering or dreaming than when you are thinking about the words. The old architecture in any case provides for those liminal states in which, while performing worldly acts, people take part in the holy. One can also see the narthex as just another veil, which every beauty wears both to repulse and to arouse. For the naos too, the main hall where the congregation pray, which I enter through a narrow arch, conceals more than it reveals.

The altar, as in all Orthodox churches, is behind another door which only the priests may open; in the Armenian churches I know from Isfahan, the bread and wine change behind a red stage curtain, out of sight of any audience. The aesthetically very subtle conception that the Holiest may be touched only by those who have promised themselves to it, as a bride to her husband – and the red and white mantle that the two priests wear over their simple robes is accordingly festive – that wise dread of immediacy is characteristic of the entire Eastern Church. Only, in Dečani, the naos itself

is subdivided by a wall, although only shoulder high, into a nave and a choir. In the darkness, not so much dispelled as enchanted by the candles and the stained-glass windows, the congregation stands around the choir, which is reserved for the monks. Some of the faithful are sitting, especially the older people, immersed in contemplation, on the few wooden benches, which they have opened down on hinges along the church walls, the men to the right of the entrance, the women to the left. They listen to the prayer, hardly seeing it, just as, in the Old Testament, God is heard but hardly seen.

This is how the mystery of the holy becomes visible in the most concrete sense: only the heads of the black-robed monks are discernible, with their beards down to their chests, some bare-headed, their hair tied at the back, some with the high cap covered by a large cloth. Sometimes the heads are still; more infrequently they move from place to place like figures on a game board. At certain points, which I do not understand because of the language, the faithful make the sign of the cross, sometimes in one manner, more infrequently in another. The index finger traces the lengthwise axis sometimes to the abdomen, more infrequently all the way down to the knees, so that the sign of the cross becomes a bow.

The conventions that the faithful observe are of course nothing compared with the performance in the choir, which I can see by standing on tiptoes like a little boy to peer over the parapet – part of the performance in any case, for what goes on in the sanctuary that only the priests may enter is hidden even from the other monks. It is a symphony of gestures and crossings, melodies and texts, solos and choruses, rattling and bell-ringing, light effects created by carrying and waving the candelabra, and carefully dispensed puffs of incense, composed down to its individual steps and cadences, handed down for one thousand five hundred years and performed in Dečani without alteration for seven hundred years. As if it

were intended to prove the completeness of divine creation, nothing in the ritual may be left to chance. It is theology, concentrated and made form: everything in it is necessary just as everything in the world is necessary, every word, every step, every hand gesture, every sound, every smell and every candle that is lit and extinguished again, everything is a sign, just as everything in the world is a sign, even if we don't always understand it. Perhaps not even the monks, to say nothing of the ordinary churchgoers, know the meaning of each detail – how much more mystified must a stranger be, an unbeliever or a believer in a different faith such as I.

Whether we understand – that is, whether man understands – is perhaps not as important as most people think. What is important is that it happens: that the bread and the wine, at certain hours of the day, the week, the month, the year, change into God. In Dečani I learn what a worship service literally means: it is not service addressed to human beings, but thanks, superseding carnal sacrifice, logically offered to God. Unlike mystical contemplation, it does not depend on personal experience. That is why not just the lay congregation but also the monks, when they are not singing or charged with other tasks, whisper with their neighbour, and even laugh or yawn. As the abbot will later explain to me, the highest state is considered to be that of constant prayer, attentive to God not just during Mass but outside it as well, while at the same time living in this world, working, helping the needy, and why not laughing or yawning too?

Because the service is to God, not man, the bread and wine are not handed to the faithful – the communicants must genuflect and lower their mouths to the spoon which the priest holds at stomach height. The offertory too, because it is intended for human beings, is collected at another time, and the sermon is very short, little more than a minute long, and given at the very end in an almost frivolous, or at least in

an ordinary tone, with no microphone of course, so that even the locals barely understand the words. And, after all, they were not allowed to sing along, hardly saw anything, and had to stand throughout the Mass, six hours every Sunday, and maybe longer on feast days. What a burden! we may think, in a time when everything, even worship services, is oriented towards the viewer, the consumer, ultimately the paying audience. Was a gift! I think, that for a few hours a day it's not about us, or me, about us human beings, and I am all the more overwhelmed by the impressions which my senses take in the more eagerly for the limitations, the scent, the carefully dispensed illumination, the perfect harmony of the voices and instruments, the not too wide but extremely high room with its celestial cupola, the hazily discernible paintings on all the walls. Before the end of the sermon, which may consist only of organizational information, the first of the congregation leave the church, cheerful in spite of the physical exertion, it seems, many of them smiling, uplifted, although, viewed from the outside, from the free world which counts for so much in Kosovo today, they have been practically demeaned, excluded, at least, as consumers.

ALSO A POLITICAL DUTY

After Mass, the churchgoers, many of whom have come from far away, eat lunch with the monks. The dishes are simple, nourishing and aromatic – vegetables, cheese and wine produced by the monastery, accompanied by soup, fish and a pudding. There is little conversation, among the monks almost none, in any case not more than during the worship service. Instead, a monk at a lectern reads aloud from the Bible. Like all the day's activities, especially the service to the community, the two daily meals are also seen as a time

of prayer. The faithful notice, without displaying any disapproval, that I do not make the sign of the cross before or after eating. Relations with the Muslim majority are tense, there's no other word for it, but within the monastery walls they seem glad, some of the monks seem glad, to cast one friendly glance after another my way, and even delighted that an unbeliever, or a believer in a different faith, is interested in their tradition.

The abbot, Father Sava, who guides me after lunch through the monastery and its small plots of land, fenced in with barbed wire, knows the reasons for the tensions between Kosovo's peoples, and hence between its religions. Although his monastery was attacked several times during the war, and even today the monks cannot shop in the neighbouring village because of verbal and also physical aggression, not a single thing Father Sava says gives the impression that he would place the blame only on the other side. He knows the history of the wars during Yugoslavia's disintegration and knows how Muslims in other places suffered at the hands of Serbs. In the monastery itself, he recounts, they sheltered many Muslims who had fled from Albania. Father Sava himself brings up the Orthodox priests who blessed the weapons of the Serbian soldiers, though he also points out that the Church as such never condoned the war, much less the atrocities and abuses. But has the Serbian Orthodox Church distanced itself from the priests who blessed weapons? Has it spoken one word of regret over Srebrenica, for example? Father Sava asks me not to write down his answer.

The monks and nuns in Kosovo are beset on all sides. The nationalists in Serbia claim the monastery as the mythic place of origin of their nation, fulminating against every sign of acquiescence to Kosovo's independence. Most Kosovars see the monastery not just as a Serbian outpost but as an expression of the very Serbian nationalism against which

they successfully rebelled. Abbots like Father Sava, obliged to come to terms with the political conditions in order to secure the continued existence of Serbian monasteries in a territory that has become hostile, stand between the opposing forces. If they accept Kosovar passports, the Serbs will revile them. If they refuse Kosovar passports, they'll be reviled as Serbs. And that is only the simplest illustration of the dilemma the monks face.

Yet, Father Sava feels, the Serbian monasteries in Kosovo are not a national issue – to him their preservation is a religious imperative. They are the oldest Serbian Orthodox monasteries anywhere; this is the only place in the world where the rite that was over seven hundred years old over seven hundred years ago is practised in every detail. That is the real world cultural heritage of Dečani and the other Serbian monasteries in Kosovo – not the onyx and not the breccia; not even the enchanting paintings on all the interior walls. It is the ritual itself, the actual act: I couldn't think of any other religious practice that has existed, practically unchanged, over so many centuries, in such a fantastic complexity as the Orthodox Mass. But it is impossible to preserve this enactment of a divine beauty outside the monastic community. All the details of the procedure cannot be written down; the Mass cannot be taught in seminaries; the words and chants, steps and acts, times and rhythms are preserved only where a community practises them for many hours daily. Even the Latin Mass that struck me as so magnificent is simple in comparison, looks almost bureaucratic, with its quicker sequences and sharp divisions. And yet it is an instructive example: once a tradition is interrupted, its restoration all too easily turns into ideology. That is why conserving the liturgy, preserving and cultivating it where its existence is still uninterrupted, is more than just a spiritual gratification or an aesthetic fascination. It is at the same time a political duty, as the Kosovars will one day

realize, because at present the neo-traditionalists are doing much more damage in Islam than in Christianity.

<div align="center">

EVERY DAY, EVERY WEEK,
EVERY MONTH AND EVERY YEAR

</div>

Father Sava would be an ideal speaker on the conference circuit for interfaith understanding, and not just because he speaks excellent English. He is thoroughly learned in much more than Christian theology and is particularly interested in Sufism, which permeates the devotion of many Muslims in the Balkans even today, forming a bulwark against fundamentalism. Maybe Father Sava, with his modern, conciliatory, comprehending political judgements, is not typical of his church. That makes him all the more suited to lend Serbian Orthodoxy a friendlier face than it has in Western Europe, in the Islamic world and, by the same token, among intellectual and secular circles in his own country. Sometimes Father Sava does find himself in a discussion group or attends a political reception, but not often – as seldom as possible, he says. He sees his most important responsibility in the monastery itself. Keeping the fraternal community together, maintaining the rite, supervising the farm, with the winery and the distillery, ensuring that the guests are cared for, organizing the charitable work that is a natural part of the monks' life, and finding a little time, in addition to the long hours of prayer, for his own studies – really, that is ambitious enough. After all, he made a conscious choice for monastic seclusion, not for a diplomatic service.

'When you enter the monastery,' Father Sava remembers, 'you know exactly what you can expect: every day, every week, every month and every year has its prescribed form.'

Age is not the only difference between the monks; they also

come from very different, you might say opposing worlds: there are scholars among them, even artists and rock musicians, former drug addicts for whom the monastery was a life-saver, but also simple men, tradesmen, farmers, labourers, and then again some who knew of their vocation at a very early age. In Dečani, Father Sava says, they still have some time to pursue interests of their own, including interests from their former lives: one likes to read before vespers, another stays in the garden longer or plays music. Maybe he has suitable abilities and knowledge to head the monastery, Father Sava says, but that is all.

'But that is not just an organizational matter,' I object. 'You are also the monastery's outward representative.'

'True, but it is not my place to pronounce a representative opinion.'

Certainly the monks have different political views, but he doesn't know them exactly because they talk more rarely about politics than I as an outsider would imagine. Perhaps he also avoids talking with some of them to prevent controversy. What is important is their common ground, and that is the practice, the established order of their lives, centuries old, the same every day.

'As fixed as the Mass itself?' I ask.

'Yes, just about like the Mass itself,' Father Sava replies.

We are standing on the lawn in front of the church. The visitors have long since gone home; many of them have a long drive ahead of them. Outside in the guardhouse container, the Italian soldiers are still bored. Father Sava is perhaps forty, perhaps fifty years old, quite young for an abbot. He seems to tolerate more than enjoy the reverence of the monks and the other church members, the bows and kisses on the hand that are meant not for him but for the institution that he represents as abbot. He has a warm voice and a distinctly friendly, even a sunny disposition. A belly bulges under his

robe that testifies to the enjoyments of life, good food and wine, I assume. He is not an ascetic, certainly not innocent of the world.

'Everything is arranged for us,' says Father Sava, 'and that is infinitely liberating. We know exactly what our day will be like today, tomorrow, the next day: everything will take place within these walls, or at most in the surrounding fields. And when God calls us away from this world, we need to be carried only a few yards. Look, over there: the cemetery is right on the other side of the church.'

Father Sava finds that a very pleasant prospect.

Light

What is most appealing in the windows on the afterlife that Hieronymus Bosch has arranged is the light – even the light of Hell. By that I do not mean the dim red of the cloud landscape in the leftmost of the four panels, in which imps or child-sized demons are reaching for slender naked people, have already seized one by the hip and tipped his torso downwards. The red, obviously, is from the fire that the damned will be thrown into. I believe the beast at the left edge wants to eat the man it's caught, or at least bite his arse off, which it's certainly not holding up to the light by chance – the beast's face one big arse-sized open maw containing nothing but fangs. Vegetarians they're not, at any rate, the beasts in the left panel, their mouths so wide that, even with their lips pressed shut, they reach almost from ear to ear. And their arms, stretched to spidery length, and their hair, sprouting like insects' feelers right by their mouths, as thick as horns and so long that the bristles could stab or skewer their prey. The people cannot escape them because, to begin with, in their weightlessness they cannot step anywhere or push off of anything; they float like blown-away dandelion seeds on the air, in the clouds to be exact, where there is no up and no down. For, in spite of the title, what Bosch shows is not a 'fall of the damned' but their weightlessness – no, not like dandelion seeds, but like bodies thrown out of an airplane in flight, except that the mercy of a final fall is denied them.

Hieronymus Bosch (*c.* 1450–1516), *Visions of the Hereafter: Fall of the Damned*;
Hell; *Earthly Paradise*; *Ascension to Heavenly Paradise, c.* 1490 or later,
oil on wood , 87 × 40 cm each. Museo di Palazzo Grimani, Venice.

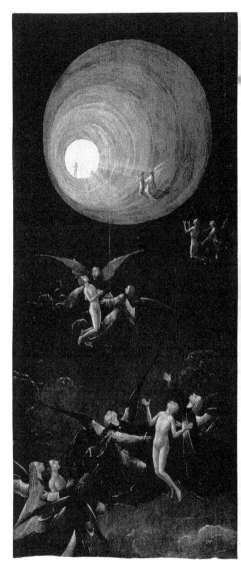

What makes me think of airplanes are the lights in the left-most of the four panels, which look like headlights, aircraft headlights shining into the clouds. Anyone who has flown through a cloudy sky at night will recall the clouds illuminated in spots near at hand, not over huge expanses as by the sun or the moon. At the top right, a spotlit person spreads his arms wide and screams in desperation, although no demon is reaching for him. But what are those lights? Everything else, and especially the aliens in the second panel from the left, is nothing but fantasy trash, or, rather, we see where the movies get their fantasies, which doesn't make the trash any more real. The aliens here, spreading their jagged wings and wagging their dogs' tails, are prophetic inasmuch as they anticipate the comics, but certainly no prophecy.

I have always been suspicious of, or immune to, the fascination of Hieronymus Bosch; I have always wondered that Christianity in general put so much more effort into picturing the punishment than in imagining the reward, notably of course in the *Divine Comedy*, which describes the Inferno much more colourfully than the Paradiso, although the goings-on in Paradise must be much merrier. The Gospel too never goes into detail about the Garden of Eden, yet it describes Hell as the outer darkness and as a furnace of fire, in which – in both of which, note, in the light and the dark – there shall be 'weeping' or 'wailing and gnashing of teeth' (Matthew 8: 12 and elsewhere). Some may object that the biggest painting in the Christian world, which, coincidentally, is also in Venice, depicts nothing other than Paradise; but in Tintoretto's work, even Heaven turns out to be so dark, and crowded with so unbelievably many people in a space that ends up being relatively small, that I can imagine nicer places; in fact, to a solitary type like me, such a throng seems more like a nightmare. And the Garden of Eden that Bosch has thought up in the second panel from the right looks the same

to me as the countryside around my home town of Siegen – hilly, wooded and just as hazy.

In comparison, the Bible's own reticence makes more sense to me: while in regard to Paradise it mentions, besides the lush vegetation, only precious stones, it adds to Hell's fire and darkness little more than Job's 'destruction' and, as an earthly analogy, the 'valley of slaughter' of the prophet Jeremiah. No, if you want to represent the hereafter, the expression you need is not that of science fiction, but one as poetic and bursting with life as the Apocalypse – which stands for the end of all time, though; certainly not for a Heaven existing now for the righteous. The Quran, however, comes up with several similarly astounding images, some referring to forces of nature, some erotically charged, for the Hereafter of each human life, and provides acoustic accompaniment at the same time, physically gripping onomatopoeia: here the warning, in dull, guttural consonants and monotonous, hammering rhythms; there the promise, in soft, sweet consonants and high, extended vowels. No wonder such a powerfully concrete eschatology, made of roaring, cooing and sighing, had an effect on the Arabs, and still more on the Arab Jews and Christians, who suddenly imagined Heaven and Hell as something real, the triumph of Islam, as we know, having been achieved in part through the fascination of the Quran's language, its musical language. And yet Islamic culture, instead of illustrating the Quran perhaps, withdrew towards abstraction, dissolved the image, wherever it had represented the Infinite in art and architecture, into fugal patterns. Occidental culture demonstrates moreover that music is the medium in which people feel most strongly what is supernatural: how much more of Paradise could a Schubert sonata capture than Bosch's hill country; how much more eschatologically disturbing can a Bach passion or his B minor Mass be than Bosch's aliens?

Two of these panels I will accept, however, for the Hereafter seems in fact to shine through those on the far left and the far right, although, unlike the middle two, which are unimportant to me, they show not Heaven and Hell proper but the way to get there – that is, the Ascent and the Fall. What kind of a spotlight is that on the far left, shining into the darkness? It must be the same light that shines from the Heavenly Paradise on the far right, the divine Light – or, rather, the light of Heaven and Earth, which is the only possible representation of God and, according to the most credible testimonies, the actual experience of Him. And by that I mean more than just the accounts of those who have almost died, the light at the end of a tunnel, a tube, or an opening, regularly attested in what are called near-death experiences. 'The likeness of His light is as a niche wherein is a lamp', says Surah 24, verse 35, 'the lamp in a glass, the glass as it were a glittering star, kindled from a Blessed Tree, an olive that is neither of the East nor of the West, whose oil well-nigh would shine even if no fire touched it; Light upon Light.'

In most traditions, aesthetic traditions included, the Hereafter begins where the shadows end. Just think of the frame of gold in the Byzantine mosaics, which illuminates the pictures as if from within because the bits of glass of which they are composed are backed with gold leaf. Think of the fire which first symbolized the one, the only God. Think of the Apocalypse of Peter, of Jesus as a shining being of light that is 'glad and laughing on the tree', of baptism as a literal 'enlightenment' and the light metaphor in the Gnostic gospels found in 1945 at Nag Hammadi. 'If one is like God, he will be filled with light,' Jesus says in the Gospel of Thomas, 'but if he is separated from God, he will be filled with darkness' (61). Think of the fact that the Christian ceremony that has probably been practised the longest without amendment is the re-enactment of the miracle of fire at the Church of the Holy

Sepulchre. *Lumen de Lumine* says the Nicene Creed, which is sung there in Gregorian chant: 'Light from Light'. Think of Empedocles' theology of light, which inspired Islamic mysticism long before Goethe would read it. In all of these traditions, light and shadow, hence Heaven and Hell, are not parts of a world beyond this one; they are, as in the Gospel of Thomas, part of man. It would be in contradiction to God's mercy if He were to cast the sinners into eternal darkness, say the Sufis, teaching that that darkness is nothing but the veil – the veil that is to be lifted, that can be lifted, and thanks to the divine mercy will finally be lifted, even to the sinners in the hereafter! – the veil of their own nature as God's creatures.

'My friend, shut your eyelids and look at what you see,' wrote the great Najmeddin Kobra in the thirteenth century, in the most exact description of the recurring colours seen during mystical contemplation.

> If you tell me: I see nothing – you are mistaken. You can see very well, but unfortunately the darkness of your nature is so close to you that it obstructs your inner vision to the point that you do not discern it. If you want to perceive it, see it before you with your eyes closed, begin by diminishing or putting away from you something of your nature. But the path leading to that end is spiritual combat (*jihād*). And the meaning of spiritual combat is to devote all your efforts to repelling or killing the enemies. The enemies in this case are nature, your appetitive soul, and the demon of your self.

It is important to keep in mind that Kobra is not constructing a theory, much less speculating; he is recording real events, described in similar terms by countless mystics in various religions, events that take place behind closed eyelids – that is, in a darkness which can glow; hence the Sufis refer at the highest level to a black light.

In the beginning, it is true, the visionary perception is aimed at shapes and objects that have their origins in the world of the senses: at the sea, rain, cities and countrysides, but also at animals, a dog, a lion, and so on – not unlike the figures of ordinary dreams, the interpretation of which was a distinct field in the Islamic sciences. But then you begin perceiving – no, not with your eye, with your heart – the nature of the shapes and objects, and this is the moment at which the visions of coloured light arise. When your own soul appears for the first time before your inner eye, it has a deep blue colour like the sky, and it bubbles up, like water, out of a spring. If your soul is good, if it is healthy and pure, then it produces only good, the good that springs spontaneously from natural existence. But if a demon dwells in your nether soul, an imp or a beast, then it appears, just as the Bible describes, as a simultaneous gushing of fire and darkness – and then there will be 'wailing and gnashing of teeth'. This demon is itself a crude fire mixed with the darkness of unbelief. Making resolutions or threatening the demon will not avail: 'For Satan laughs at all your threats,' Kobra notes, whose honorific Najmeddin means 'star of religion': 'What frightens him is seeing a light in your heart.' That means precisely that the shadow is within a person, not in the external world. Conversely, though, the seeker is also a spark of the light he seeks: every time the heart sighs for the throne, the throne sighs for the heart, so that the two meet. Every gem that is in you shines back towards Heaven. Every time a light rises up from you, a light descends upon you. And every time your flames flare up, flames come down: 'But when the substance of light has grown in you, then this becomes a Whole in relation to its counterpart in Heaven: then it is the substance of light in Heaven which yearns for you, for it is your light that attracts the divine light, and it descends towards you. That is the secret of the inner journey.'

It is on this journey that the multicoloured apparitions of light appear that have been described similarly in other mystical traditions, white at first, as in the accounts of near-death experiences and in Bosch, then yellow, the sign of the true believer, deep blue as the sign of good action, green for the soul's peace, azure for hope, red for insight and, finally, at the seventh level, the black light, *nur-e siyāh*, which is the sign of the passionate, consuming love; it is this sequence that indicates the growth of the light organism, the issuing forth of God, until the human being too is nothing but light. The exchange of the first and the third person – until It is you and you yourself are the Light – is to Kobra the critical event in which the seeker, however fleetingly, is able to see the promised face of God:

> When the circle of the face has become pure, it emits lights as a spring pours forth its water, so that the seeker perceives the sparkle of these lights gushing forth between his two eyes and his two eyebrows; then it spreads to cover the whole face. In this moment, there is another face before you, facing your face; a Face likewise of light, radiating lights; while behind its translucent veil a sun becomes visible which appears animated by a movement to and fro. In reality this Face is your own face, and this sun is the sun of the Spirit (*rūḥ*) that moves to and fro in your body.

Najmeddin Kobra understands the relation between God and man explicitly as not that of Father and son, Creator and creature. He understands it as a relation between lover and beloved, in which both of them are creative, in which man is not only created by God, but God, conversely, owes His existence to man. Henry Corbin, to whom I am indebted for these insights into Kobra's mysticism of light, replaces here the concept of man's filial relation to God with an 'uxorial'

one, inasmuch as it is a creative one, that of the mother who gives birth to her own father – although, in the experience of God, gender assignments dissolve, and Persian grammar has no genders to begin with.

> There are lights which ascend and there are lights which descend. The ascending lights are those of the heart; the descending lights are those of the Throne. Creatural being is the veil between the Throne and the heart. When this veil is rent and a door to the Throne opens in the heart, like springs toward like. Light ascends to light and light descends to light, and it is 'Light upon Light'.

And the shaft through which the souls in Bosch's painting ascend towards the light? 'The heart is a light in the depths of the well of nature, like Joseph's light in the well into which he was thrown.' Lost in the translation is the fact that, in Arabic, 'heart' (*qalb*) and 'well' (*qalīb*) are derived from the same root, *q-l-b* – that is, the heart has a lexical association with the depths of a well, from which it springs forth, as in the rightmost of the four panels. 'At the end of the ascension, you will see the well below you,' Kobra continues. 'From there on, the whole well changes into a well of light or green colour. Darkness at the beginning because it was the dwelling-place of demons; now the well is luminous with green light because it has become the place where the angels and the divine compassion descend.'

And the angels that Bosch paints? Najmeddin Kobra also tells of angelic apparitions that were granted to him: the ascension from the well under the guidance of four angels surrounding him – not just the two that Bosch depicts; the descent of the divine peace, the quranic *sakīna*, or the rabbinical *shekhinah*; a group of angels that descend into his heart; and the vision of a single angel that raised him up as the Prophet was raised up. Kobra certainly did not think of them

anthropomorphically, neither with feathered nor – for what else would the demons of your self be? – with jagged wings; the sense of his platonic account is rather that each action, each feeling, each event corresponds to a spiritual being, an 'angel' in other words, that manifests itself in its own light; personally I imagine it, because a person who is awake and yet dreaming must imagine something, as sparks, sparks shooting out of a fire, or as starlight.

In Kobra there is another explanation, however, that is closer to the view from Bosch's rightmost window, although I don't know, in fact I doubt, whether he specifically meant angels. Kobra mentions that not only the seeker's face can be illuminated, but his whole figure, and accordingly he then sees before him not just a face but a whole person of light. 'The seeker has the sensory perception of this radiation of lights emanating from his whole person. Often the veil falls from the person's whole reality, and then it is with your whole body that you perceive the whole. The opening of the inner vision begins in the eyes, then in the face, then in the chest, and finally in the whole body.' The person that the seer finally sees before him, Kobra writes, is a witness (*shāhid*) whom he can call his own master (*shaykh*) of the unseen: 'He takes the seeker towards Heaven.' In that case, the winged figures in the four panels would be neither angels nor demons; they would be witnesses, and thus martyrs too, who guide the dead upwards, or else downwards to Hell. But they could also be the witnesses of any earthly love: 'While sojourning in Egypt, in a village on the banks of the Nile, I fell passionately in love with a young girl,' writes Najmeddin Kobra, who undertook not only inner journeys but also long external travels from his central Asian home.

For many days, I remained practically without food and without drink, and in this way the flame of love within me

became extraordinarily intense. My breath exhaled flames of fire. And each time I breathed out fire, lo and behold, from the height of heaven someone was also breathing out fire which came to meet my own breath. The two shafts of flame blended between the Heavens and me…. At last I understood that it was my witness in Heaven.

And, finally, up and down? While in Hieronymus Bosch the movement that leads towards the light is clearly vertical, Najmeddin Kobra is not always certain: 'It may happen that you visualize yourself as lying at the bottom of a well and the well as moving downward from above.' This is an illusion, and in retrospect Kobra knows it: the light is in the north. But did I not write at the beginning that the leftmost panel shows, not a fall, but eternal weightlessness? I was deceived. There may be no up and down for the damned, which is why their limbs are extended randomly in all directions; yet for the observer, for Hieronymus Bosch and for us too, we hope, there definitely is an up and a down, if only because down is where the fire is. At least the desperate figure with the outstretched arms is crying out upwards, I now notice, into the blackness.

From time immemorial, people have oriented themselves after a certain point that gave their world, their landscape, a direction up and, by the same token, a direction down. Before there was modern technology, it was impossible to travel in the northern hemisphere without the vertical orientation of the North Star. Henry Corbin – whose friends included not only the Sufis but also Mircea Eliade, Gershom Scholem and other Western explorers of the soul – Henry Corbin goes so far as to equate the loss of the metaphysical dimension in modern civilization with losing north. The compass once bound our sense of direction at least to the material reality, but the North Star and hence up and down have now lost virtually all importance in day-to-day life. A person with a

satellite navigation device no longer has to look heavenward to find their way – only woe is him whose sat-nav stops working. Losing north means no longer being able to distinguish between Heaven and Hell, between angels and demons, light and shadow, unawareness and suprasensory awareness, says Corbin, who explained Najmeddin Kobra to me: it is presence only in the horizontal dimension, unable to discern the forms in ascent. 'And as soon as all creation crumbles, the people in the east shall flee westwards, and the people in the west shall flee eastwards; and those in the south shall flee northwards and those in the north southwards,' Jesus warns in the Apocalypse of Peter, 'and the wrath of the terrible fire shall strike them everywhere.' Then the damnation of the leftmost panel would consist in the damned not noticing that they are falling – that is, knowing no up or down. I didn't notice it myself at first.

Lust I

I am shocked. Throughout the exhibition I looked at pictures of Jesus, crucifixes and madonnas, Marys enthroned with and without child, enthroned angels with and without wings, well-known and unknown martyrs, busts of bishops, statues of bishops, funerary slabs of bishops, the sword of St George with sheath, reliquaries and reliquary purses, thuribles, abbatial croziers, monstrances, ostensoria, ciboria, family altars, Bibles of course, in all sizes and colours, likewise books of hours, missals, antiphonals, evangelistaries and, not least, graduals; also church windows, tapestries, chasubles, morses, dalmatics, diptychs, triptychs, polyptychs, as if the Board of Tourism's motto 'Holy Cologne' had once been spoken, in ages past, without irony, without a mischievous grin, without a jocular awareness of the human and all too human. 'Splendour and Magnificence of the Middle Ages' is the title of the exhibition, the first to gather together Cologne masterpieces from the world's collections, a sensation for the locals of course, who queue for admission as soon as the museum opens, even on weekdays; they've only recently extended the opening hours. For my part, I rode my bicycle, in spite of all I still had to do before flying the next day, to Neumarkt, which has, among all the city's drab squares, the aggravating misfortune of being the biggest, to see with my own eyes the glory that must once have been Cologne. And it's true, the exhibits are not only aesthetically spellbinding; each one of them is

also a document of social history, testifying to flourishing artisanship, artistic sense, opulence and power. The sheer quantities of gold, for one thing! I think of such Cologne street names as Unter Goldschmied and remember having read somewhere that Cologne had the most eminent and the richest workshops in all Europe.

And yet the exhibits, which one instinctively shrinks from calling works of art, do not look garish even in the concentration of an exhibition, not self-congratulatory, not too opulent; on the contrary, they look severe, even their excessive luxury aimed at some goal, subordinate to a higher cause, serving a purpose. And, in fact, the goldsmith's art which flourished so remarkably in Cologne was considered the most elegant of crafts for no other reason than because it produced the sacred vessels used at Mass. There is something solar, clear and pure in this art, perhaps because gold, more than any other material, is closely associated with the sun. On the whole, the exhibits lack the ambiguity, the undercurrent, the suggestive appeal to the very earthly senses that has been characteristic of Christian art since the Renaissance, in Cologne as elsewhere, even if Cologne has since lost its splendour and magnificence. All right, sometimes the angels do grin mischievously, and there are a few paintings of patricians and their wives whose purpose quite patently lies in this world, escutcheons here and there, those of guilds for example, and secular ornaments and utensils such as the 'Willkomm', the mulled-wine pitcher of the Counts of Katzenelnbogen, but these are only isolated pieces, and even they look noble and solemn (except for the mischievous angels). As a rule, it seems as though the inhabitants of Cologne in the Middle Ages wanted to celebrate only God, not their lives.

But that's impossible! I said to myself, thinking not only of the self-image today's Cologne cultivates, in which the holy is nothing more than a reminiscence, or a World Cultural

Heritage if you insist, but also of Petrarch's travelogue, endeared to the people of Cologne by its flattery: while the Italian poet praises 'such civility in barbarian lands, the gravity of the men, the elegance of the women,' he had more to say about the festivals, the *joie de vivre* and the altogether sensuous pleasures that characterized the city even in the Middle Ages. While Rome is steeped in the sighs of prisoners, Cologne is ruled by peace and tranquillity; while Roman streets roar with the noise of wheels and weapons, the streets of Cologne twitter with the voices of jesters; while Rome's stern Senate meets in the Capitol, handsome youths and maidens sing, 'mixed in eternal concord, nocturnal hymns of praise' in its counterpart in Cologne. What figures, what faces, what bearing! Anyone could love them whose heart is not yet taken.

Perhaps it is possible, I thought, that the people of Cologne once celebrated only God, and I let myself be moved more and more deeply, as I went from room to room, by the spiritual objects that the exhibition brings together; perhaps people in Cologne really were so devout, and Cologne bears the three crowns as its emblem not only because of the Three Kings. And suddenly, surrounded by two crucifixes that display the Redeemer in a disturbing state of decrepitude and a group of mourners transported with pain, suddenly I am standing in front of this picture, whose title is *The Love Spell*, no less. I don't know what to say to that, because everything has already been said – the woman absolutely unmasked and after only one thing; the man absolutely intentionally summoned for only one thing. To call the postures of the two bodies obscene would be an understatement: the woman with one leg forward, the second leg and her breast turned slightly to the opposite side so that her sexual characteristics are displayed both left and right; the man too unable to walk straight for excitement, his head stretched forward in desire, his crotch wide open, his dagger hanging between his legs as

Anonymous Cologne master (fifteenth century), *The Love Spell*, *c.* 1470, oil on wood, 23.9 × 18 cm. Museum der bildenden Künste, Leipzig.

a blatant phallus. And then the charmer's veil, transparently increasing his desire to mix in eternal concord, and her slippers, which can also administer pain, lustful pain, once the youth lies spellbound at her feet. What nocturnal hymns of praise will they then sing mixed in eternal concord! But no, not at night – no such decency as that: as if to exaggerate still further the shamelessness of the performance, the painter, called only 'Cologne master' in the catalogue, sets the scene in broad daylight – no curtains in the big windows, but a wide and perhaps prophetic view. What was supposed to be written on the five flying banderoles that are left blank? The words of the spell, perhaps, that makes love appear on command? The dog seems to find nothing remarkable about the man, whom he must have heard and smelled, goes on sleeping undisturbed, seems to be accustomed to men visiting his mistress, and indeed she holds the glowing coals and the wet sponge so gingerly over the heart, and with such a tranquil gaze, that we may assume she has had practice. Do people often come to her door, and is it a different person every time? Did she once summon the devout poet Petrarch, perhaps, and is that why he liked Cologne so much? In any case *The Love Spell*, hanging brazenly between two crucifixes, teaches us that people have been suggestively appealing to the very earthly senses since the time, and perhaps were appealing to them at the time, when Cologne still had and deserved a reputation of sanctity. Today, however, during Cologne's carnival for example, which many inhabitants and all visitors seem to consider a mere mating season, while sanctity to most people is nothing more than world cultural heritage, today … well, the banderoles are blank on which we might have read how earthly and heavenly fulfilment go together.

Lust II

I finally have an inkling why the scene that Giotto all but hid high up in a corner of the Scrovegni Chapel moves me. It is not just the absolutely unexpected tenderness, the kiss on the mouth that two lovers share in public, unique in European painting probably right up to the modern period, and outrageous in a salvation history. And it is not just the age of the couple, Joachim's beard almost white, more grey than brown in Anne's hair too, and lines around her eyes that are almost visible from the chapel floor – even in present-day Western Europe, where everyone seems to permit themselves everything everywhere, two unabashed elderly kissers might not cause a scandal, but they would draw startled, disapproving looks. No, what filled me with such warmth that I would have liked to fling my arms around the woman who has been my wife for what feels like forever was the awkwardness of the contact. Joachim and Anne are not well-practised kissers, that much is obvious. They're standing too far away from each other to kiss comfortably; their feet must be a yard apart. Although the robes may conceal their movements, they still have to lean over forward in order for their lips to touch.

To be exact, it is Anne who is leaning towards Joachim, while at the same time pulling his face to hers. Her right hand presses against the back of his neck; her left seizes his beard. But Joachim lets her do so, laying his hand on the back of her shoulder, and not on the front, as he might if he thought

to repel her. Forty days and forty nights he has spent in the desert, neither eating nor drinking; 'My prayer shall be unto me meat and drink,' he said. Anne had already given him up for dead and, bewailing her widowhood, lamented the child-lessness that had driven him to do penance in the first place. And now she has him back, and, thanks to his prayers, she has conceived a child too. That is why she is the one who cannot contain herself but must draw his lips to hers. Although too close to see anything, they look into each other's eyes, as the position of the pupils indicates, paying the outside world no attention, probably not perceiving it at all in this moment. But the outside world is not hostile to them. Except for one woman veiled in black who does not care to look at such a kiss, the women are more than just friendly. Their gestures too are somewhat awkward; they laugh, rejoicing at the love that was lost and so surprisingly found again.

When two people, after so many years of sharing day-to-day life, the quarrels that must surely have occurred, anger, disappointment, doubt, crises, afflictions, and simple physical decay, wrinkles and creases, to name only the least of it – when two people have tasted the boredom that can poison even the most passionate love (especially without children, because children, in addition to everything else they do, quite simply help to pass the time) – when two people know each other's every pore, nocturnal noise and exhalation, and still remain not just loyal but affectionate, when regardless of age they still desire, and visibly physically desire one another, then they cannot help but break in a moment of the greatest joy, of fulfilment, with custom and propriety – when two people pay no mind to the disparaging looks of younger, at best infatuated onlookers, ignoring their spite – and when the onlookers on the other hand do not begrudgingly whisper, as the black-veiled woman would no doubt love to do, poisoned as she probably is by boredom – when the younger people,

Giotto di Bondone (*c.* 1266–1337) and workshop,
Joachim and Anne Meeting at the Golden Gate,
c. 1303/5, fresco, *c.* 185 × 200 cm.
In the cycle of scenes from the lives of Mary and Christ,
Cappella degli Scrovegni, Padua, right wall, top row, sixth picture.

including the infatuated among them, recognize the grandeur and the transcendence of the moment – when they outright rejoice and laugh, awkwardly if need be – when, that is, the symbiosis of two lovers softens the hearts of the onlookers, not least that of the young farmer who stares at the kiss in amazement, if not enthusiasm – then, only then, is the one set as a seal upon the other's heart and as a seal upon the other's arm. 'For love is strong as death; jealousy is cruel as the grave,' says the Song of Solomon (8: 6–7), 'the coals thereof are coals of fire, which hath a most vehement flame. Many waters cannot quench love, neither can the floods drown it.'

That would be my favourite part of the Bible, if I had to name one, my favourite passage or my favourite book, to be exact. Of course the Song of Solomon tells of two young lovers, one with bushy locks as black as a raven, the other with breasts like two young roes that are twins, which feed among the lilies. The kiss that Giotto all but hid high up in a corner of the Scrovegni Chapel says something different: isn't youthful, callow infatuation, which is what literature, well into the modern age, means when it talks of love – isn't it a flash in the pan compared with the deep ardour, which truly feels eternal to those who know it, of two lovers who have grown old together, side by side with one another, sometimes toe to toe with one another?

The thing I least associated with the Christianity I grew up with was lust. When I pictured Christians, I saw good but not beautiful people; sensible but boring homilies; loving thy neighbour, but no sex. After all, I was born in Protestant Siegen, not in Catholic Rome. Those of my classmates who read the Bible during the breaks – and there were always a few; Siegen in the 1980s was still well-versed in scripture as cities go – were not the cool kids who showed up at parties but the ones in pleated trousers and starched blouses. And although I wouldn't have said so publicly, inwardly I found

fault with Christianity for not respecting the body and for calling even conjugal sex a necessary evil. The Trinity didn't make sense to me either, but the asensuality that I attributed to Christianity positively repelled me. The annual Church Conferences in particular, which I knew as a forum of the peace movement, were the most unerotic events of all my youth, exceeded in their rectitude only by the Evangelical Academies, inventors of interfaith dialogue.

But I noticed my aversion weakening. The reason was not so much that I saw so many other faces of Christianity over the years, including some magnificently painted ones. It was mainly, I believe, that capitalist propaganda had made hedonism holiest and self-expression an ideology that cast suspicion on all abstinence. What neither religion nor Siegen itself had achieved, namely putting me off desire and lust, seduction and nudity, was accomplished only by pornography becoming an everyday phenomenon. Everyone thinking they can, indeed must, permit themselves everything everywhere seemed so horrible to me, at times so apocalyptic, that I gradually came to appreciate the pleated trousers and the starched blouses. At least there used to be pleats and starch, I said to myself at a time when I could associate Christianity only with breathable textiles, fleece jackets and thermal trousers: the very formlessness of today's worship services, in which everyone permits themselves everything everywhere, up to and including sitting in a circle. Starch is the very opposite of arbitrary, I realized, at worst a little bit rigid perhaps. And rigidity can be relaxed.

And then I discovered the kiss that Giotto all but hid up high in a corner of the Scrovegni Chapel and thought of my awkward townspeople of Siegen. And I thought I had been unjust towards them when I thought them lustless. How I would have liked to see them kissing like Joachim and Anne.

Recessional

My Catholic friend asks in a whisper why the church is so empty, even emptier than churches in Germany. I shrug my shoulders. If we haven't missed anyone standing behind a pillar, there are not more than seven churchgoers scattered among the pews, wrinkled, some of them bowed, the women in manteaux and knee-length skirts, their headscarves tied under their chins, the men in dark, mostly worn-out suits, their old-fashioned hats and peaked caps lined up on the hooks beside the entrance. Even those conducting the service are more numerous, and at least a generation younger too: a tall, very slender priest in the golden cope, three stout helpers in sky-blue robes with red stoles, the organist and choir likewise dressed in blue, only without the stoles, the three singers' hair loosely covered with white scarves.

'Counting us,' I whisper, not sure whether I am offering my friend consolation or excuses, 'there are still more people attending the service than officiating.'

I used to come to this church often when I was a student, because I was already interested in religion then, and there were so many different religions in Isfahan: Muslims of course, Armenian Christians, Jews and Zoroastrians more numerous than today, and the Baha'is, who have been suffering persecution since the state became Islamic. Still more than the muezzin's call to prayer, which was not audible in our neighbourhood, I associate Isfahan with the ringing of

church bells; my aunt lives right near the biggest church, and my parents lived not far away on the edge of Jolfa, the Armenian quarter of Isfahan. Among my cousins' friends there were always a few Christians who invited us, or whom we invited, to play when we were children, to parties when we were adolescents, and lately to talk, mostly about politics, about the state, because it had become Islamic.

Unlike the Muslims of our middle-class circles, who were more and more repelled from Islam by the Islamic Republic, our Armenian friends remained true to their faith, so that the Mass was always well attended. I got on well with them in part because they were the people I could still talk with about religion without coming up against ridicule or contempt. None of my Muslim – or should I say formerly Muslim – acquaintances would have thought of taking me along to Friday prayers, or even accompanying me.

The priest who takes us with him into his simple office after Mass reckons that, of the twelve thousand Armenians who were counted in Isfahan at the last census eight years ago, half have left the country – during the terrible years of the big talker who emptied the treasury and filled the prisons. The Muslims wanted to emigrate too, especially the young, educated people of the middle class, but they didn't have the same opportunities as the Christians and Jews, whose emigration was encouraged, financed and supervised by HIAS.

'HIAS?' my friend asks, while I act as interpreter. I have never heard the name either.

'Yes, HIAS,' the priest confirms, and explains that, for the past few years, only one organization has been promoting the exodus of Christians from Isfahan, probably from all Iran. The name the priest spells out for us is known to every Christian in Iran. A Muslim has a thousand hurdles to clear to get to the West, involving smuggling gangs, passport dealers, asylum authorities and, most of all, the feeling of being

unwelcome; a Christian needs only to yield to HIAS's blandishments to find himself a short time later in Vienna, where within one or two months he can expect a residence permit for the United States.

'But aren't the Christians being persecuted in Iran?' my friend asks.

The state, the priest explains, sees only the Muslims as its community. That is often offensive to Christians, because they haven't been treated as first-class citizens since the revolution. The state bars them, to give a simple example, from all offices and positions related to national security, from the presidency to the intelligence agency to the upper ranks of the military. That illustrates clearly enough that Christians are not considered true citizens – but honestly, who wants to work for the intelligence agency? The only thing that really restricts them is the ban on evangelism: after all, it is every Christian's duty to expound his faith. The fear of Christian proselytism has grown so great that not even the Bible is allowed to be printed in Persian any more.

'But the Bible is sacred to the Muslims too,' I interject.

'Tell that to the censors.'

From a practical viewpoint, though, the prohibition against the Christian mission has not had grievous effects either, the priest continues, since the Armenian Catholic Church has always been nationally defined, and its whole congregational life has been bound to the Armenian community. The situation is different for the new evangelical groups who proselytize aggressively, among Armenians too: they do have problems with the state; the evangelicals cannot practise their faith publicly, cannot obtain permits for their festivals; and there are said to have been arrests. But the Armenians often

Woman praying in the Armenian Apostolic Church of St George (seventeenth century), Isfahan.

find their religion an advantage, because the state interferes less in their lives. They are allowed to drink alcohol; they can hold concerts even on the Shiite days of mourning; they are exempt within their community from gender segregation and the Islamic dress code.

'In the free labour market Armenians are even preferred,' I tell my friend, 'simply because they have the reputation of being reliable, honest and industrious.'

'Yes, people appreciate us,' the priest confirms. 'We feel that too, especially since the revolution.'

'So why are the Armenians emigrating?' my friend asks.

'Because the middle class, to which most Armenians belong, is being systematically destroyed,' the priest answers.

Here in the parish they recently had a job in the museum to fill, a respectable position requiring an academic qualification – and they were ashamed of the salary they offered the applicant. The five or six hundred thousand toman that a teacher, a white-collar worker, or a museum professional earns in Iran – the equivalent of 125 or 150 euros, I whisper to my friend – won't even pay the rent. Five or six hundred thousand toman, the priest exclaims, you have to realize that doesn't even put you above the official poverty line: that means every teacher, every white-collar worker, every museum professional, even by official standards, is poor – a large part of the population, in other words.

'And that in one of the world's richest countries in natural resources,' I add.

'So you can imagine what happens when HIAS waves a green card.'

The priest says he doesn't know either where HIAS gets its money and its good connections, including some among the Iranian authorities, who do nothing to stop its mission.

'The people behind it – are they evangelicals?' I ask.

'No, no, they're Jews.'

'Jews?'

'Yes, American Jews.'

My friend casts a glance at me, his brow furrowed.

In effect, the priest explains, getting his blood up, the Americans and the Islamists are working hand in hand to purge the Orient of Christians. In Iraq, in Egypt now too, and soon in Syria, Islamists supported by America's partner Saudi Arabia are burning down the churches. In Iran, Americans are luring the Christians out of the country with money. One way or the other, the result is that the congregations are dying out. Of the twenty-four churches in Jolfa, only half are still being used, and it is difficult to keep up those that remain. On an ordinary Sunday, they are barely able to hold four Masses.

'Sunday is a working day in Iran, of course,' I explain to my friend, unsure once more whether I'm trying to offer him consolation or excuses. 'People who have jobs have to go to work.'

'But in Germany you said that the churches in Isfahan are full, and not just at Christmas and Easter,' my friend recalls.

'Yes, that's how it used to be,' I concede, 'and the bells all rang.'

What we experienced during the Mass is a rare, precious, and by now four-hundred-year-old symbiosis of East and West. The Church of St Stephen is not nearly as sumptuous as other churches in Isfahan because its interior walls, once covered with frescoes, have been plastered white in a fervour of modernization. At first glance the church looks almost Protestant. The contrast to the thoroughly Oriental-looking Safavid tilework that lines the nave to chest height is all the greater; the yellow and light-blue pattern shines all the brighter under the white ceiling. The structure too, with its square arrangement and richly ornamented, celestial cupola, resembles Islamic sacred architecture more than an Occidental church, and the floor is covered with Persian rugs

more beautiful than those found in any mosque today. But the pictures hanging on the walls, and the few frescoes that have been uncovered again, show the unmistakable brush of the Italian painters that Shah Abbas invited to Isfahan in the early seventeenth century to placate the Christians after their abduction from their Armenian homeland. The glass chandeliers too, although made in Isfahan, attest to European influence, as do the pews that have recently been installed in the church, perhaps because of the great average age of the worshippers. The chancel seems at once Eastern and Western: the arches, colours and decorations could be from the Thousand and One Nights, but at the same time I can't help thinking of a stage in a European theatre, raised three feet above the floor and with stairs at the left and right for the entrances. Hanging from a metal rod is an original Brechtian curtain that is pulled shut by a string after every section of the Mass and opened again for the next part, as they used to do at the Berliner Ensemble between scenes. But Orient and Occident are especially united in the music, which makes up almost the entire Mass: the quarter-tones of Oriental melody are unmistakable, no matter how European the harmonies of the organ and the female choir sound. And the faces! Not only do the men all look like Charles Aznavour, some in younger, some in much older years, with their bushy eyebrows and the high, narrow bridges of their noses, but the women too could appear in French black-and-white films, with their light faces and their brown, mostly curly hair, especially as they doff their headscarves after Mass with the elegance of Edith Piaf.

'In Isfahan we have preserved our Armenian culture, our language, our orthodox faith for four hundred years,' says the priest. 'But America is different; in America it takes only one generation and the language is gone, then the culture, and finally the faith. In America everyone ends up the same.'

Back in the flat on the edge of Jolfa, we google HIAS and

are dumbfounded, ashamed of our ignorance of history too, as we read under the very first link that the acronym stands for the famous Jewish organization that saved thousands upon thousands of lives during the Second World War: the Hebrew Immigrant Aid Society. During the war, HIAS helped Jews escape the Nazis; since then, the organization has expanded its aid to refugees of all faiths, advocating the right to asylum worldwide and sharply criticizing American as well as Israeli border regulations. The organization appears – at least after a first Internet search, which the big talker has not completely prohibited, although it has become a national test of patience – the organization doesn't appear to be driven in the least by imperialist or Zionist interests.

'They seem to mean well,' my Catholic friend whispers, not sure himself whether he means to offer me consolation or excuses.

Art

As if Cologne was as glad to have me back as I was to be home, it allowed me, on the very first day, to be a witness. It was my hour to look after our newborn; I was delighted, as always when I looked at her contented, alert face; I had no desire to see the Rhine, where I had been for a walk the night before to get some fresh air after the long drive; then I thought of the new window by Gerhard Richter in Cologne Cathedral, which the people of Cologne had been talking about since its unveiling.

I had actually promised my eldest to go and see it with her as soon as we got home, but the moment was so opportune and my curiosity was too great. The new window, whatever it looked like, would be our constant companion from now on, for longer than a precious rug. The only other thing I want to say about the cathedral at this point is that I had been uplifted by the idea of living at its feet since my first school excursion to Cologne, and I am gratefully aware of that idea's fulfilment when I look up at it. I was also nervous, although I had liked the photos I had seen on the Internet; I found the abstraction theoretically persuasive; and if the principle of randomness made sense to me for the novel I was writing, how much the more for a house of God.

For four years Gerhard Richter made one study after another until he had determined the seventy-two colours that were needed for the cathedral. With the help of physicists he

calculated the light's rays and their reflections at the different times of day, installed a succession of test panes in the window, made seventy-two glass squares of each colour and developed the necessary software with the help of programmers. But then he pressed a button, touched a key on the computer that arranged the seventy-two times seventy-two coloured squares using a random-number generator. Up to now, however, it was only photos I had seen and a principle I had reflected on. How would the 5,184 squares look in the cathedral window? All the critiques I had read – and during our Roman year I had read everything on the topic I could find on the web – they all sounded enthusiastic, so that strictly speaking there was no debate; there were only Cologne's cardinal on one side, who thought the window would be more suitable for a mosque, and everyone else on the other, rebutting him angrily or sarcastically. And yet they should have been grateful to the cardinal, since he was the only one to voice the dissent that is indispensable in the opinion business.

The sanctified tone in the press aroused scepticism. The cardinal's objection spoke louder in the window's favour than all the ovations. My eldest asked whether the builders could take the window for the new mosque if the cardinal refused to have it, and we worked out a letter to that effect from the Muslims of Cologne to the Catholic Church. A new window for the cathedral! I get weak in the knees with apprehension when I have to give some speech or other, yet Gerhard Richter faced a task whose audience is literally numbered in millions and millennia.

It's a common figure of speech to say something takes one's breath away, but it's not something that happens often. When I arrived with the pushchair in front of the south transept, it happened to me. I looked up and was not just speechless, but breathless. The window is huge (113 square metres, I have since read), and it glows. It radiates self-assurance, and at the

same time it negates human agency. Granted, the cathedral is mainly façade. Heinrich Böll once claimed that more natives of Cologne had seen the Klingelpütz, the city's prison, from the inside than the cathedral. Although it was intended sarcastically, it struck a true note: you don't simply step inside after a shopping expedition in the Hohe Strasse. But when a person from Cologne goes on holiday, whether to the mountains or to Italy, he stands on the balcony of his hotel room and sighs, *He fählt nur die Aussich op d'r Dom* – all that's missing is a view of the cathedral. And, at every homecoming, his heart leaps when he sees it from as far away as the A4 autobahn, and how much higher it leaps as he crosses one of the Rhine bridges, Zoobrücke or Severinsbrücke, and sees the twin spires stretching towards the sky. The cathedral is an exterior. Inside it is impressive, to be sure; it has delightful parts, views, details. But after six hundred years under construction there wasn't the energy left for a total work of art. Only from the outside is it the one and only, *the* church, the world architectural landmark. Other churches are magical inside, such as Great St Martin's in Cologne – Romanesque churches in general for that matter. There is nothing divine about the cathedral that is at the same time as light, impenetrably clear, and hence celestial as the Sheikh Lotfollah Mosque in Isfahan or the Sant'Ivo chapel that stole my heart in Rome. The cathedral is an achievement of mankind. Its very ostentation, its swagger, is what makes it great. It praises not God, but the people of Cologne. I like that, and not just because I am one of them.

With the Richter window, the interior catches up to the façade. Perhaps the window also restores something that was lost in the war. Obviously it doesn't match the other windows,

Gerhard Richter (b. 1932), Window in the south transept
of Cologne Cathedral, 2007.

or the cathedral as a whole; it radiates the present. But, after all, the cathedral doesn't belong to any specific era, since every era has made its mark on it. It would have been unfitting to add something from a bygone age today. The cathedral looks much brighter than we are accustomed to seeing it, at least in the nave, and that turns out to be a great improvement. Paradoxically, it looks not only more modern but, at the same time, older, since its connections to Romanesque churches come to light. The cardinal is right: the Richter window brings abstraction, mathematical arrangement, and even some principles of colour from Islamic architecture to the cathedral. Its influx of light dispels the darkness and staleness that had always given the cathedral the atmosphere of a storeroom. Suddenly the outside, with its changes, becomes visible. The way the sun and clouds play with the light of the south window is spectacular. And it is impenetrable in its clarity.

What is sacred art? Titus Burckhardt – who knew almost as much about art and a great deal more about religion than his great-uncle Jacob – Titus Burckhardt pointed out that by no means every work of art which takes its subject from religion can be called sacred for that reason: sacred art is 'founded on a science of forms, or in other words, on the symbolism inherent in forms', which is assured only by tradition and does not come from the individual creativity of the artists and artisans. This is one reason why the artists are often anonymous; indeed, they need not be aware of the science of the forms in their work. If I understand Burckhardt correctly, sacred art expresses a spiritual order in the world, while art that is merely religious in a general sense bears witness to subjective moods, impressions, visions, ideas. Or, to put it more concisely: religious art captures man's perception; sacred art captures God's plan. In this sense, sacred art is always a parable of creation itself. Instead of imitating creation as seen

by an individual person, it symbolizes creation's inner order – hence the avoidance of one-point perspective in Islamic miniature painting, long after it had begun to be used in Arabic scientific works; hence, ultimately, the prohibition of images, which is more precisely a prohibition of illusion: in the oft-quoted hadith, the Prophet condemns not images in general, but specifically those artists who try to 'ape', that is imitate, God's creation. The prohibition of images is directed against mimesis, and thus against a fundamental principle of art in the modern age; at the same time it encourages alienation and, more strongly, abstraction, which became constitutive of modern art. 'Pictures are better the more beautifully, wisely, madly and extremely, the more vividly and unintelligibly they describe in parables this incomprehensible reality,' Gerhard Richter wrote of painting, the 'analogy of what by nature surpasses our understanding'. By excluding the pictorial, Islamic art creates the emptiness which in that tradition is the only permissible expression of the divine; the purpose of ornament, even the barely legible ornamental calligraphy of God's word, is definitely not to fill the emptiness, to negate its infinity – by its continuous, regular and, most importantly, endless-seeming woven structure, ornament represents infinity.

That is a completely different principle – an equally plausible or implausible one – from that of church architecture once it became definitely Western; not in the Romanesque, which still incorporated the structures and the colour patterns of the East, but since the Gothic, which gave the cathedral its basic shape as that of the crucified body – with the nave as the torso and legs, the transept as the extended arms, and the apse as the head. The cathedral, as an example of all church architecture, is oriented towards the place where God was present on Earth; it describes man's movement towards God, a long passage from the outside world through the nave to

the altar, where light falls steeply downwards: if the whole church represents the body of Christ on the cross, this is his heart. A mosque on the other hand has no centre – not even the *miḥrāb* or prayer niche, which merely indicates a direction; no one would pray in the niche itself; it would be too small anyway. From anywhere in the interior, the faithful look into the cupola arching over them like the vault of heaven. That means the mosque is oriented not towards God's appearance at a certain place, in a certain person, but towards the aesthetic expression of God's omnipresence. In a mosque, no matter where the worshipper sits, stands, or prostrates himself before God, he is surrounded by the universe and the symbolism of infinity in circular forms, without edges or corners blocking his vision. 'But even the Kaaba is not a sacramental centre comparable to an altar, nor does it contain anything to symbolize such a centre, for it is empty inside,' Titus Burckhardt remarks. 'While the Christian consciousness of God is principally gathered in an objective midpoint – just as the "incarnate" word of God, as a turning point in history and in the form of the Eucharist, is a proclaimed midpoint – the Islamic consciousness of God denies any objectified centre of gathering and instead rests on the experience of expanse and endlessness to sense God's omnipresence.' And now in the cathedral, the cathedral of all places, the strict focus on just one place is, I won't say abolished, but augmented by a view in another direction and by another principle: by the view towards Heaven, where God also is, and by the aniconic principle, which is also biblical. Not God's incarnation in a single man, but His omnipresence as light, 'like unto a stone most precious, even like a jasper stone, clear as crystal,' as the penultimate chapter of the Book of Revelation says of the heavenly city, 'and I saw no temple therein: for the Lord God Almighty and the Lamb are the temple of it.' The role played in sacred art by tradition, which

was held to be divine, and which was supplanted in the course of the Enlightenment by human genius, is for the new cathedral window the button Gerhard Richter pressed to start the random-number generator.

The people of Cologne – I could tell most of them were from Cologne by the melody of their speech – stand in clusters in front of the new window, looking up like sleepwalkers. There is also a sense of relief that nothing has been done to the cathedral, our cathedral, except good. The operation was successful, a heart surgeon would sigh. After only a first visit I find it already inconceivable that they could have put up something figurative, as the cardinal wanted: the Catholic martyrs of the twentieth century or – no, someone else must have proposed this – a treatment of the Holocaust.

Later I would read that the seventy-two colours do not appear with equal frequency in the cathedral window; certain tones occur slightly more often. Furthermore, Richter did not cover the whole area with uniform randomness but used repetitions and reflections in certain places. And in the tracery parts he found that the geometry of the stonework had to be taken into account. The sacred too is not God's work alone.

Friendship

In studying Francis of Assisi, who appeared the more saintly to me the less I believed the hagiography, I discovered a staggering assertion in an anthology published by the North American Franciscan Institute: in a meticulously documented, cogently argued and bone-dry essay, the director of the institute, Michael F. Cusato, comes to the conclusion that, in the famous Cartula, the sheet of parchment that Francis wrote upon immediately after his stigmatization to give to his brother monk Leo – one of only two extant manuscripts in Francis's own hand – St Francis very probably expressed his deep affinity with Islam and his particular friendship with the sultan of Egypt, al-Malik al-Kamil. This is not the place to retrace Cusato's train of thought in detail – the interested reader may see 'Of Snakes and Angels: The Mystical Experience behind the Stigmatization Narrative of 1 Celano' in *The Stigmata of Francis of Assisi: New Studies, New Perspectives* – and so I will mention only his four most important arguments.

To wit: (a) the time and the circumstances of the mountain retreat at La Verna where Francis had the mystic ecstasy in which he received the stigmata: as scholars up to now have little noted, Francis withdrew with his closest companions to fast in late July or early August 1224, just when Pope Honorius III had announced another crusade against the sultan. It cannot be proved, but it is plausible that Francis's dejection,

or possibly depression, at that time, reported in many sources, was connected with the general mobilization; for, according to all we know about his life, his words and in particular his journey to Egypt and Syria, he must have despaired of his own church and Christianity as a whole, which were ready to wage another war in the Orient, and a war against al-Malik al-Kamil at that, who, instead of taking him prisoner or killing him as his fellow Christians had predicted, had given Francis a friendly reception in Egypt five years before. Because the Archangel Michael, to whom the retreat was consecrated, was revered as the protector in battle, Cusato suspects that Francis climbed to La Verna to pray for the sultan.

The suspicion is also plausible because, as scholars have again little noted, (b) the famous Praise of God that Francis wrote on the back of the Cartula draws distinctly on the ninety-nine most beautiful names of God, the Islamic rosary so to speak, with which he was surely acquainted from his meetings with Muslims: 'Thou art Love, Thou art Wisdom, Thou art Humility, Thou art Patience, Thou art Beauty, Thou art Refuge, Thou art Charity, Thou art Tranquillity, Thou art Joy and Gladness, Thou art our Hope, Thou art Justice' – and so on.

This in turn leads Cusato to (c) the suspicion that the blessing Francis wrote on the front of the parchment – 'May the Lord bless thee and keep thee; may He show His face to thee and have mercy on thee; may He turn His countenance to thee and give thee peace' – was written not with Brother Leo in mind, as the scholars have assumed up to now, but Sultan al-Malik al-Kamil. In this case, Brother Leo, in referring later to a 'friend', also meant the sultan.

And finally, (d) the last, decisive link in the chain of arguments that Cusato forges in support of his interpretation of the Cartula as an early – perhaps the earliest – document of the friendship between Christianity and Islam: the oblong,

rounded shape under the tau cross, usually thought to be a head, supine, or a skull, that of either Adam or Brother Leo. Cusato claims to discern a turban and whiskers below the tau, and thinks Francis, however hastily and spontaneously, drew the head of the sultan – and drew it so that the tau issues from the sultan's mouth. That would imply that the sultan acknowledged the cross, or, more probably, should acknowledge it – that is, Francis prays God to lead the sultan to the path of salvation lest he die an unbeliever on the battlefield. For to someone like St Francis, one thing is clear: because the sultan is a friend, he would like to see him convert and save his soul. What sets Francis apart from his time is not any lack of missionary zeal; it is the peaceful way in which he advocates the path of Christ: members of his order must have neither disputes nor contentions with the 'Saracens and other infidels', he stipulated in chapter 16 of the *Regula non bullata*, probably in 1221, shortly after his return from the Orient; the Friars Minor must 'be subject to every human creature for God's sake, yet confessing themselves to be Christians'.

That sounds like a stereotype of today's interfaith dialogue, in which no one wants to convert anyone else and provocation is limited to confessing one's own faith, unless it has indeed already dissolved in a general do-goodism uniting all mankind. But, in the early thirteenth century, such a sentence from the pen of a Catholic monk was an enormity; no wonder that the 16th chapter, except for two innocuous legal provisions, was struck out from the rule less than two years later, after Francis had resigned as head of the order in anger over interference by the curia – 'From now on, consider me dead!' Canon law, specifically a resolution of the Third Lateran Council of 1179, prohibited Christians from submitting to infidels: consequently, Jews could not hold public office, and it was completely out of the question to submit voluntarily to the Saracens' sovereignty, as Francis had done. By papal

Cartula of St Francis: *Blessing for Brother Leo*, 1224. Sacro Convento, Assisi.

order, the Christian policy towards Islam must be 'purification of dross', and a widely known propaganda song, alluding to Psalm 137: 9, said, 'Happy shall he be that dasheth thy little ones against the stones; happy the daggers that the knights of Christ wield.' The crusade bull *Quia maior* of 1213 also decreed that, after the kiss of peace, all men and women must prostrate themselves on the floor of the church for the singing of Psalm 79: 1, 'O God, the heathen are come into thine inheritance'; and when the prayer was ended with the beginning of Psalm 68, 'Let God arise, let his enemies be scattered: let them also that hate him flee before him,' the priest must call upon God 'to snatch from the hands of the enemies of the Cross the land which Thine only-begotten Son consecrated with His own blood and to restore it to Christian worship.' That was done not just here and there but ordered for all Masses in all Catholic churches for years and decades – a ritualized rehearsal of hate. Accordingly, every male Christian who evaded the universal military duty without purchasing exemption by a great financial contribution was to be found guilty by the Church of sinful ingratitude and sacrilegious perfidy. The monasteries were an integral component of the war machine: although monks were excluded from active participation in the crusade, the abbeys played a significant role in financing and propagating it.

Francis alone resisted. While Christianity, and with it all Christian writings, was filled with the ideology of holy war, not a single positive mention of it by Francis is known, much less a word of support for the crusade. While the papal bull calls Muhammad a 'son of perdition' and grants Islam the apocalyptic title of the 'beast', not a single hostile or even haughty remark by Francis about the Saracens has been handed down. While the Christian world waged three crusades against the Saracens within Francis's lifetime alone, he marched, with no weapons, with no protection of any kind, and with no money

or possessions, with just one barefoot brother, into the camp of Sultan al-Malik al-Kamil, the enemy and Antichrist, and called out, apparently aware of the Islamic greeting *salam alaikum*: 'May the Lord give you peace.' The decision to travel on a mission of peace to the Orient during the Fifth Crusade is the more remarkable because Francis had no historic model – except, in a certain sense, the Gospel itself. The whole peace movement consisted of Francis alone.

But this Fifth Crusade must have shaken him more deeply than the preceding war, which had been waged primarily by the kings and noblemen, although the Church had supported it to the best of its ability. The Fifth Crusade, however, was declared by Pope Innocent III personally and led by the Church. That is why *Quia maior* constitutes the high point of a theological militarism that had been developed primarily by Bernard of Clairvaux – the rigorous abbot who claimed to have received his message from Mary personally – a theology in which those who kill or die for Christ's sake are worthy of the highest praise. Moreover, in Bernard's argument, when the Christian kills, it is to Christ's benefit; if the Christian is killed, it is to his own benefit. That is why, in addition to the many political and social reasons, the holy war attracted so many fighters: because it promised direct access to Paradise even to the worst rogues.

That sounds like a stereotype of today's political reporting, and its essence is in fact related to jihadism, the ranks of which are filled with former criminals. 'You should therefore always be prepared to shed your blood for Christ,' wrote Jacques de Vitry, Bishop of Acre and one of the chief preachers of the Fifth Crusade,

that is, to lay down your lives for God with the sword and with your full will, following the example of that knight of Christ who, when he saw a horde of Saracens, began to speak to his

horse, his heart filled with great faith and joy: 'O Morel, my good comrade, I have lived many good days in the saddle and on your back, but this day will surpass all of them, for today you will bear me to Paradise.' After these words, he killed many Saracens, and then was finally killed in battle himself. He has attained the crown of martyrdom in eternal bliss.

You love life, and we love death.

The religious idealization of war was carried to such an extreme that the pope rejected the peace treaty that Frederick II concluded with al-Malik al-Kamil on 18 February 1229 in Jaffa, although it would have granted the Christians dominion over Jerusalem, Bethlehem and the cities along the pilgrimage route from the coastal city of Acre in exchange for a truce. The pope's rationale: the bloodless liberation of the holy sites would have robbed the Christians of the opportunity to earn salvation by sacrificing their lives. As inhuman, and decidedly un-Christian, as the idea may seem today, we must take it seriously as a religious concept – as seriously as the religious rhetoric of the 'Islamic State' – if we are to recognize the audacity, the originality and the theological implications of the mission Francis took upon himself. He, the saint with whom Christians today identify as with no other, stood practically alone against his time, stood against the Christianity he found on every hand to the point of openly flouting canon law. And he remained alone: in striking the 16th chapter of the *Regula non bullata*, the later rule also changed the meaning of the other provisions, such as the principle that the brothers must always be 'the lesser': 'let them be inferior and subject to all who are in the same house,' as the 7th chapter stipulated. It did not help matters that Francis insisted to the very end on the universal nature of Christian love. 'We were uneducated and subordinate to everyone,' he writes in his Testament, recalling the commandment of subjection to all, not just

members of one's own faith, and explained his response to *salam alaikum* by divine inspiration: 'The Lord has revealed to me that we should say in greeting: May the Lord grant you peace.' Not long after his death, Franciscans too distinguished themselves as crusade preachers, and in the hagiographies of their order's founder the Saracens were 'rude barbarians' and 'unfeeling hearts' such as Francis had never mentioned.

But how do we know how Francis talked about the Saracens? The voyages to Egypt and Syria are known only from the accounts written by those who came later, visibly embellishing them to the glory of the Church, waxing more fanciful as the years rolled on. The friendly encounter, which is at least suggested in the earliest biography by Thomas of Celano, becomes in later hagiography a contest of the religions which Francis survives only thanks to a miracle. In Thomas's version, the Muslim soldiers have only scorn and derision for Christianity, but 'the sultan himself neverthe-less received him with extreme generosity.' In the Chronicle of Ernoul, Francis invites the sultan to summon the most learned people in his land so that he can 'prove to them on the basis of sound arguments that their doctrine is nothing.' In Bonaventure, the disputation broadens into the famous ordeal by fire that Francis proposes with the chutzpah of a magician. The story becomes heart-rending when the sultan, already all but persuaded by Francis, out of fundamental obduracy or for fear of his co-religionists, refuses salvation after all: 'When that cruel beast [the sultan] saw Francis, he recognized him as a man of God and changed his attitude into one of gen-tleness,' the crusader bishop Jacques de Vitry wrote when Francis was dead and could no longer contradict him. And of course the hagiographers are unanimous in assuming that Francis went to the sultan not to sue for peace but to meet certain death and become a martyr: 'He longed so greatly to die for Christ that he went among the infidels to preach the

Christian faith, even to the cruel sultan,' Cardinal Odo de Châteauroux asserted less that fifty years after Francis's death in his sermon on the saint's feast day at Paris, 'but when the sultan perceived his intention, he refused to make a martyr of Francis, and so deprived him of that great honour.' In the *Compilatio Assisiensis*, the saint turns out to be an apologist for the crusades, glorifying the fallen as martyrs because they 'pursued the infidels unto death with much sweat and strife: thus they attained glorious and noteworthy victories.' All of this is so incredible, I have learned from recent Francis scholarship, a good deal of which is conducted by Franciscans, because it contradicts the surviving statements of St Francis himself, his letters, which were long kept secret, and the two earliest biographies by Thomas of Celano, which were rediscovered only in the twentieth century, having been expunged by the Franciscan order after Bonaventure's hagiography was pronounced canonical.

Without a doubt, Francis had trust enough in God to die for his faith if necessary, but there is no indication in his writings that he might have sought martyrdom or purposely brought it to pass – on the contrary: his instructions to missionaries are undeniably oriented towards living with, and under the laws of, the Saracens. And Francis was no scholar seeking victory in learned disputations; he didn't even think much of preaching. He did not preach the Gospel so much as live it, teaching it by example. And accordingly, the 16th chapter of his rule begins not with the proclamation of Christ's mission from Matthew 28: 19 – 'Go ye therefore, and teach all nations, baptizing them in the name of the Father, and of the Son, and of the Holy Ghost' – but with the commandment to meekness from Matthew 10: 16: 'Behold, I send you forth as sheep in the midst of wolves: be ye therefore wise as serpents, and harmless as doves.' Francis replaces the Church's eschatology of war with the eschatology of a terrestrial paradise: by

going among the Saracens 'as sheep' – that is, in the spirit of humility – the brothers learned that wolves are not necessarily cruel, ravenous beasts, and that sheep can live with them in peace. And so the Kingdom of God is restored in which 'the wolf also shall dwell with the lamb' (Isaiah 11: 6). For Francis, the voyage to the Orient was thus a renewal of his awakening: just as he had learned among the lepers that not they, but the people of money and vainglory – hence his own relations – are a danger to society, now among the Saracens the enemies turned out to be friends, while the supposedly faithful – Francis had seen with his own eyes the crusaders' massacres, pillaging and broken treaties – behaved like enemies of God. After the conquest of Damiette, in which 60,000 Saracens died 'without sword and struggle', Jacques de Vitry rejoiced at the genocide and at the Christians' breach of the surrender agreement in which the survivors had been assured of a free retreat: 'The Lord hath unsheathed His sword and killed the enemies, from the greatest to the littlest.'

We can only speculate as to whether the peace that the sultan offered the Christians in 1219 and again in 1228, with his proposals to cede dominion over the holy sites, was also inspired by his meeting with Francis, who had answered the Islamic greeting. 'Do not say to him who wishes you in greeting peace, "Thou art not a believer",' says the Quran in Surah 4, verse 94, which presumably was already among the core principles of a Muslim upbringing in the Middle Ages. Arabic sources mention a monk who visited al-Malik al-Kamil: 'And what happened to the sultan because of the monk is well known,' says one inscription, without informing us exactly what was once well known – was it perhaps his pacification? In any case, the sultan encouraged Francis and his brothers to visit the holy sites and gave them a horn that is said to have granted them safe conduct. And not only that: al-Malik al-Kamil allowed St Francis to preach to the Muslim soldiers.

Jacques de Vitry, who reports it, can explain it, in view of the sultan's cruelty and intransigence, only as a miracle brought about by the saint's charisma; but if we study the sultan's biography, such liberality seems only logical.

The ruler Francis met in Egypt was a gentle and very devout man; Arab historians have often underscored those traits, recounting how al-Malik al-Kamil drew the criticism of the legal scholars for his surrender of Jerusalem, as well as for releasing Christian prisoners of war and for his opposition to converting churches into mosques. When he had finally defeated the crusaders, he gave them more than just their lives; he gave them food, equipped them with ships for their return home, and held a farewell banquet for their leaders. 'Those whose parents, sons, and daughters we killed with various tortures, whose property we scattered or whom we cast naked from their dwellings, refreshed us with their own food as we were dying of hunger,' writes Oliver of Cologne in his history of *The Capture of Damietta*, 'and so with great sorrow and mourning we left the port of Damietta.' Home again, Oliver wrote a letter to the sultan to thank him:

> When the Lord allowed us to fall into your hands, our impression was not that of being in the power of a tyrant or ruler, but under the tutelage of a father who showers us with good deeds, stands by us in danger, visits us at trial, and supports our grievances. You cared for our sick; you forcefully punished those who mocked us.

Realpolitik was certainly a motivation for that magnanimity, as the sultan himself admitted (although his policy was not to prove realistic): weakened by the long war and pressed by his opponents, he preferred to give the Christians no cause to plot revenge. At the same time, however, the mercy the sultan showed was characteristic of his piety in other matters.

The fact that al-Kamil was sympathetic to Sufism, followed the teaching of the crucified Hallaj, and maintained friendships with famous mystics of his time may have been decisive when Francis appeared before him dressed in a simple, threadbare, dusty piece of wool. A Sufi! al-Kamil may have thought on seeing him: the word, after all, is derived from the simple, threadbare, dusty piece of wool, *sūf*, that the Sufis too wore. But God knows it was not just his clothes: if there is one out of all the Christian saints who fits the stereotype of the Islamic God-seeker, God-lover, God-botherer, it is Francis of Assisi. His poverty and abstinence, his love for his enemies and radical submission to God, his hours and days of meditation and his periodic religious ecstasies, his charisma and his humility, his candour towards rulers and his fellowship with the poor and the lepers, all the exaltations, the absolutes, sometimes the eccentricities and provocations, up to and including outright scandals – in the Orient these were associated with ascetics such as al-Wasiti, who was arrested for having declared the souls of unbelievers saved; in court al-Wasiti lectured the qadi, 'If these people are not exculpated in your judgement, they are in God's.' Kazaruni's description of the ideal Islamic mystic in the early eleventh century could be applied word for word to St Francis: 'In your humility and meekness towards people, be like the ground under their feet, and in your kindness and generosity be like the water that bathes them, and let your indulgence shine on them as the sun shines, that is to say, deny your indulgence neither to the noble nor to the lowly, as the sun denies no one its warmth.' Even Francis's distinctive reverence for nature and for animals was familiar to the sultan from the Sufis, who were practically the patron saints of the despised dogs and sometimes talked to the birds. The most beautiful Sufi story to me has long been that of Imam Ali breaking out in tears when he accidentally injures an ant with his foot, and then trying to help the ant. In

his dreams at night he hears the Prophet scolding him, saying he should be careful where he walks because Heaven was in mourning for two days for the ant. Ali begins to tremble and his teeth to chatter at the thought of the ant's pain, but finally the Prophet comforts him, saying the ant has interceded on his behalf.

Considering that Francis spent a week in the sultan's camp, or almost a month according to some accounts, and wandered in his *sūf* cassock perhaps as far as Syria, he must have met numerous Sufis – in fact, the *shaykh al-akbar* himself, the greatest master of Islamic mysticism, Muhyiddin Ibn Arabi, was wandering through the same regions at the same time. And if I, wandering in Trinità dei Monti or in Mar Musa, encountered the cheerful submission to God that I associate with Islam – starting with the word itself – then Francis, conversely, will have found the religious life of the Sufis Christian; and after all they did refer directly to the Gospel, and especially the Sermon on the Mount. Francis will also have observed the simple people who organized their day's work around the five daily prayers; he will have gone into the simple mosques with their courtyards like gardens of Paradise and their cupolas like the vault of Heaven; he will have been amazed to see the poor who, if they happened to arrive first for prayers, naturally took their places in the first row, and to see the leader of the prayers stepping down into a recess in the floor so that he stands lower than all the other worshippers; he will have learned the *inshallah* that Muslims add to every wish or hope – 'God willing' – and the *mashallah* which they say of any past event – 'What God has willed'. He will have experienced their hospitality on his long journey with no money, no escort, no luggage or provisions and been amazed at the tolerance that he must have encountered in spite of the crusades, because it is documented in the writings of the Templars and the Copts, to whom most crusaders seemed like barbarians,

arrogant, brutal and unmannered. In any case, Francis was so struck by the alleged enemies that, on returning to Europe, he collected their manuscripts: 'Because the letters occur in them from which the most glorious names of the Lord our God are composed,' he answered a brother who had asked him why, 'and the good that is found therein belongs not to the infidels, nor to any people at all, but to God alone, to whom all good belongs.' But Francis not only kept one or more copies of the Quran, which is plainly what he was referring to here; in Assisi he instituted an imitation of the central religious practice of Islam: 'Every evening, at the call of a herald, or in another way, let praise and thanks be given to almighty God by all the inhabitants,' he proposed, inspired by the call of the muezzin, introducing a kind of Christian ritual prayer. 'When His name is pronounced, you shall prostrate yourselves with your forehead upon the ground and worship Him in reverence and adoration.' And the peace that Francis had passively advocated before his journey he propagated openly after his return in pulpits and market squares. And he ended all his sermons with the formula 'Whatever God pleases'.

I notice in writing this that it sounds like an apologia, but I have copied almost all of it from Franciscan research. Moreover, in one Franciscan historian, Sr Kathleen A. Warren, I found the Islam with which Francis evidently was happy to live described more lovingly than I will ever dare to do:

He heard of the reverence they had for the Name of God. He heard of the presence of God on earth in God's Word, the Holy Quran. He experienced their reverence for this Word in their attentive listening, savoring the Word on their tongue, their respect for the written word in the calligraphy decorating their mosques. He experienced their receiving this Holy Word as a living presence among them. He heard about and

witnessed their rich and pervasive prayer life: being called to prayer five times a day, complete with a purification ritual and prostrations. This is a prayer of the heart in which the whole body participated. It acknowledged the struggle involved in turning one's heart to God and the constant temptation to turn to self in place of God. It recognized what a proper response tears and weeping is for the alienation from God humankind experiences. It celebrated gratitude to the giver of all good gifts in word and action, specifically through generosity to the poor. In its most mystical form it proclaims the rootedness of the human in God's love and desires nothing but deeper union with that loving God. In that context, love is the way and the means and the goal unto radical transformation so that even the enemy can become the friend. In the striving to surrender to God's will and thus to enter into God's peace (the true meaning of Islam and Muslim), one empties oneself of everything for God's sake and divests oneself of reliance on the material world. Thus the struggle with oneself, if victorious, brings about true freedom to be exactly what God created the person to be, one who freely chooses to embrace God's ways, God's path of mercy and compassion. This brings about unity and oneness on the earth among all peoples, reflecting Allah Who is One. No matter what others thought about the Saracens, Francis found them to be believing, praying, peace-filled people.

What I read about Islam seems unreal to me too as I study the life of St Francis in the autumn of 2014. Because I also read the newspapers, scroll down the headlines in the Internet in the evening. Just as Christianity, in the books about the crusades, is always linked with something terrible, I am frightened by everything I read in the papers about Islam – just this morning the news of another American hostage beheaded, of acid attacks on insufficiently veiled young women in Isfahan.

But the time of the crusaders also produced a Francis, and our time will also produce saints, God willing, with whom future Muslims will identify. 'And when you are greeted with a greeting, greet with a fairer than it, or return it' (Surah 4, verse 86).

I took my Catholic friend along to Assisi. He was a little bit reluctant; the trip was long, and he revered Francis but not the Franciscans. It is indeed astounding that a mausoleum more sumptuous than St Peter's was erected for the priest of the poor almost as soon as he was dead. And in the ceiling vaults of the lower church, to mention just one example of the heretical glorification of St Francis, he is seated on the throne that is reserved, in any other church, for Christ. But, on the other hand, my friend said as we stood amazed under the vault, it was of course clever of the pope to elevate Francis into Heaven. Clever? Yes, much cleverer than branding him a heretic, said my friend; such a thorn could not be extracted from the Church's side: it could only be covered in gold. But it really is an unbelievably beautiful mausoleum that the pope built for Francis, I murmured, and was almost reconciled with his co-optation, especially since I had found thorns enough in the Franciscan literature. It is all the more lamentable that no other order is so free of preoccupation with form, my friend continued, and found the most disparaging comparison to describe the Mass we had attended that morning: a Church Conference. When we had thoroughly studied all the walls and sat a long time, first in the upper and then in the lower church, we prayed at the shrine of Francis, he with folded hands, I with hands outstretched.

I hadn't told him anything about the Cartula, not just because I wanted to surprise him but also because I was unsure whether the oblong-rounded figure below the tau cross actually represented the sultan's head. In the very small illustration that was printed in the essay, I had been able to

discern neither a beard nor a turban – no head at all, to be honest, whether Brother Leo's or Adam's. But because my research had confirmed all of Michael F. Cusato's other arguments, I had made the trip to Assisi to see the beard and the turban with my own eyes, and had persuaded my friend to come along so that he too might be glad to see an early, perhaps the earliest, document of the friendship between Christianity and Islam. Standing in front of the glass behind which the Cartula is displayed, I pointed to the oblong, roundish figure below the tau cross.

'Can you make it out?' I asked, since, try as I might, I couldn't recognize a thing.

'What am I supposed to see?'

'It's supposed to be a head.'

'A head?'

'Yes, a head with a turban and a beard,' I said, and recapitulated arguments (a) through (d) for the theory that St Francis, immediately after receiving the stigmata, might have expressed his deep affinity with Islam and his friendship with the Egyptian sultan al-Malik al-Kamil in particular.

'That's all well and good,' said my friend, 'but there's no turban and no beard.'

'There's not even a head,' I finally admit.

'It's more like something wild-boarish.'

'Wild-boarish?'

Both of us pressed our foreheads to the little pane of glass, which may have looked somewhat strange to any outsiders watching – two grown men staring like children into a laterna magica, and so presenting their hindquarters to the rest of the world.

'They really could be a wild boar's bristles,' my friend murmured.

'Maybe it's an outstretched arm,' I said, not ready to give up, 'and it's holding a cross in its hand.'

'But there's no hand anywhere.'

'I admit St Francis wasn't a very good artist if that's supposed to be the head of a sultan.'

'Or else he was the first abstract artist!' my friend said, with a teasing punch in my ribs.

'It's really just a spot,' I said, straightening up, 'an ink blot.'

'I've got it, I've got it!' said my friend, pulling me back to the glass.

'Yeah?'

'Below the tau ...'

'Yeah?'

'That's clearly a strawberry leaf, and a strawberry.'

'A what?'

'A strawberry leaf. Or blackberry.'

'You're impossible.'

'But our trip was worthwhile all the same.'

Acknowledgements

In 2008, shortly before I went to Rome to spend a year at the Villa Massimo, I received a request from the *Neue Zürcher Zeitung* to write an article for the paper's series of essays on specific works of art. Before leaving Cologne, I sent a short passage from my novel in progress, *Dein Name*, about a picture in the Wallraf-Richartz Museum. In Rome I wrote another piece, and then another and another. Finally there were eight essays on artworks that ended up in the novel which appeared in advance in the *Neue Zürcher Zeitung* – including one on Guido Reni's *Crucifixion* that gave rise to some public controversy in connection with the Hessian State Cultural Award. I soon perceived that my engagement with Christian art had only just begun, and so I continued working – or started in earnest, because I only then imagined a separate book – when the novel had been published in 2011. Thus *Wonder Beyond Belief* is the third book – after *Über den Zufall* ('On Chance'), my Frankfurt Lectures on poetics, and *Ausnahmezustand* ('State of Emergency'), my travel reports – to arise from the accumulated material that the novel *Dein Name* also comprised from its inception. Musicians ordinarily publish their albums first and their archives of demos, sessions and aborted takes only later, if at all. *Dein Name* seems to have done the opposite; it was in a sense an archive from which subsequent individual, self-contained albums were not simply excerpted, but grew, as twigs grow out of a tree (and

may continue to grow; we shall see). The rewriting of the first sections, which I had written into the novel, followed from the plan of the present book and from my own point of view, which had changed in the course of my study of Christianity and its art.

As the reader will have noticed from the opening pages, the book is not a scholarly work but a freely associating meditation on – an expression of wonder at – forty images, concepts, saints and rituals. Nonetheless, it draws on many works, most of them scholarly, which I have read over the years and which have shaped my ideas, my impressions, and even my emotions. And, of course, I have also consulted reference works in theology and art history again and again while writing, as well as the pertinent monographs on individual artists and the catalogues of collections and exhibitions. In order to keep the bibliography concise, in keeping with the character of the present book, I have limited it to those titles from which I have directly taken individual pieces of information and insights. My thanks go to the countless scholars, however – often identified only by their initials under encyclopaedia entries – all of whom together are working, meticulously, passionately, and ultimately for little earthly reward, on what may be humanity's greatest project: the one we call culture.

I owe my thanks to the Villa Massimo with its wonderful staff and its director, Dr Joachim Blüher. It was during my year in Rome – the many walks, encounters and readings and some of the excursions organized for the visiting fellows – that I found myself on the trail of a Christianity of my own. In the Vatican, I also thank the Most Reverend Archbishop Dr Georg Gänswein and the Right Reverend Dr Eugen Kleindienst, who granted me access to unforgettable sights. In Assisi, Brother Thomas Freidel gave me a most cordial reception and a tour of the Basilica San Francesco. I thank the community of Mar Musa in Syria, and in particular

Sister Carol, Sister Friederike and Father Jens Petzoldt, for their hospitality at the monastery, and for the time they took later to talk to me about Father Paolo. I also owe thanks to the Krokodil literature festival and the Goethe Institute in Belgrade, and to the Qendra cultural centre in Priština, all of which invited me to travel to Serbia and Kosovo. I especially thank Roman Bucheli of the *Neue Zürcher Zeitung*, the editor who not only published my essays in the series *Bildansichten* – which I cannot praise highly enough, by the way – but solicited them, and then improved them by his comments. I thank my German publishers, C. H. Beck, for their fantastic collaboration yet again, and especially my editor of many years, Dr Ulrich Nolte; his assistant, Gisela Muhn; the book's designer, Jörg Alt; and Jasmin Daam, who painstakingly researched the illustrations. Dr Holger Arning of the Department of Medieval and Modern Church History at the University of Münster read the manuscript and made numerous corrections in regard to the history of theology and the Church. Any errors that remain are entirely my responsibility, and the more so because I have in certain cases intentionally preferred interpretations or views that are controversial (to say the least) in the pertinent academic fields. Not only is my book often more interested in believed truth, and in aesthetic truth, than in what is considered historically true today, but it is also itself an expression of religious and aesthetic experience.

And my Catholic friend? God has blessed me with more than one.

Cologne, Nowruz, 1394
Navid Kermani

Bibliography

The Bible is quoted after the King James Version. Quran verses are quoted after the English translation by Arthur J. Arberry, or after the author's German translation, which draws on that of Friedrich Rückert.

Adorno, Theodor W., 'Parataxis: On Hölderlin's Late Poetry', in *Notes to Literature*, vol. 2, trans. Sherry Weber Nicholsen. New York: Columbia University Press, 1992, pp. 109–52.

Alcolea, Santiago, *Zurbarán*, trans. Sörine Lasche. Barcelona: Poligrafa, 2011.

Andrae, Tor, *In the Garden of Myrtles: Studies in Early Islamic Mysticism*, trans. Birgitta Sharpe. Albany, NY: SUNY Press, 1987.

Badde, Paul, 'Roms geheimer Schatz', *Vatican-Magazin*, no. 5, December 2007, pp. 6ff.

— *Heiliges Land: Auf dem Königsweg aller Pilgerreisen*. Gütersloh: Gütersloher Verlagshaus, 2008.

Bätschmann, Oskar, *Giovanni Bellini: Meister der venezianischen Malerei*. Munich: C. H. Beck, 2008.

Belting, Hans, *Bild und Kult: Eine Geschichte des Bildes vor dem Zeitalter der Kunst*. 5th edn, Munich: C. H. Beck, 2000.

— *Florenz und Bagdad: Eine westöstliche Geschichte des Blicks*. Munich: C. H. Beck, 2008.

Berger, Klaus, *Jesus*. Munich: Pattloch, 2004.

— *Kommentar zum Neuen Testament*. Gütersloh: Gütersloher Verlagshaus, 2011.

Bertaux, Pierre, *Friedrich Hölderlin: Eine Biographie*. Frankfurt am Main: Insel, 2000.

Bonaventure, *The Life of S. Francis of Assisi: From the 'Legenda*

Santi Francisci' of S. Bonaventure, ed. Henry Edward. London: Washbourne, 1868.

Borchert, Till-Holger, *Hans Memling: Porträts*. Stuttgart: Belser, 2005.

St Bridget of Sweden, *The Revelations of St. Birgitta of Sweden*, vol. 4, ed. Bridget Morris, trans. Denis Searby. Oxford: Oxford University Press, 2015.

Bruckstein, Almut, *Vom Aufstand der Bilder: Materialien zu Rembrandt und Midrasch*. Munich: Fink, 2007.

Büchsel, Martin, *Die Entstehung des Christusporträts: Bildarchäologie statt Bildhypnose*. Mainz: von Zabern, 2003.

Bull, Duncan (ed.), *Rembrandt – Caravaggio*. Amsterdam: Rijksmuseum, 2006.

Burckhardt, Jacob, *The Cicerone: or, Art Guide to Painting in Italy*, trans. A. H. Clough. London: John Murray, 1873.

— *The Civilization of the Renaissance in Italy*, trans. S. G. C. Middlemore. London: Penguin, 1990.

Burckhardt, Titus, *Vom Sufitum: Einführung in die Mystik des Islam*. Munich: O. W. Barth, 1953.

— *Sacred Art in East and West: Its Principles and Methods*, trans. Walter James (Baron Northbourne). London: Perennial, 1967.

— *Spiegel der Weisheit: Texte zu Wissenschaft, Mythos, Religion und Kunst*, ed. Irene Hoening. Munich: Diederichs, 1992.

Carminati, Marco, *Veronese: The Wedding at Cana*. Milan: 24 Ore Cultura, 2012.

Conisbee, Philip, *Georges de La Tour and his World*. Washington, DC: National Gallery of Art, 1996.

Corbin, Henry, *L'Homme de lumière dans le soufisme iranien*. Saint-Vincent-sur-Jabron: Présence, 1971; Eng. trans.: *The Man of Light in Iranian Sufism*, trans. Nancy Pearson. New Lebanon, NY: Omega, 1994.

— *Alone with the Alone: Creative Imagination in the Sūfism of Ibn 'Arabī*. Princeton, NJ: Princeton University Press, 1998.

Dalarun, Jacques, Cusato, Michael, and Salvati, Carla (eds), *The Stigmata of Francis of Assisi: New Studies, New Perspectives*. St Bonaventure, NY: Franciscan Institute, 2006.

Dall'Oglio, Paolo, 'In Praise of Syncretism: A Message to Jesuits Involved in Muslim–Christian Relations', trans. Thomas Michel, www.westcoastcompanions.org/jgc/1.2/dallogliotext.htm;

quoted here after the Italian original: 'Elogio del sincretismo',
www.deirmarmusa.org/node/67.

— *Amoureux de l'Islam, croyant en Jésus*, trans. E. Gabaix-Hialé.
Paris: Atelier, 2009.

Dinzelbacher, Peter, *Bernhard von Clairvaux: Leben und Werk
des berühmten Zisterziensers*. Darmstadt: Wissenschaftliche
Buchgesellschaft, 1998.

Dombrowski, Damian, *Botticelli: Ein Florentiner Maler über Gott, die
Welt und sich selbst*. Berlin: Wagenbach, 2010.

Dünzl, Franz, *Kleine Geschichte des trinitarischen Dogmas in der Alten
Kirche*. 2nd edn, Freiburg im Breisgau, Herder, 2011.

Ebert-Schifferer, Sibylle, *Caravaggio: Sehen – Staunen – Glauben:
Der Maler und sein Werk*. Munich: C. H. Beck, 2009.

Fischer, Heinz-Joachim, *Rom*. 5th edn, Cologne: DuMont, 2008.

Fischer, Stefan, *Hieronymus Bosch: Das vollständige Werk*. Cologne:
Taschen, 2013.

Francis of Assisi, *The Writings of St. Francis of Assisi*, trans. Paschal
Robinson. Philadelphia: Dolphin Press, 1905; www.ecatho-
lic2000.com/francis/writings.shtml.

Fürst, Alfons, *Hieronymus: Askese und Wissenschaft in der Spätantike*.
Freiburg im Breisgau: Herder, 2003.

Greschat, Katharina, and Tilly, Michael (eds), *Die Mönchsviten des
heiligen Hieronymus*. Wiesbaden: Marix, 2009.

Greshake, Gisbert, *Maria – Ecclesia: Perspektiven einer marianisch
grundierten Theologie und Kirchenpraxis*. Regensburg: Pustet, 2014.

Guardini, Romano, *The Spirit of the Liturgy*, trans. Ada Lane. New
York: Sheed & Ward, 1935.

— *Hölderlin: Weltbild und Frömmigkeit*. Leipzig: Jakob Hegner,
1939.

Haas, Alois M., *Mystik als Aussage: Erfahrungs-, Denk- und Redeformen
christlicher Mystik*. 2nd edn, Frankfurt am Main: Suhrkamp
Taschenbuch, 1997.

— *Mystik im Kontext*. Stuttgart: Fink, 2004.

Hägglund, Bengt, *History of Theology*, trans. Gene J. Lund. 4th edn,
St Louis: Concordia, 2007.

Hesemann, Michael, *Der erste Papst: Auf der Spur des historischen
Petrus*. Munich: Pattloch, 2003.

Hierzenberger, Gottfried, *Maria: Die weibliche Dimension Gottes*.
Kevelaer: Topos plus Verlagsgemeinschaft, 2004.

Hoeberichts, Jan, *Feuerwandler: Franziskus und der Islam*. Kevelaer: Butzon & Bercker 2001.

Hölderlin, Friedrich, 'Patmos: Dem Landgrafen von Homburg; Zweite Niederschrift', in *Hölderlins Werke*, ed. Karl Quenzel. Leipzig: Hesse & Becker, 1923.

Holländer, Hans, *Hieronymus Bosch: Weltbilder und Traumwerk*. 3rd edn, Cologne: DuMont, 1988.

Hoping, Helmut, *Mein Leib für euch gegeben: Geschichte und Theologie der Eucharistie*. Freiburg im Breisgau: Herder, 2011.

Ibn Arabi, Muhyiddin (Muḥyī d-dīn ibn ʿArabī), *Fuṣūṣ al-ḥikam*, ed. Abu l-Aʿlā ʿAfīfī. Teheran, 1370/1991; excerpt in German trans.: *Die Weisheit der Propheten*, trans. Titus Burckhardt and Wolfgang Herrmann. Zurich: Chalice, 2005.

— *al-Futūḥāt al-makkīya*, 9 vols, ed. Nawāf al-Jarrāḥ. Beirut: Dār ṣādir, n.d.; excerpt in German trans.: *Abhandlung über die Liebe*, trans. Maurice Gloton and Wolfgang Herrmann. Zurich: Chalice, 2009.

Innocent III, 'Quia maior', trans. Louise Riley-Smith and Jonathan Riley-Smith, in *The Crusades: Idea and Reality, 1095–1274*, vol. 4 of *Documents of Medieval History*. London: Edward Arnold, 1981.

Jacobus de Voragine, *The Golden Legend: Readings on the Saints*, trans. William Granger Ryan. Princeton, NJ: Princeton University Press, 2012.

Jäggi, Carola, *Ravenna: Kunst und Kultur einer spätantiken Residenzstadt: Die Bauten und Mosaiken des 5. und 6. Jahrhunderts*. Regensburg: Schnell & Steiner, 2013.

James, M. R. (trans.), *The Apocryphal New Testament*. Oxford: Clarendon Press, 1924.

Jean Paul [Richter], *Life of Jean Paul Frederic Richter: Compiled from Various Sources, Together with His Autobiography*, vol. 1, trans. Eliza Buckminster Lee. Boston: Little & Brown, 1842.

Kermani, Navid, *Dein Name*. Munich: Hanser, 2011.

— *The Terror of God: Attar, Job and the Metaphysical Revolt*, trans. Wieland Hoban. Cambridge: Polity, 2011.

— *God is Beautiful: The Aesthetic Experience of the Quran*, trans. Tony Crawford. Cambridge: Polity, 2015.

Kier, Hiltrud, *Köln*. Stuttgart: Reclam, 2008.

Krauss, Heinrich, and Uthemann, Eva, *Was Bilder erzählen: Die*

klassischen Geschichten aus Antike und Christentum in der abendländischen Malerei. Munich: C. H. Beck, 1987.

Kremer, Jacob, *Lazarus: Die Geschichte einer Auferstehung*. Stuttgart: Katholisches Bibelwerk, 1985.

Krischel, Roland, *Stefan Lochner: Die Muttergottes in der Rosenlaube*. Leipzig: Seeman, 2013.

Küster, Niklaus, *Franziskus: Rebell und Heiliger*. 3rd edn, Freiburg im Breisgau: Herder, 2014.

Largier, Niklas, *Lob der Peitsche: Eine Kulturgeschichte der Erregung*. Munich: C. H. Beck, 2001.

Lascaratus, John, 'Child Sexual Abuse: Historical Cases in the Byzantine Empire (324–1453 A.D.)', *Child Abuse and Neglect* 24 (2000), pp. 1085–90.

Lauster, Jörg, *Die Verzauberung der Welt: Eine Kulturgeschichte des Christentums*. Munich: C. H. Beck, 2014.

Luther, Martin, *Luther's Works*, vol. 54: *Table Talk*, trans. Theodore G. Tappert. Philadelphia: Fortress, 1967.

McGrath, Alister E., *Christian Theology: An Introduction*. 5th edn, Oxford: Wiley-Blackwell, 2010.

Marani, Pietro C., *Leonardo: Das Werk des Malers*, trans. Erdmuthe Brand, Uta Grabowski and Bettina Gronenberg. Munich: Schirmer Mosel, 2005.

Markschies, Christoph, *Die Gnosis*. Munich: C. H. Beck, 2001.

Markschies, Christoph, and Wolf, Hubert (eds), *Erinnerungsorte des Christentums*. Munich: C. H. Beck, 2010.

Mosebach, Martin, *Häresie der Formlosigkeit: Die römische Liturgie und ihr Feind*. Munich: Hanser, 2007.

Moses, Paul, *The Saint and the Sultan: The Crusades, Islam, and Francis of Assisi's Mission of Peace*. New York: Doubleday, 2009.

Most, Glenn W., *Doubting Thomas*. Cambridge, MA: Harvard University Press, 2005.

Mulack, Christa, *Maria: Die geheime Göttin im Christentum*. Stuttgart: Kreuz, 1985.

Murata, Sachiko, *The Tao of Islam: A Sourcebook on Gender Relationships in Islamic Thought*. Albany: SUNY Press, 1992.

Nagel, Ivan, *Gemälde und Drama: Giotto, Masaccio, Leonardo*. Frankfurt am Main: Suhrkamp, 2009.

Neumahr, Uwe, *Inquisition und Wahrheit: Der Kampf um den reinen Glauben*. Stuttgart: Kreuz, 2005.

Oliver of Paderborn, *The Capture of Damietta*, trans. John J. Gavigan. Philadelphia: University of Pennsylvania Press, 1948.

Pagels, Elaine, *Beyond Belief: The Secret Gospel of Thomas*. New York: Random House, 2003.

Patterson, Stephen J., and Robinson, James M., *The Fifth Gospel: The Gospel of Thomas Comes of Age, with a New English Translation by Hans-Gebhard Bethge et al.* Harrisburg, PA: Trinity, 1998.

Perniola, Mario, *Del sentire cattolico: la forma culturale di una religione universale*. Bologna: Il Mulino, 2001.

Randt, Richard, *The Raising of Lazarus by Rembrandt*. Los Angeles: Los Angeles County Museum of Art, 1992.

Ratzinger, Josef (Pope Benedict XVI), *Jesus of Nazareth*, 3 vols. San Francisco: Ignatius Press, 2007–12.

Richter, Gerhard, *Zufall: Das Kölner Domfenster und 4900 Farben*. Cologne: Kölner Dom, 2007.

Sander, Jochen (ed.), *Dürer: Kunst – Künstler – Kontext*. Munich: Prestel, 2013.

Schade, Oskar, *Die Sage von der heiligen Ursula und den elftausend Jungfrauen: Ein Beitrag zur Sagenforschung*. Hanover: Rümpler, 1854.

Schama, Simon, *Rembrandt's Eyes*. London: Penguin, 2014.

Schätze, Sebastian, *Caravaggio: Das vollständige Werk*. Cologne: Taschen, 2009.

Schenke, Hans-Martin, Bethge, Hans-Gebhard, and Kaiser, Ursula Ulrike, *Nag Hammadi Deutsch: Studienausgabe*. Berlin and New York: De Gruyter, 2010.

Schimmel, Annemarie, *Meine Seele ist eine Frau: Das Weibliche im Islam*. Munich: Kösel, 1995.

— *Jesus und Maria in der islamischen Mystik*. Munich: Kösel, 1996.

Schindler, Alfred (ed.), *Apokryphen zum Alten und Neuen Testament*. Zurich: Manesse, 1998.

Schmidt, Heinrich, and Schmidt, Margarethe, *Die vergessene Bildersprache christlicher Kunst: Ein Führer zum Verständnis der Tier-, Engel- und Mariensymbolik*. 5th edn, Munich: C. H. Beck, 1995.

Schmidt, Wilhelm, *Ravenna: Die Botschaft seiner Bilder*. Bremen: Schmidt, 1971.

Schreiner, Klaus, *Maria: Jungfrau, Mutter, Herrscherin*. Munich: Deutscher Taschenbuch, 1996.

Schumacher, Andreas (ed.), *Perugino: Raffaels Meister*. Ostfildern: Hatje Cantz, 2011.

Schuon, Frithjof, *Christianity/Islam: Perspectives on Esoteric Ecumenism*, ed. James S. Cutsinger. Bloomington, IN: World Wisdom, 2008.

Schütze, Sebastian, *Caravaggio: Das vollständige Werk*. Cologne: Taschen, 2009.

Spear, Richard E., *The Divine Guido: Religion, Sex, Money and Art in the World of Guido Reni*. New Haven, CT, and London: Yale University Press, 1997.

Ströter-Bender, Jutta, *Die Muttergottes: Das Marienbild in der christlichen Kunst: Symbolik und Spiritualität*. Cologne: DuMont, 1992.

Surmann, Ulrike, and Schröer, Johannes (eds), *Trotz Natur und Augenschein: Eucharistie – Wandlung und Weltsicht*. Cologne: Greven, 2013.

Tanizaki, Junichiro, *In Praise of Shadows*, trans. Thomas J. Harper and Edward G. Seidensticker. London: Vintage, 2001.

Täube, Dagmar, and Fleck, Miriam Verena (eds), *Glanz und Größe des Mittelalters: Kölner Meisterwerke aus den großen Sammlungen der Welt*. Munich: Hirmer, 2011.

Teresa of Avila, *The Autobiography of Teresa of Avila*, trans. E. Allison Peers. New York: Doubleday, 1991.

Thode, Henry, *Franz von Assisi und die Anfänge der Kunst der Renaissance in Italien*. 2nd edn, Berlin: G. Grote, 1904.

Thomas of Celano, *The Lives of S. Francis of Assisi*, trans. A. G. Ferrers Howell. London: Methuen, 1908.

Vasari, Giorgio, *The Lives of the Artists*, trans. Julia Bondanella and Peter Bondanella. Oxford: Oxford University Press, 2008.

— *Das Leben des Piero di Cosimo, Fra Bartolomeo und Mariotto Albertinelli*. Berlin: Klaus Wagenbach, 2008.

Warren, Kathleen, *Daring to Cross the Threshold: Francis of Assisi Encounters Sultan Malek Al-Kamil*. Eugene, OR: Wipf & Stock, 2003.

Wismer, Beat, and Scholz-Hansel, Michael (eds), *El Greco und die Moderne*. Ostfildern: Hatje Cantz, 2012.

Wolf, Norbert, *Giotto di Bondone: Die Erneuerung der Malerei*. Cologne: Taschen, 2006.

— *Albrecht Dürer: Das Genie der deutschen Renaissance*. Cologne: Taschen, 2012.

Zander, Hans Conrad, *Als die Religion noch nicht langweilig war: Die Geschichte der Wüstenväter*. Cologne: Kiepenheuer & Witsch, 2001.

Zehnder, Frank Günther (ed.), *Sankt Ursula: Legende, Verehrung, Bilderwelt*. Cologne: Wienand, 1985.

— *Stefan Lochner: Meister zu Köln*. Cologne: Locher, 1993.

Illustration Credits

81 Caravaggio, *Death of the Virgin*. Musée du Louvre, Paris. From Ebert-Schifferer, *Caravaggio*, p. 185, fig. 134.

86–7 *The Good Shepherd*. Mausoleum of Galla Placidia, Ravenna. © akg-images/Erich Lessing.

97 Stefan Lochner, *Madonna of the Rose Bower*. Wallraf-Richartz Museum, Cologne. © akg-images.

104–5 Fernand Cormon, *Cain*. Musée d'Orsay, Paris. © akg-images/Laurent Lecat.

110 Albrecht Dürer, *Job on the Dunghill*. Städelsches Kunstinstitut, Frankfurt am Main. © akg-images.

111 Albrecht Dürer, *Piper and Drummer*. Wallraf-Richartz Museum, Cologne. © akg-images.

116–17 Caravaggio, *Judith and Holofernes*. Galleria Nazionale d'Arte Antica, Palazzo Barberini, Rome. From Ebert-Schifferer, *Caravaggio*, p. 109, fig. 67.

123 Mariotto Albertinelli, *The Visitation*. Galleria degli Uffizi, Florence. © akg-images/Mondadori Portfolio/Antonio Quattrone.

127 Caravaggio, *The Crucifixion of St Peter*. Santa Maria del Popolo, Rome. From Ebert-Schifferer, *Caravaggio*, p. 138, fig. 95.

134 Leonardo da Vinci, *St Jerome in the Wilderness*. Pinacoteca Vaticana, Rome. © akg-images/Nimatallah.

139 Master of the Legend of St Ursula, *An Angel Appears to St Ursula*. Wallraf-Richartz Museum, Cologne. © akg-images.

144–5 Caravaggio, *The Martyrdom of St Ursula*. Palazzo Zevallos Stigliano, Naples. From Ebert-Schifferer, *Caravaggio*, p. 234, fig. 170.

153 Pietro Perugino, *The Vision of St Bernard*. Alte Pinakothek, Munich. © akg-images.

158–9 Georges de la Tour, *The Ecstasy of St Francis*. Musée de Tessé, Le Mans. © akg-images/Erich Lessing.

164–5 Francisco de Zurbarán, *The Apparition of the Apostle Peter to St Peter Nolasco*, Museo del Prado, Madrid. © akg-images/Erich Lessing.

171 *Queen Simonida*. Gračanica Monastery, Kosovo. © Zeljko Radovic.

179 Paolo Dall'Oglio. Still image from a television interview, www.belfasttelegraph.co.uk/video-news/video-father-

paolo-dalloglio-at-raqqa-rally-before-kidnap-29459940. html. © YouTube/syriaraqqa1.

198–9 Caravaggio, *The Calling of St Matthew*. San Luigi dei Francesi, Rome. From Ebert-Schifferer, *Caravaggio*, p.127, fig. 84.

205 Hans Memling, *Portrait of a Young Man Praying*. Museo Thyssen-Bornemisza, Madrid. Photo: Fundación Collección Thyssen-Bornemisza.

210–11 Caravaggio, *The Sacrifice of Isaac*. Galleria degli Uffizi, Florence. From Ebert-Schifferer, *Caravaggio*, p. 110, fig. 68.

216 A sister of the Community of Jerusalem, Cologne. © Hermann Dornhege.

223 Monstrance. Kolumba, Kunstmuseum des Erzbistums Cologne. © Kolumba, Cologne; photo: Lothar Schnepf.

230–1 Caravaggio, *The Incredulity of Thomas*. Bildergalerie im Park Sanssouci, Potsdam. From Ebert-Schifferer, *Caravaggio*, p. 172, fig. 122.

237 Visoki Dečani monastery, Kosovo. © picture alliance/dpa.

250–1 Hieronymus Bosch, *Fall of the Damned*; *Hell*; *Earthly Paradise*; *Ascension to Heavenly Paradise*. Museo di Palazzo Grimani, Venice. © akg-images/Cameraphoto.

265 Anonymous Cologne master, *The Love Spell*. Museum der bildenden Künste, Leipzig. © akg-images.

269 Giotto di Bondone, *Joachim and Anne Meeting at the Golden Gate*. Cappella degli Scrovegni, Padua. © akg-images/ Cameraphoto.

275 Woman praying in the Armenian Apostolic Church of St George, Isfahan. © Isabelle Eshraghi/Agence VU/laif.

282 Gerhard Richter, Window in the south transept of Cologne Cathedral. © akg-images/Bildarchiv Steffens.

291 Cartula of St Francis: *Blessing for Brother Leo*. Sacro Convento, Assisi. © akg-images/Gerhard Ruf.